Poly-Modeling with 3ds Max

Poly-Modeling with 3ds Max
Thinking Outside of the Box

Todd Daniele

Routledge
Taylor & Francis Group

LONDON AND NEW YORK

First published 2009
This edition published 2013 by Focal Press

Published 2017 by Routledge
2 Park Square, Milton Park, Abingdon, Oxon OX14 4RN
711 Third Avenue, New York, NY 10017

First issued in hardback 2017

Routledge is an imprint of the Taylor and Francis Group, an informa business

Library of Congress Cataloging-in-Publication Data
Daniele, Todd.
 Poly-modeling with 3ds Max : thinking outside of the box/Todd Daniele.
 p. cm.
 Includes index.
 ISBN 978-0-240-81092-8 (pbk. : alk. paper) 1. 3ds max (Computer file)
2. Computer animation. 3. Computer graphics. I. Title.
 TR897.7.D34 2008
 006.6'96—dc22

 2008026269

British Library Cataloguing-in-Publication Data
A catalogue record for this book is available from the British Library

ISBN 13: 978-1-138-40080-1 (hbk)
ISBN 13: 978-0-240-81092-8 (pbk)

Typeset by Charon Tec Ltd., A Macmillan Company

Contents

Contents

Acknowledgments

I thank some of the people who helped make this book a reality: Laura Lewin, Chris Simpson, Georgia Kennedy, and all of the people behind the scenes at Focal Press. I also thank Amer Yassine for his help with the technical review and editing. My sincerest thanks go out to Jeff Patton; Jeff put me in contact with Focal Press, and without that initial introduction, none of this would have happened.

I thank some of my colleagues, Daniel Presedo and Bahman Dara, for giving me my first "break" into the industry.

Thor Raxlen, Jesse Holmes, Steve Sullivan, and Vance Miller: These guys have given me the opportunity to do what I love and to learn something new on a daily basis. I can write a book partly because of what I have learned working alongside this amazing collection of professionals.

Most of all, thanks to my wife and family for the support, faith, and understanding they have shown me during this arduous process.

Todd Daniele

Chapter 1

Introduction

Poly-Modeling with 3ds Max is a practical guide for intermediate- to advanced-level 3ds Max modelers, covering techniques that will significantly impact the quality of your models as well as work flow and productivity. This volume covers Poly-Modeling extensively, while also touching on other methods of modeling that can be implemented in your Poly-Modeling work flow. I present an abundance of technical information; it is up to you as an artist to use this information in a creative manner. It is also up to you to take this information and think about how to apply it dynamically, to know how to use what you have learned to solve problems. An integral part of being a good modeler is having the ability to solve problems.

So, what is "Poly-Modeling"? It's a technique that allows the modeler a great deal of control and flexibility. Rather than starting with a basic "primitive" object, in many cases we will start with a single polygon or a small group of polygons. Why? Well, by doing so, and using some basic intuitive techniques, we can shape the model on the fly, modeling in an almost sculpture-like fashion. There are many advantages to this approach, adding infinite amounts of detail, and controlling the edge flow of your mesh is considerably easier to achieve using this method.

Throughout this book, extensive written exercises outline, in great detail, basic and advanced Poly-Modeling techniques, tips, tricks, and shortcuts. Easy to follow images serve as a visual accompaniment to the written text. There are also companion 3ds Max files (available for download at http://www.todddaniele.com/FocalPress.htm) showing the progression of each modeling exercise. These files can serve as a starting point for those readers who wish to start from a specific point in the exercise, or as a reference for those who want to check their own progress against the

1

finished model. Finally, there is an Internet-based forum at http://www.todddaniele.com/forum/, where you can post questions and comments pertaining to any part of this book or its exercises.

In addition to the information on 3ds Max's included tools, this book covers some external scripts and plug-ins that can be used to enhance your modeling capabilities and speed further. In later chapters we will also delve into nonmodeled geometry such as displacement map creation via Mudbox and ZBrush. These applications have had a significant impact on our industry; they have changed the way we work and the methods we use to add fine details to our creations.

In the end, you will have a well-rounded arsenal of techniques, applications, and theory that should allow you to model anything thrown your way in a real-world production environment. The ability to make quality models with confidence, competence, and speed will catch the attention of current and/or potential employers, as well as co-workers and colleagues.

Now that you have an idea of what type of content to expect, you may be wondering just what qualifications I have, so here is a brief overview of what I do and how I ended up where I am. I arrived here via a slightly different route than expected. My interest in 3D was piqued in the late 1990s by films like *Jurassic Park* and *Twister* and animated Pixar features like *Toy Story*. Nintendo 64 also played a part in my curiosity; seeing the 3D models in a semiprimitive form was very intriguing to me. Although I did take a class (and that means one) in 3D graphics, that is not how I became a 3D professional. I am self-taught; through the use of books like this and publicly available information (forums/tutorials) I created my own path to success.

In 2004, after three years of diligently practicing, studying, and working toward a goal of becoming a professional 3D modeler, I created www.todddaniele.com. My new site was intended to be a place to showcase my 3D work to potential clients and employers. Within six weeks of the site's launch, I was contacted, and subsequently hired, by a large West Coast graphics software developer. I still provide content for the company to this day, as well as modeling, texturing, and rendering assets for television, film, print, and web-based "New Media" advertisements. I have worked as an independent contractor for several major New York-based studios, settling in comfortably at GuerillaFX, a rapidly growing studio catering to a host of notable clients. My work for GuerillaFX has been featured on television and the Internet and even graced the Jumbo-Tron screens in Times Square, the heart of New York City. Although my main task is modeling, I also do quite a bit of lighting, texturing, and rendering on a daily basis. The learning process never ends in this industry; being surrounded by a team of people who are passionate about what they do and open about what they know has only fueled my desire to be better at what I do.

I have worked on projects for many high-profile clients during my time with GFX, including BMW, Nike/Nike Zoom, Coke Zero, Citibank/CitiRewards, MTV/Old Navy, MTV–T-mobile, MTV–Amp'd Mobile, MTV/ATT/Cingular, Sonic Drive-In, Checker's/Rally's Drive-In, Verizon/LG, Proctor & Gamble/Old Spice, Target/Archer Farms, and MTV.

While working for the clients listed above I modeled everything from phones to photo-real food, cars to sneakers, many times facing challenges I could never anticipate. Applying the information found on the pages of this book, I overcame these challenges. I never second-guessed my abilities or the ability of 3ds Max and Poly-Modeling techniques to get the job done. Adversity is something I welcome; with each new challenge a lesson is inevitably learned, and applying this information in other situations is what raises the bar and makes the continuing process of learning while working so enjoyable. There is always room for improvement regardless of your skill level.

Now that you have a basic idea of what to expect, and my qualifications, let's jump right in and get started with some modeling!

Chapter 2

Modeling Types

Let's start out by covering some of the traditional modeling options available to us in 3ds Max. I am going to touch on each of these approaches, discuss their pros and cons, and show how all of these methods can work in conjunction with Poly-Modeling techniques later on in this book. Reviewing these basic techniques early on gives you an opportunity to refamiliarize yourself with some tools you may not have used for a while and also gives you a chance to get familiar with the way I am going to present information to you throughout this book.

I would like to say that some of these are very basic techniques or considered to be "old" by many users, but I don't believe that discounting the abilities of any of these options is a smart thing to do; they all can produce high-quality results. As an example: Let's say you are asked to model a bowling pin. Well, you could Poly-Model it and achieve great results, but in my opinion the quickest, and best, method would be to create a spline profile of the pin and then use a lathe modifier with the appropriate options and segments to create the model. As with anything you may encounter, knowing which approach to use to achieve the desired results in the least amount of time is the key. Combining techniques to create "hybrid" work flows will ultimately be the best option. The support files for this, and all the exercises featured in this book, are available for download at http://www.todddaniele.com/FocalPress.htm. There is also a public support forum here: http://www.todddaniele.com/forum/.

Spline-Modeling

First up, we are going to take a look at Spline-Modeling with the Surface modifier. For a full description of how to use the Splines/Surface modifier you can refer to your 3ds Max manual (hot-key F1). Basically, you can create a network of splines and apply a Surface modifier to create a surface. The limitations? Well, you need to keep your spline network made up of three- or four-sided regions,

and verts (vertices) need to be within the designated threshold under Parameters/Spline options. Figure 2.1 shows a spline network with three- and four-sided frameworks as well as the resulting spline network with a Surface modifier applied. Figure 2.2 shows a spline network with a six-sided opening; note how the Surface modifier does not fill the opening because it is not a three- or four-sided region.

I am going to recommend experimenting with the Patch Topology steps value depending on the intended use of your model (value can range between 0 and 100). Figure 2.3 shows the Patch Topology rollout set to 0.

For models you plan to modify, and/ or add a TurboSmooth modifier to, you can set the value relatively low, or even to 0, to create polygons that explicitly mirror the end result of the spline-cage after applying the Surface modifier. If you want to create a clean, basic model, and do not have plans to modify or subdivide, you can set the value higher according to your needs.

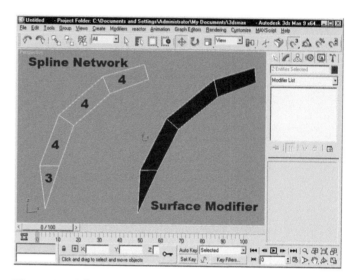

Figure 2.1 *Spline network and resulting surface.*

Figure 2.2 *Spline network with a six-sided region in the center. The Surface modifier does not fill the opening because it is not composed of three or four sides.*

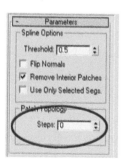

Figure 2.3 *Patch Topology rollout.*

The Creation Method rollout also has two option boxes, Initial Type and Drag Type. Depending on the desired result, you can use any combination of options. Using Corner on both options in conjunction with a Patch Topology value of 0 will allow you to create large groups of polygons in a very precise manner. This approach is ideal for creating models you plan to later subdivide. Figure 2.4 shows the results of two different

Patch Topology values on the same spline network. On the left, Patch Topology is set to 0, on the right, Patch Topology is set to 50.

In my experience, splines are a great option for creating free-form shapes with flowing transitions, organic meshes, and general base meshes for any type of hard-edge model. A large part of having control over your spline models (and later your patch models) is getting familiar with the Bezier handles and how to control their influence. We are going to review briefly some tips and tricks that will make your experience go much more smoothly.

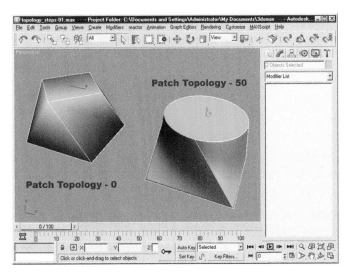

Figure 2.4 *Spline network with two different Patch Topology values. Zero produces a low poly result, a high value (50) produces a smooth clean shape.*

Controlling Bezier Handles

Let's say you have a spline-based model. As you develop your model you want to alter the shape. Well, by simply clicking on a vert you will be presented with a group of Bezier handles. Controlling the Bezier handles may seem odd at first, but with a couple of simple steps you should be able to master this with minimal practice. The first thing to keep in mind is that you can right-click your

vert and select from a list of vertex types in the Quad menu. Depending on the desired surface you can alter the vert type—I recommend taking a few minutes to experiment with the different options available to you. The types are Bezier Corner, Bezier, Corner, and Smooth. Figure 2.5 shows the Quad menu with the types highlighted.

The next thing we want to do is manipulate the Bezier handles. As I said this can seem tricky at first, but is in fact very easy to do. Clicking on one of the green points on the handle will allow you to move it, either side to side or up and down. By default you are going to move the handle only in a planar direction, i.e., front to back, side to side, or up and down. If you attempt to move the handle up and down while the handle is in front-to-back mode, you are still going to move the point front to back. By simply clicking on one of the

Figure 2.5 *Quad menu with vertex types highlighted.*

7

arrows (axis handles in the manual) on the Transform gizmo, you can toggle the direction in which the Bezier point and handle are going to travel. Clicking on the up-facing arrow will give you up and down control over the handle, clicking the front-to-back arrow will give you control front to back, and of course, clicking the left-to-right arrow will give you control in the corresponding direction. Figure 2.6 shows the gizmo with the Z-axis activated. Handles will move only in a direction that corresponds to the selected axis (Z).

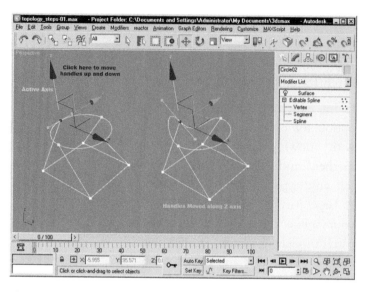

Figure 2.6 *Active axis Z. Directional arrow moves the handles along the Z-axis.*

In addition to this planar direction control, you can also move the point in two directions at one time. On the Transform gizmo, we also have plane handles. These are the areas between two axis handles that turn yellow when we put our pointer over them. Selecting the area between the X- and the Y-axis handles (by clicking) will now give you control of the Bezier in both the X and the Y directions. A good rule of thumb when using this method is to manipulate the handles in a

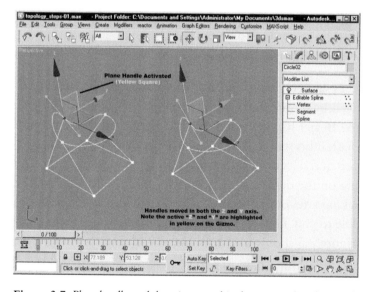

Figure 2.7 *Plane handles and the points moved in the corresponding direction(s).*

nonorthographic view. Using the front, top, or side viewport will give a more accurate view of what influence the handle is having and in which direction it is having it. With the few bits of information we just outlined and a little bit of practice, you should now be able to manipulate Bezier handles predictably and, ultimately, the shape of your splines, patches, and models. Figure 2.7 shows the plane handles and the points moved in the corresponding direction(s).

In addition to using the Surface modifier, you can also use splines to create profiles that you can later lathe, extrude, or loft. Lathing is an excellent option for quickly modeling things like wine glasses, pedestals, bowls, lamps, and table legs ... I think you get the picture. Extruding and/or lofting spline profiles is a great approach for building walls, crown moldings, and many architectural elements. We will go into some quick easy ways to create architectural details with 3ds Max's basic tools later on in this book. Figure 2.8 shows a spline and resulting lathe. Using the Show End Result toggle you can move the spline's points to create a completely different profile with instantaneous visual feedback.

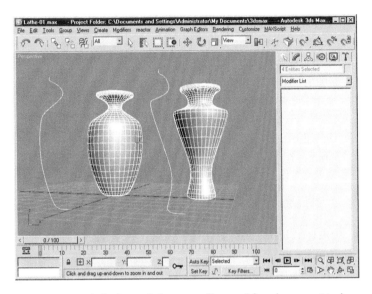

Figure 2.8 *Lathed spline and alternate profile created from the same original spline.*

Now that you have experimented with spline basics, let's move on to something a little more complex.

Spline-Modeling an Eye Socket

1. Click in the front viewport to activate it. In the Create panel we are going to select Line and change both the Initial Type and the Drag Type to Corner (Figure 2.9). For this exercise this configuration will give the best results with the least amount of effort.
2. In the front viewport, start clicking point by point to create the basic outline in the shape of a human eye opening. When you have made a full loop by returning to the initial point a pop-up dialog will ask if you wish to "Close spline?" Select Yes (Figure 2.10).
3. When you have finished creating this spline, go to the modifier stack, and click the + next to the word Line. Highlight the vertex subobject level and in the selection rollout under Display, check the Display Vertex Numbers checkbox. You will now be presented with numbers above each vertex, making it easy to create

Figure 2.9 *Creation Method dialog box.*

consistent splines with uniform vertex counts. Figure 2.10 shows the initial spline from step 2 with the vertex numbers displayed.

4. Let's create the second loop. It should be roughly the shape of a skull's eye socket, so I have approximated the shape of the brow ridge and cheekbone areas. The completed loop has another 13 points and a closed spline for me to work with (Figure 2.11). In my example I used 13 points to create the first spline shape; as I created the next spline for our network, I used the same amount of points as in the initial shape. Keeping the point count the same makes the process of connecting the spline loops we are creating much easier, by eliminating the need to Refine the splines. As you lay out these splines, visualize the shapes that you are trying to mimic. You can always look at a reference if you feel it is necessary. This is a basic demonstration, so I am modeling without a reference.

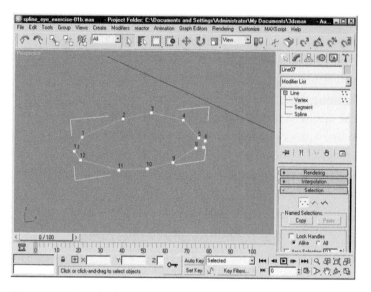

Figure 2.10 *Initial spline consisting of 13 points.*

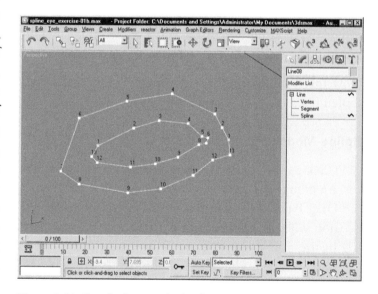

Figure 2.11 *Second spline created using the same vertex count.*

5. Create a third loop using the same point count, closing the spline when done (Figure 2.12).
6. Let's move the splines to create some depth. By moving the first spline back, we are going to create the depth of the eye socket. You can also take this opportunity to create some curvature from side to side to the eye and socket, although I am going to do that a little

later on (top or bottom view is best if you decide to do this at this point). Figure 2.13 shows the center spline moved back to create depth.

7. Now we are going to attach the three splines to one another using the Attach button. Figure 2.14 shows the Attach button.

8. After the splines are attached we can access the Create Line tool. This is a great time to set your Snaps toggle to Vertex (you can use the hot-key S to toggle this

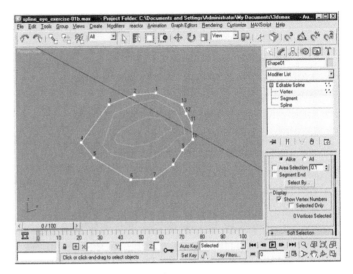

Figure 2.12 *Three completed splines, with 13 points each. The lines can be left as lines or converted to editable splines if desired.*

Figure 2.13 *Center spline moved back along the Y-axis.*

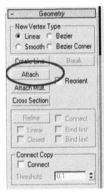

Figure 2.14 *The Attach button.*

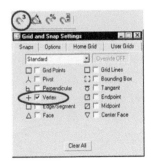

Figure 2.15 *Snaps toggle and Vertex setting activated.*

on and off). The result of this setting is that, as we create the lines for the cross sections, they will snap to the existing verts for more precision (Figure 2.15).

9. With three clicks each, let's connect the 13 points on each spline loop to one another in an orderly fashion. Start with an identifiable

location on each spline and create the cross splines (I started with the top inner corner of the eye). Figure 2.16 shows the splines positioned and connected.

10. In the Modifier list, add a Surface modifier. With this step, you may need to adjust some of the parameter settings. I had to Flip Normals on my example. For this model we are going to set the Patch Topology steps to 0. Figure 2.17 shows the Patch Topology set to 0. We are using 0 as the value so that our model will have polygons that

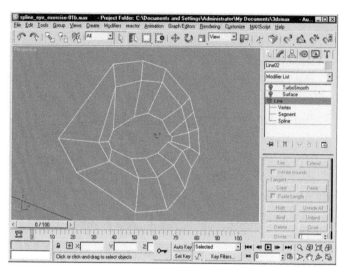

Figure 2.16 *Splines positioned and connected.*

are exactly the same in size and number as our spline grid when we collapse to Editable Poly.

11. In this case we cannot collapse to Editable Poly by right-clicking the modifier stack, so we are going to right-click on the model itself in the viewport and select Convert To/Convert to Editable Poly from the Quad menu. If you would like to see the subdivided end result of this exercise, you can apply a Bend modifier with a suitable value and direction (to add curvature to the model) and a TurboSmooth modifier. Figure 2.18 shows the end result of this exercise.

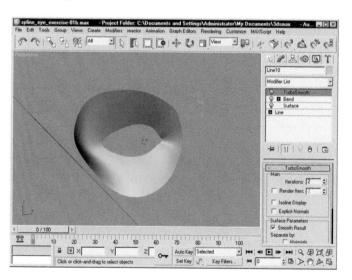

Figure 2.18 *Final result of Spline-Modeling exercise. Bend modifier and TurboSmooth applied.*

Figure 2.17 *Patch Topology set to 0.*

The accompanying file for this exercise includes several extra steps, which are performed with techniques outlined in later chapters. I think we have seen that Spline-Modeling is a very effective modeling technique. The additional steps in the file show how spline models can be further developed with Poly-Modeling techniques (after conversion to Editable Poly).

The Zip file containing the step-by-step splines and meshes for this exercise, and other spline-based modeling exercises, can be found at

Figure 2.19 *Converted spline model (Editable Poly) with additional Poly-Modeling techniques applied.*

http://www.todddaniele.com/FocalPress.htm. Figure 2.19 shows the final model with additional Poly-Modeling steps applied.

Patch-Modeling

Now that you are a bit more familiar with Spline-Modeling and the methods of controlling the output, we are going to move along to Patch-Modeling. There are many similarities between Spline-Modeling and Patch-Modeling, which is why we are going to jump right into patches next. You can create patch grids by going to Create > Geometry > Patch Grids. You will be presented with options for quadrangle (Quad) or triangle patches; I strongly endorse the use of Quads, as any good subdivision model always begins with Quads as a base. Figure 2.20 is a good example of a Quad-based mesh and the subdivided result.

Figure 2.20 *Quad mesh (left) and subdivided result (right).*

13

If you want your final mesh to reflect your displayed patches, just as with splines, you do have some options that will allow you to control the output. The first are the Length and Width segments in the Parameters rollout displayed when you initially create your Quad patch (Figure 2.21).

The second option to control both the poly count and the precision of your mesh is the Surface parameter in the Geometry rollout (keep in mind you must first convert the Quad patch to an editable patch). View Steps will affect your mesh if/when you convert your mesh to an Editable Poly (Figure 2.22).

Figure 2.21 *Parameters rollout.*

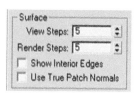

Figure 2.22 *Surface Steps rollout.*

To get an idea of the poly count of the converted mesh you can tick the Show Interior Edges checkbox to see a viewport display of the polygons in the patch surface.

A nice feature with Patch-Modeling is the ability to take multiple patches and create a network by welding them together at their seams. This option lends itself nicely to creating more detailed meshes with a high level of editability.

Any model we create with the Spline-Modeling technique can be converted to an editable patch surface. In addition, any primitive object or existing polygon-based model can be converted to an editable patch. Results can vary; as always, I encourage experimentation, exploration, and an open mind. Just as with splines, Patch-Modeling is a nice option for creating free-form shapes with flowing transitions, organic meshes, and general base meshes for any type of hard-edge model. The drawback of both Spline- and Patch-Modeling for many users is the awkward manipulation of the Bezier handles. Any modeling technique requires a bit of practice. Practice will make manipulating Bezier handles a very intuitive and productive process. See Controlling Bezier Handles under Spline-Modeling earlier in this chapter.

Patch-Modeling a Computer Mouse

1. Let's get started by going to the Create panel and selecting Patch Grids from the rollout menu. Remember, we want to have Quad-based models when we are subdividing, so Quad Patch is the better option here. Figure 2.23 shows the rollout and the resulting Object Type rollout.

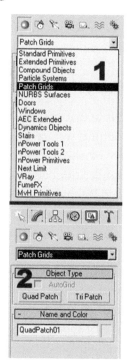

Figure 2.23 *Create panel rollout and resulting Object Type rollout.*

2. In the top viewport, create a rectangular shape with the approximate proportions of a PC mouse. For this exercise we are going to leave the Length and Width segments under Parameters at 1. Leaving this value at 1 will give us four vertices to use to manipulate our Bezier handles. Adding more segments would create more points, each point with its own set of Bezier; with more segments/points and Bezier comes more opportunity to make a wavy or messy mesh. Figure 2.24 shows the Quad patch in the top viewport. Experiment; as you get more adept at using patches, you will find that more points may be ideal for creating more complicated models.

3. Right-click on either the rectangle in the viewport or the word "QuadPatch" in the modifier stack, and select Convert to Editable Patch.

4. In the left viewport create a soft arcing shape at both ends by selecting Vertex (under Editable Patch in the modifier stack), then clicking the vertex and the appropriate Bezier handle, and then adjusting to the desired shape. Figure 2.25 shows handles manipulated to create the side profile.

5. Do the same for each corner vert (each one separately, one at a time), creating a smooth profile from front to back and from side to side. You will now be left with a

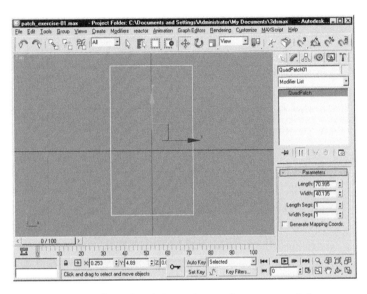

Figure 2.24 *Initial Quad patch in top viewport. Segments set to 1, 1.*

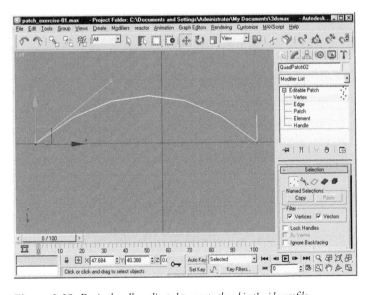

Figure 2.25 *Bezier handles adjusted to create the object's side profile.*

15

shape that arcs in two directions, much like the top surface of a computer mouse. *Note: If you are having difficulty controlling the handles, you may need to refer back to Controlling Bezier Handles earlier in this chapter.* Figure 2.26 shows the mouse top surface, arcing in two directions.

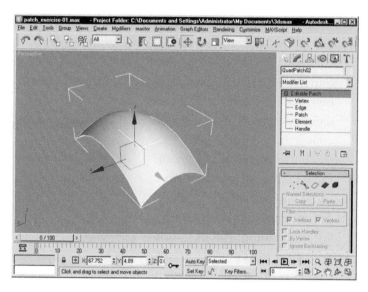

Figure 2.26 *Mouse top surface, arcing in two directions.*

6. In the front viewport, zoom in to our mesh and, using it as a guide, create another Quad patch stretching from the left side vert to the right side vert. Give it a little bit of height; for this just use your own judgment (Figure 2.27).

7. Once this shape is created go to your top viewport, and align the newly created patch to the front of the existing surface (mouse top). Next convert the Quad patch to an editable patch, and manipulate the Bezier handles to match up with the curves of the existing mouse top geometry. You should take a little time to match the curves of the new surface, both side to side

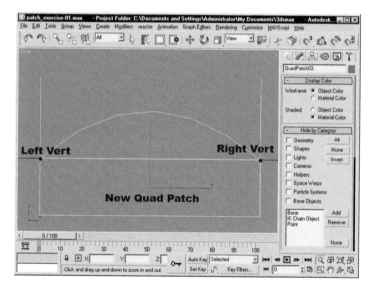

Figure 2.27 *New Quad patch and highlighted vertices from step 6.*

and top to bottom. Figure 2.28 shows the second patch in its initial state and the converted/edited version matching the curves of the mouse top surface.

8. Upon completing the last step, you can simply clone this front surface to the rear of the mouse top by holding Shift while dragging it with your mouse. When prompted, select Copy in the Clone Options dialog box. Once the surface is cloned you will need to mirror

the new patch along the appropriate axis to have it line up with the back of the top section. We are going to create a similar patch for the side surfaces, although there will be a small opening between the mouse top and the side surface.

9. Go to Create panel, Quad Patch, and create a rectangle spanning from the front to the back of the mouse in the side viewport. Using the same process we used for the front, we are going to make the new patch follow the existing curves of our front and back patches. We are *not*, however, going to match the side profile of the mouse top surface. You will see why we are not concerned with matching the mouse top profile shortly. As with the previous patch, we are going to clone and mirror the patch to the opposite side of the mouse top surface. Figure 2.29 shows the new side patch as it should look when you are finished (it should appear the same on the opposite side as well).

Figure 2.28 *New patch in its initial state (left) and converted with Bezier handles manipulated (right).*

Figure 2.29 *Side patch; we are not concerned with the opening between the side and the top surfaces.*

10. Next we attach all of the patches. Select the mouse top surface in the modifier stack, and under the Geometry rollout, select Attach. Click on each of the other patches that make up our current object. As you click, each patch will change to the color of your mouse top surface, indicating it is now part of the same object. When finished you will be left

with one object displayed all in one color (in my example everything matches the green of the top surface when complete) (Figure 2.30).

11. In the Perspective viewport, select the verts where the left side, front, and top surfaces meet. You should have a total of three vertices selected when you have done this. Right-click the vertex selection, and convert them to Corner in the upper left Quad menu. You will find that if you do not convert your three vertices to Corner the side patch we created will become curved during the next step. We do not want that to occur in this particular circumstance.

12. Under Geometry/Weld set the value to 1 and click Selected. Did anything happen? In your Selection rollout you should now see one vertex listed instead of the previous three. If not, increase the value and click the Selected button again. Repeat these steps on the verts on the right side in the same area and do

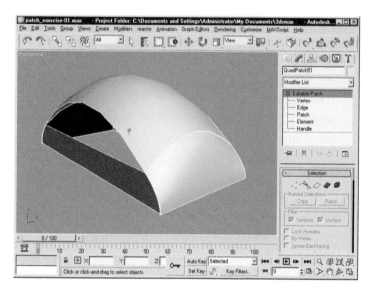

Figure 2.30 *All patch surfaces attached. Notice the object is all one color.*

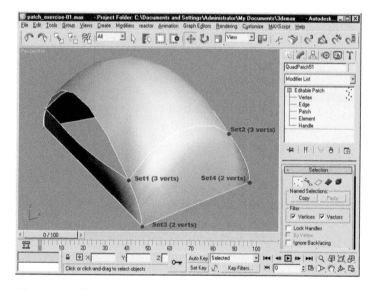

Figure 2.31 *Vertex selections, with vertex count prior to welding.*

the bottom left and right sets of verts. Do not forget to convert each selection of verts to Corner for this series of steps. Figure 2.31 shows the vert locations and how many verts you should have in each area before welding.

13. We are now going to move to the corresponding vertices at the back of the mouse object. This time we are *not* going to convert our selections to Corner. By leaving the verts set

to Coplanar, we are going to create a more curved area at the rear of the mouse. We are also going to start with the lower sets of two verts this time to show clearly the effect of welding the top sets of vertices (Figure 2.32).

14. After the bottom two sets, let's go for the top two sets of verts. You will notice with your first weld that the gap along the side of the object vanishes. Repeat this action on the other side, and what we are left with is a single, flowing mesh. The nice thing about this technique is that

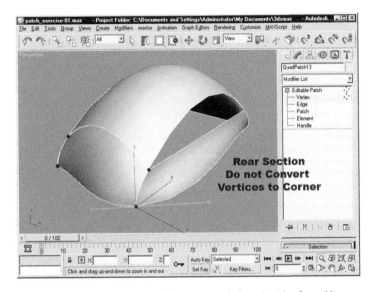

Figure 2.32 *Rear vertices. Note the curve created along the side after welding the first set.*

we still have editable Bezier handles attached to each vertex, so we are not locked in to the shape we currently have (Figure 2.33).

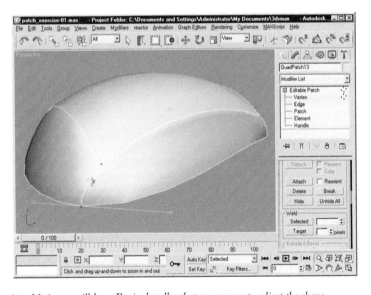

Figure 2.33 *Welded points. Notice we still have Bezier handles that we can use to adjust the shape.*

15. Some minor adjustments in the top and front viewport will result in a nice overall shape to our basic object. Add a TurboSmooth to see the final result (Figure 2.34).

The accompanying file for this exercise includes several extra steps, which are carried out with techniques outlined in later chapters. I think we have seen that Patch-Modeling is a valid option with a high level of editability. The additional steps in the file show how patch models can be further developed with Poly-Modeling techniques (after conversion to Editable Poly) (Figure 2.35).

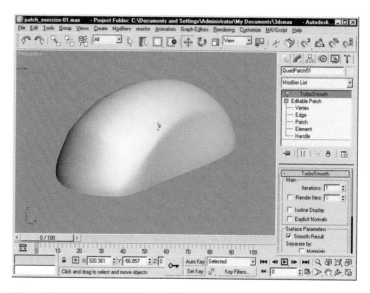

Figure 2.34 *Patch-Modeled mouse object.*

The Zip file containing the step-by-step patches and meshes for this exercise, and other patch-based modeling exercises can be found at http://www.todddaniele.com/FocalPress.htm.

Box-Modeling

So far we have covered two very similar modeling techniques, Spline-Modeling and Patch-Modeling. Next up is Box-Modeling, which has a

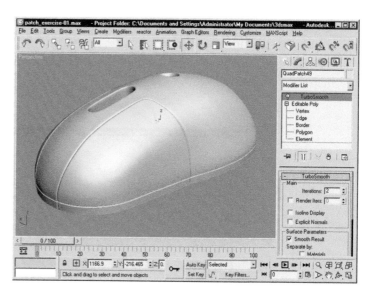

Figure 2.35 *Converted patch model (Editable Poly) with additional Poly-Modeling techniques applied.*

considerably different work flow. Box-Modeling is a very popular, very commonly used technique. The reason for Box-Modeling's popularity? Well, I believe part of its popularity has to do with the ability of almost any 3D application to allow the user to apply the technique. Before we had the robust tools that allow us to Poly-Model, there was Box-Modeling. Due to the fact

that Box-Modeling has been around for quite some time in multiple 3D packages, the amount of available information and the maturity or quality of that information make it a good choice for those users who have the ability to think and model in this manner.

Many of the techniques we are going to use later when we move to Poly-Modeling are applicable to Box-Modeling. The main difference between Poly-Modeling and Box-Modeling is how we start the process. With Box-Modeling we establish the mass of our model at a very early stage. This is beneficial as we have an almost instantaneous visual aid for the rest of the modeling process. In my experience, the main drawback of this technique is that adding geometry can be a little daunting for the inexperienced and experienced alike. In many instances you will have a mass of Quad-based geometry with the polygons running neatly from side to side and/or up and down. When modeling something like a car or product this can be helpful (although I find it slows my work flow down). When modeling something organic, say a human head, it can be a bit hard to visualize a dynamic mesh flow when you are staring at a screen full of perfectly aligned edges and polygons. It can be done, and there are many great modelers who use Box-Modeling to create amazing models. Box-Modeling is not something to be avoided; we are going to concentrate on raising your level of comfort with Box-Modeling in this exercise.

Box-Modeling a Cartoon Turtle's Head

1. Because this is called "Box-Modeling," we are going to start out by creating a box primitive in the top viewport. Once your box is created you can input three equal size values for the length, width, and height, as well as two segments for each (Figure 2.36).

2. Convert your box to an Editable Poly object by right-clicking either the object in the viewport (Quad menu) or the object name in the modifier stack.

3. Next we are going to select the top/front polygon on both the left and the right side of the box and bevel them with a negative

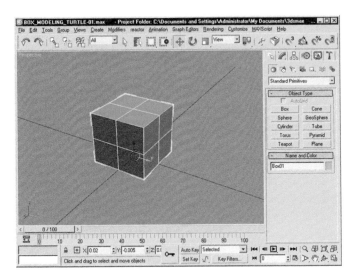

Figure 2.36 *Beginning "box" geometry with even proportions and segment count.*

value to produce an inset that will later be the basis for the eye of our turtle character (Figure 2.37).

4. We are also going to move around some verts and edges to begin shaping our box into the basic shape of the turtle's head. Figure 2.38 shows the box after the bevel to the two polygons and the manipulation of the edge and verts are performed. You can also add a TurboSmooth at any point during this exercise so you can toggle it on and off to see the result of your modeling changes on the final subdivided mesh.

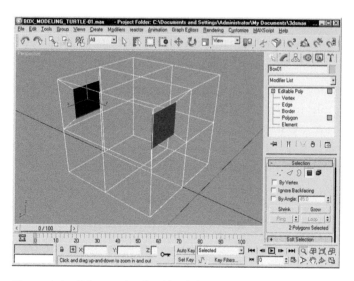

Figure 2.37 *Polygons selected and beveled with a negative value.*

5. The two polygons we beveled have a basically square shape; when subdivided, this would create a circular opening for the eye (which is what we want), but for more precision we are going to divide the area both vertically and horizontally. Do each direction separately to ensure desired results. In the Edge subobject level we are going to select one of the vertical edges that make up the eye shape and then do a ring selection by either clicking the

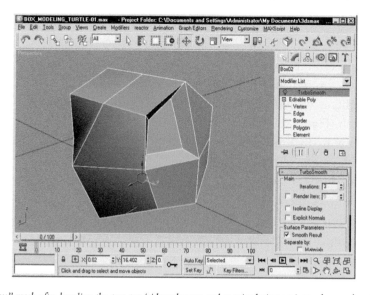

Figure 2.38 *Our "box" mesh after beveling the two top/side polygons and manipulating various edges and verts.*

Ring button under Selection or using a keyboard shortcut (Alt+R). Figure 2.39 shows the edge–ring selection on both a vertical and a horizontal edge–ring selection (two separate actions).

6. Use Connect to create a new edge loop horizontally (with your horizontal edge–ring selection), or use a keyboard shortcut to connect (I have mine set to Ctrl+Shift+E). Do the same steps for the top and bottom edge of the eye opening. Select the top edge, Ring select, and then use the Connect tool. Figure 2.40 shows the new edge loops highlighted in red.

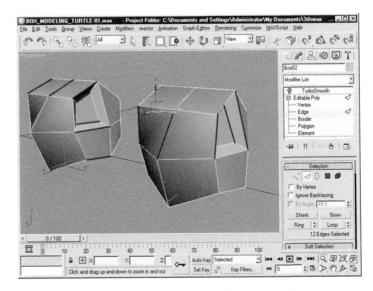

Figure 2.39 *Highlighted selection for the vertical and horizontal edge–ring selection.*

7. If you toggle on your TurboSmooth, you will see that the area that was round now looks sort of square. Don't worry, the next few steps will fix that. We are simply going to move some edges/verts to create a low-poly mesh that will once again create a circle when

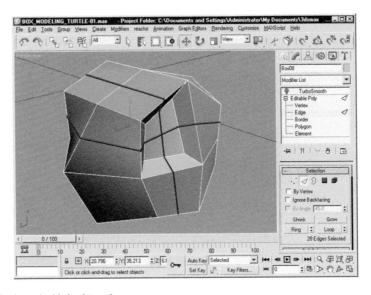

Figure 2.40 *New edge loops, highlighted in red.*

subdivided. Figure 2.41 shows the smoothed result. Notice that our round opening is now a bit square.

8. There are four new edges inside the faces that bevel toward the eye area. Select these four edges, and right-click to convert the selection to vertex. Now using the Scale tool we are going to scale these verts uniformly to create an eight-sided circular diamond shape. You will need to do this to both sides of the model. *Note: This would be a good time to experiment with deleting one-half of your mesh in the front viewport and using a Symmetry modifier.* For this quick exercise I am just going to repeat the action on both sides. Figure 2.42 shows the mesh as it should look after scaling the vertices, as well as the edges mentioned in this step.

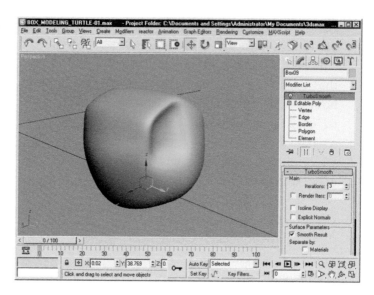

Figure 2.41 *The opening after edge loops are added. Notice the square shape when subdivided.*

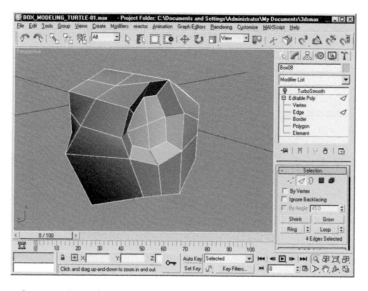

Figure 2.42 *New shape after manipulating the vertex selection. The edges highlighted in red are the edges that should be selected at the beginning of the process.*

9. We have a good foundation for the eye area. Next we are going to do more edge/vertex moving and scaling to develop the shape of the turtle's head further. Figure 2.43 shows the new shape after the changes are made to the mesh. The highlighted edges (red) are the edges we moved or scaled to get a more round, or organic, shape to the object. In Figure 2.44 you will notice the long horizontal edges running out from the center line

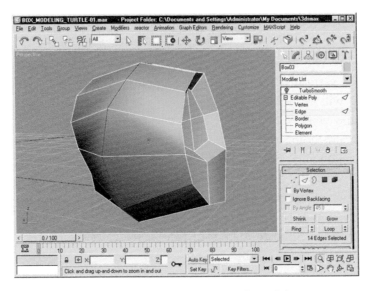

Figure 2.43 *New, more developed shape. Red edges are the areas we moved and/or scaled to create a more organic mesh.*

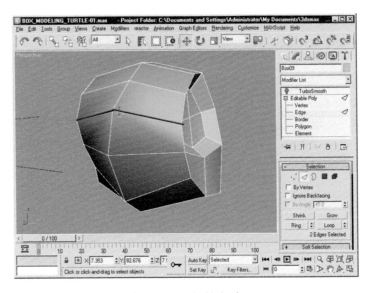

Figure 2.44 *Long edges to use for Ring selection and Connect are highlighted.*

of the object. We are going to select the centerline edge loop and chamfer it to make two evenly spaced loops from this one loop. Adding two additional loops gives us more geometry to work with (Figure 2.45).

10. These newly created loops should be scaled vertically in a manner that will retain a round head shape when subdivided. We are also going to delete the four polygons on each side that make up the eye area to create an opening where the eye will later sit. The easiest way to eliminate these four faces is to select the center vertex and delete it. Figure 2.46 shows the results of this step.

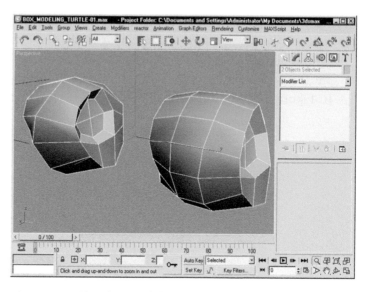

Figure 2.45 *Edge selection and the resulting mesh after using Chamfer on the centerline edge loop. There are now two edges where there was one.*

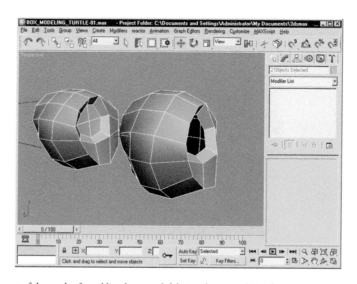

Figure 2.46 *Screen capture of the mesh after adding loops and deleting the eye socket polygons.*

11. Select the three polygons shown in Figure 2.47 and use Bevel with a negative value to create an opening for the mouth.

12. Okay, let's give this little guy some nostrils. For the nostrils we are going to start by selecting the two vertices above the mouth and between the eyes. In the Vertex subobject level select these verts and then chamfer them to create two small diamond shapes (Figure 2.48).

13. Now go to the Polygon subobject level and select the two

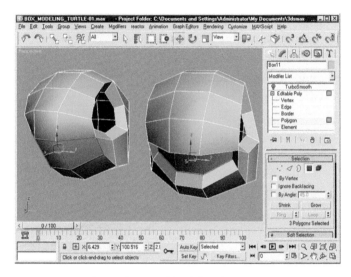

Figure 2.47 *Polygon selection and beveled result.*

newly created diamond polygons. We are going to use Bevel to create some depth to the nostrils. Instead of clicking the word "Bevel," click the Settings box next to the word. You will be presented with a dialog box with fields for numerical values. I recommend right-clicking on the spinners for each value box to reset them to 0 and then sliding each

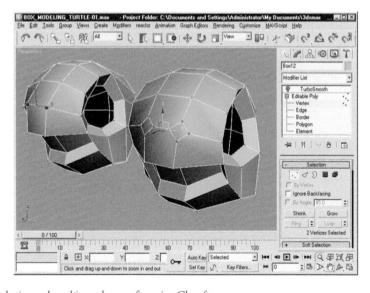

Figure 2.48 *Vertex selection and resulting polygons after using Chamfer.*

spinner as you view the results in the viewport. Figure 2.49 shows the result of chamfering the vertices and beveling the polygons.

14. If you apply or toggle your TurboSmooth right now you will see that this is shaping up to be a very good base mesh for a turtle character.

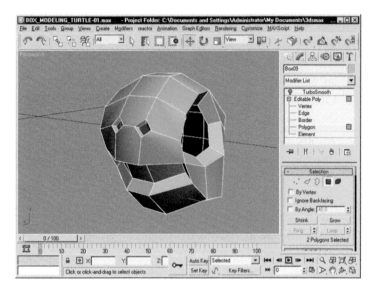

Figure 2.49 *We can see the result of beveling the polygons (shown in red).*

Moving polygons to create cheeks, beveling edges to create lips, and adding edges or extruding polygons can further develop this little fellow's character. For this demonstration we are going to leave him at this stage of development. If you wish to continue working on him, feel free. You can always return to him later, once you have acquired other modeling tools and techniques from later chapters. Figure 2.50 shows this character after a few additional steps are applied.

The Zip file for this exercise includes the turtle head model in various stages and the extra steps (Poly-Modeling). You can download this file (and all the lesson files for this book) at http://www.todddaniele.com/FocalPress.htm.

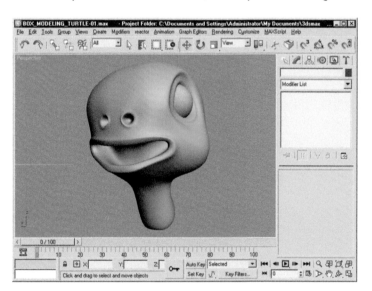

Figure 2.50 *Final model with additional Poly-Modeling steps applied.*

Poly-Modeling

Well, I've saved the best for last. It is time to take a look at Poly-Modeling. It may not be fair to call Poly-Modeling "The Best," but for many modelers in the industry today, there is no other method that offers the control,

accuracy, intuitiveness, and speed that Poly-Modeling does. Although I do feel that all the methods discussed thus far have their strengths, and can produce results equal in quality to models we produce with Poly-Modeling, to me this method seems the most intuitive and natural; I would liken it to sculpting with polygons.

Earlier I mentioned that Box-Modeling and Poly-Modeling had many similarities, so let's discuss the differences. When Box-Modeling, we usually start with a primitive, quickly establish the mass of the model, and then add detail as we develop the model. With Poly-Modeling, I often start with a single polygon, or a group of polygons. From this initial polygon or group of polygons, several techniques can be used to build the model, polygon by polygon. The ability to control the placement of each polygon, edge, and vertex gives a huge amount of control over the mesh and the directional flow of the polygons. Using this control to our benefit, we can often create the more difficult, more detailed areas of a model and work our way out toward the less complicated regions. The drawback to this technique would have to be that we aren't blocking out the model's mass early on. I hold the opinion that with a good set of references, or a clear, well-thought-out concept, we can easily create the mass after the difficult areas of geometry are in place. I also feel that by modeling the detailed areas first, we are establishing a basis for the density of the polygons the finished mesh will require. When modeling, having too few, or too many, polygons can drastically affect your final product; too few polygons and you will see pinching in areas where the mesh density changes; too many polygons, and the mesh will be difficult to edit and inevitably will become wavy.

I've talked a little about Poly-Modeling. This is a great time to move on to the Poly-Modeling chapter in which I will cover some basic techniques used to create models.

Chapter 3

Poly-Modeling Basics

In this chapter we are going to review quickly some powerful techniques that are going to make the modeling process much more efficient, controllable, and intuitive. This chapter will lay the basic groundwork for all of the upcoming exercises in the remainder of this book. The most basic, and in my opinion most powerful, technique we are going to employ throughout the rest of this book is a simple technique known as "shift–drag." Shift–drag can be used with most of the subobject elements (Vertex, Edge, Border, Polygon, Element) with great ease. The support files for this, and all exercises featured in this book, are available for download at http://www.todddaniele.com/FocalPress.htm.

There is also a public support forum at http://www.todddaniele.com/forum/.

Working at the Edge Level

1. Let's begin by going to the Command panel, and in the Create panel let's create a "plane" object in the top viewport, giving it one length and one width segment (Figure 3.1).
2. In the viewport right-click the plane, and select Convert

Figure 3.1 *Plane object with one width and one height segment.*

To/Convert to Editable Poly. This simple conversion unlocks all of the power of Poly-Modeling, giving us access to a host of modeling tools that would otherwise be unavailable to us (in the Convert to Editable Patch or Convert to Editable Mesh options). Figure 3.2 shows the Quad menu after right-clicking the plane object.

3. If you haven't already done so, select the plane object we just converted to Editable Poly. Take a look at the modifier stack; we can start manipulating our mesh at the subobject level. For the time being we are going to skip the Vertex subobject level and begin our training with the Edge subobject level.

4. Let's select an edge by clicking on the word Edge in the subobject list. Now if we select any single edge, or group of edges, in our viewport they will turn red and the fun begins (Figure 3.3).

5. With the Move tool selected, we hold down the Shift key and begin to drag the edge selection, in the process cloning the edge or group of edges as we move them (Figure 3.3).

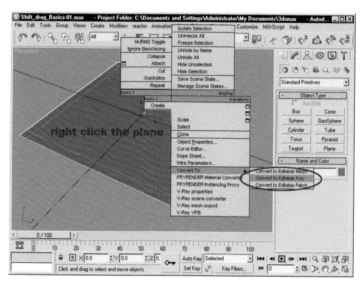

Figure 3.2 *Quad menu with Editable Poly highlighted.*

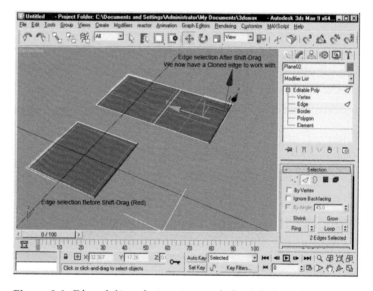

Figure 3.3 *Edge subobject selection prior to and after shift–drag technique is executed.*

We can now quickly move, rotate, and scale edges to any point in 3D space, and through the use of shift–drag create additional polygons that have an additive effect on our base mesh.

Subsequently, we are adding form and detail to our mesh in a quick, easy manner. Keep in mind that at any point you can switch your subobject level from Edge to Vertex, Border, Polygon, or Element and manipulate each of these levels for an even higher level of control over your mesh.

OK, so we have seen the power of the shift–drag method when manipulating the Edge subobject level. Now let's give it a try with the Border subobject level. A border is a group of edges that define an inside or outside border of an object, hence the name.

Working at the Border Level

1. Working with our base plane object in our viewport, we are going to inset one of the two polygons in our shift–dragged mesh. After insetting the polygon, we delete the new polygon to create an open hole, or border (Figure 3.4).

2. With the new open area in our mesh, select the Border subobject level in the stack and begin shift–dragging one or more border selections. Select your desired border, and shift–drag just as we did earlier with the edge selection. You will notice it is having the same effect, only now we are cloning and manipulating border selections with the same ease and speed. This is a great way to create depth in models with open details, for instance, the eye socket opening we modeled in an earlier lesson.

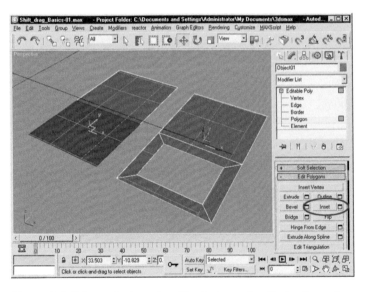

Figure 3.4 *Polygon selection and resulting border opening after insetting and deleting new polygon.*

An interesting note: You can shift–scale or shift–rotate an open border or any subobject (use the respective tool to execute the technique). I recommend sticking with border selections for both techniques, as other subobject selections don't really lend themselves to either method. Of course, you should take a few minutes to experiment with all of the available subobject levels and see which work best for you.

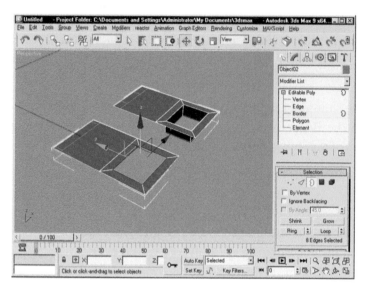

Figure 3.5 *Border subobject selection before and after shift–drag.*

Figure 3.6 *Different results of shift–dragging a polygon to an element (bridging the edges of the left mesh results in the center mesh) and finally shift–dragging to an object.*

Figure 3.5 shows the border selection before and after shift–drag has been performed.

Moving farther down the modifier stack, next up is the Polygon subobject level. Shift–dragging a polygon (or group of polygons) will create a detached clone of the selection, which you can designate as either an element or a completely separate object. With Clone to Element, the advantage is that we can always move this polygon (or group) and then, using other tools available to us, bridge the gaps between the original mesh and the clone to create a single, cohesive mesh. With Clone to Object we can derive precise objects or shapes from our base mesh that we can use as other separate parts in our model. This will come in handy later when we want to model something like a car door (more about this later).

Working at the Polygon Level

Using our existing base mesh, let's shift–drag a polygon to both an element and an object. Figure 3.6 shows, from left to right, the result of shift–dragging to an element, bridging the edges to the new element, and finally shift–dragging to a separate object.

Working at the Element Level

At the bottom of the modifier stack we have Element. Many times we will have a single mesh consisting of different parts or elements. Even though it is seen as a single mesh, it can have detached sections or parts (see Clone to Element mentioned above). Shift–dragging an element will bring up the same dialog box as shift–dragging a polygon. Select accordingly and implement the information from the previous paragraph to suit your needs. Figure 3.7 shows the element selected and the result of shift–dragging the element.

Figure 3.7 *Element subobject selected (left) and result of shift–drag on the same element (right).*

Working at the Vertex Level

Finally, we are going to jump back up to the Vertex subobject level. Shift–dragging a vertex, or group of vertices, will create clones of the selection. These vertices will not form a polygon unless you do so manually through the use of other tools available. Using the tools included with 3ds Max, this process is not very efficient, so I recommend carefully considering shift–drag in conjunction with other subobject level options to achieve the same result. It can be done; in our example cloning the polygon would give the same result

Figure 3.8 *Shift–drag creates four new vertices (right). Not a useful or efficient method in my opinion.*

as shift–dragging the verts and then creating a polygon from the new vertices. Instead of using two steps to achieve our result we would be using one . . . efficient and quicker! (In a later chapter we are going to cover some scripts that do make shift–dragging vertices a viable option.) Figure 3.8

shows the end result of using shift–drag on a vertex selection. The four vertices floating in space are the newly cloned verts.

Upon finishing this first exercise, you have a basic knowledge of the core Poly-Modeling tools and techniques and how they function. Next we are going to apply some of this knowledge to create something a little more complex, a human nose. The Zip file for this exercise includes the base model in various stages. You can download this file (and all the lesson files for this book) at http://www.todddaniele.com/FocalPress.htm.

Poly-Modeling a Nose Using the Shift–Drag Technique

We are going to build a human nose model using some of the basic Poly-Modeling techniques we have covered so far.

1. Start by dragging out a single plane object in the front viewport. Give it one length and one width segment and convert the plane to an Editable Poly object (Figure 3.9).
2. At the Edge subobject level, in the front viewport, select the top edge of the single polygon. Switch to the left viewport and use the shift–drag technique at the Edge subobject level to create some new polygons, creating the profile of a nose as you clone your edges. In my example you will see I dragged out three new, evenly sized polygons above our initial polygon (Figure 3.9, middle mesh).

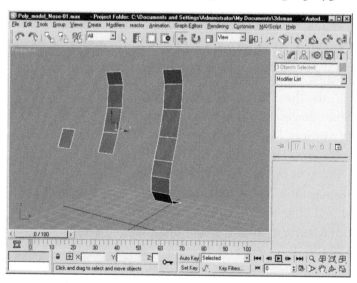

Knowing which viewport to use is pretty important when modeling. Always think about what view will give you the best opportunity to create the shape and mass you are trying to create with the most visual feedback.

Figure 3.9 *Initial polygon and resulting mesh after the shift–drag process.*

3. Next, repeat the process we just used, only this time using the bottom edge of your original polygon to shift–drag four relatively equal-sized polygons curving under to form the bottom of the nose. Figure 3.9 shows the initial polygon and the resulting mesh after shift–dragging

the bottom edges to create the nose profile.

4. From here we are going to select a single horizontal edge and use Ring (Alt+R) to select all of the horizontal edges. With the Connect button (or assigned keyboard shortcut Ctrl+Shift+E) we are going to create a new vertical edge loop (Figure 3.10).

5. Next we are going to delete half the mesh and use the Symmetry modifier to mirror our remaining mesh using X as our Mirror Axis. You want to uncheck the Slice Along Mirror box.

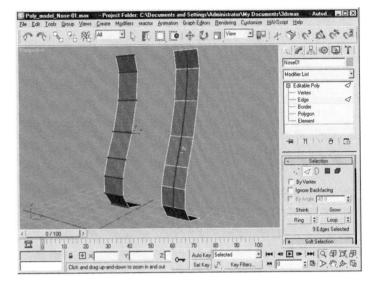

Figure 3.10 *Edge Ring selection and new edge loop created with Connect.*

NOTE: You may be thinking this (Symmetry) could have been done a lot quicker by moving the edges closer together, and you are right. I think it's a good idea to get you familiar with some of the tools you are going to use often in your work flow, so at the expense of a few extra steps I am hoping to instill a work-flow process for mirroring your mesh. Use of Symmetry will cut your workload in half in many cases, as all future mesh edits will be mirrored to the other half of your model. We will go into greater depth on the Symmetry modifier a bit in the next chapter.

6. Go to the modifier list, and add a TurboSmooth modifier. Before we move on, another good practice you should start to implement at this stage is the use of the Show End Result on/off toggle. In the next steps we are going to be moving edges and creating new detail; this toggle will give you accurate visual feedback of the final shape of your mesh as you work. While modeling you can turn off TurboSmooth and use the End Result toggle to display your mesh with the Symmetry modifier applied. Throughout this, and every project you do, you should toggle on TurboSmooth from time to time to see how your base mesh looks after being subdivided. Figure 3.11 shows the mesh with the Symmetry modifier applied. You can see the settings used under the Parameters rollout in the screen capture.

With the resulting mirrored mesh, we are going to start moving edges and points to create a more organic, flowing shape to our object.

7. Click on Edge in the sub-object list, and click on the Show End Result on/off toggle (next to the thumbtack at the bottom of your modifier stack). You will notice that one-half of your mesh now has orange edges; this is how the mesh is displayed by default when the Show End Result toggle is active. When you select an edge with the toggle on, it will turn from orange to yellow.

NOTE: You can adjust the cage colors under Subdivision Surface/Show Cage. Consult the 3ds Max user manual for details.

8. From the top of the right edge of the outer loop select six edges, working downward as you go (Figure 3.12). Once they are selected, move them back slightly to create an angle toward the middle of your mesh. We are also going to select the single edge that makes up the bottom area of the nose—the area where the nose ties in to the upper lip. With Symmetry still active,

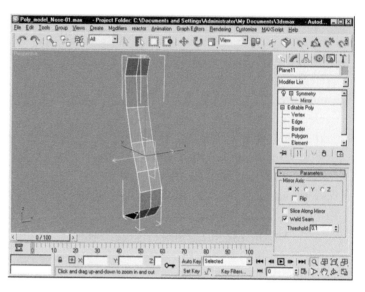

Figure 3.11 *Our mesh after removing half and applying the Symmetry modifier.*

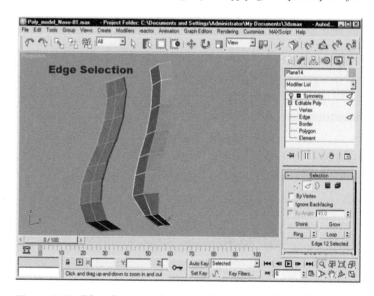

Figure 3.12 *Edge adjustments shown with Symmetry modifier applied and Show End Result toggled on.*

move this edge toward the center line of your mesh, thinning out the area to a more realistic proportion. Figure 3.12 shows the mesh after making the edge adjustments.

If you would like to use a reference, you can use a search engine and browse human nose images. I think the best thing you can do is touch your nose as you work. I'm not saying

to pick your nose; just feel it, take note of the shapes you feel, and try to interpret that into your model-building process. A mirror could also come in quite handy right now. Finding a high-quality nose to use as reference might be tricky; why not use the one in front of your face?

9. Remember the six edges you just moved? Select them again (Show End Result still toggled on), and shift–drag them to the side of your existing mesh to create another vertical edge loop (Figure 3.13, meshes 1 and 2).
10. With the loop still selected, move the edges back a little to continue the soft curve of the bridge of the nose.
11. Let's add an additional horizontal loop to the bottom of the nose by selecting the bottom right edge and using Ring and then Connect (Figure 3.13, mesh 3).
12. Last, select the two verts shown in Figure 3.13 (mesh 3) and use Collapse to create a directional loop (Figure 3.13, mesh 4). This newly formed edge loop will help to define the shape of the nose and its central mass. This last step is something very powerful that we will cover with more depth a little later on in the book. The bridge, or center of the nose, is pretty well established, so we are going to start forming the nostrils and the area where the nose meets the cheek.

Figure 3.13 *From left to right: (1) original mesh, (2) mesh after shift–dragging edges, (3) points selected to collapse, (4) points collapsed.*

13. First, select the same six edges you did before, only this time you are also going to select a seventh edge, the edge below the original selection (Figure 3.14, left mesh).

14. Using shift–drag, pull/clone a new edge loop to the side of the existing mesh. Again, we are going to move this edge back a little to create a soft organic slope (Figure 3.14, right mesh).

15. Subtract the top five edges from our existing edge selection and shift–drag the

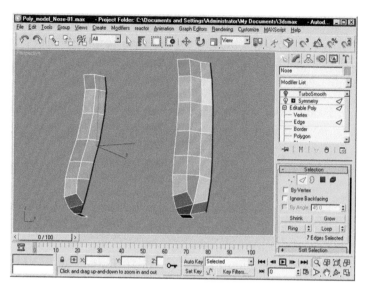

Figure 3.14 *Edge selection and the result of shift–dragging the selection.*

remaining two bottom edges. We are quickly forming the shape of the nostrils; some moving of edges and vertices is required to get an accurate representation (Figure 3.15).

16. With the same two edges still selected, execute another shift–drag to create two more new polygons. This time when you clone the edges move them back along the Y–axis, as we are trying to form the mass of the nostril, and it should flow toward the cheek. Move the edges

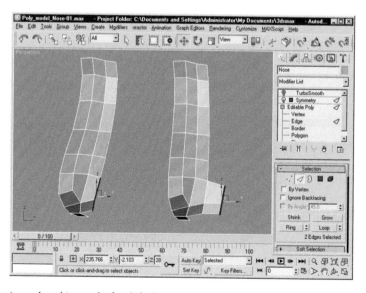

Figure 3.15 *Edge selection and resulting mesh after shift–drag.*

a bit to the side as well, to give a base for the curvature (Figure 3.16).

That mirror I recommended using before … pick it up and look at yourself; examine the area you are modeling.

17. Repeat the previous step one more time, creating two new polygons and moving edges and verts to shape the outer curve of the nostril further (Figure 3.17).

18. All right, last time, shift–drag the same edge selection one

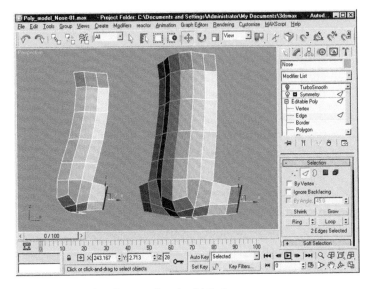

Figure 3.16 *Edge selection and result of shift–drag.*

more time, moving it back along the Y-axis, then move the selection in sideways along the X-axis toward the center of the model. This will help create the crease that separates the nose from the cheek. Figure 3.17 shows the mesh during the various actions we just performed, starting with our base from the previous step.

Hey … we are getting somewhere. The nose is starting to take shape!

Figure 3.17 *Mesh as it progresses, starting on the left and moving right.*

19. In the front, or perspective, viewport, select the bottom two edges. We are going to create the area that flows from the nose toward the lip area. Shift–drag these edges three times; remember to keep them spaced pretty evenly (Figure 3.18, center mesh).

20. The new polygons are straight in a row in the side view, which wouldn't produce a natural result when subdivided, so in your left or right viewport, move the edges one at a time to create the profile or curve to the indent found between your nose and lip. Figure 3.18 shows the progression of the mesh.

Figure 3.18 *Base mesh, newly created polygons (shift–drag), and new edges repositioned to form a curve.*

21. Time to add the transition area where the nose meets the cheek. Select the top four edges along the side of your nose model, and shift–drag them to create three lines of new polygons. Why three rows? The nostril area below consists of three polygons, we want to maintain a Quad-based mesh, and this will allow you to bridge to the existing polygons with minimal effort (Figure 3.19).

Figure 3.19 *Edge selection and new polygons created by shift–drag.*

22. In the perspective viewport, rotate around your model, then move the edges, polygons, or vertices of the new polygons to match the existing slope of the nose bridge. Rotating around the model step will help to give you a good idea of what the mesh flow is doing

and make it a bit easier to match the existing curvature if you find the right vantage point or viewing angle.

23. Once you have finished moving the new polygons into position, what you should be left with is a mesh with a gap between the nostrils and the upper/side portion of the nose. The edges that comprise the top and bottom of this gap are going to be equal in number, three on the top and three on the bottom. Nice, huh? Figure 3.20 shows the edge selection (left mesh).

Figure 3.20 *Edge selection and resulting mesh.*

24. Select the six edges (total) and simply use the Bridge tool to fill this gap (Figure 3.20, right mesh).

We have a nice looking, organized mesh that subdivides well, so we need to direct some polygons to help define the details (remember to toggle TurboSmooth as your project progresses). At this point our horizontal edges are pretty linear in nature, running side to side, evenly spaced. Well, the top of your nostril isn't straight is it? We need to move some edges and verts to help us along with the shapes of things.

25. Move three verts as seen in Figure 3.21 to create a curved outline that establishes the shape of the nostril. When we increase the detail in this area later, this simple vertex edit will give a nice shape-defining crease to this area.

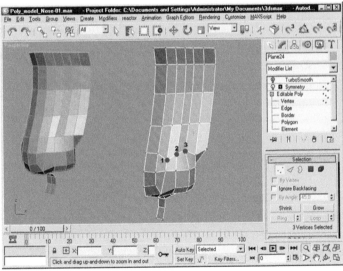

Figure 3.21 *Vertices to be moved are labeled 1, 2, and 3. Left example shows mesh before editing, right shows mesh after editing.*

The back of the nostril opening needs a little more work to complete the mesh.

26. Select the two edges seen in Figure 3.22 (left mesh) and use Bridge to connect them. We are going to click on the Settings box rather than the word "Bridge." When presented with the dialog box, input 4 for the segments and click the OK button. Bridge has bridged the gap (hence the name) and we have four new polygons neatly going from one edge to the other (Figure 3.22, center mesh).

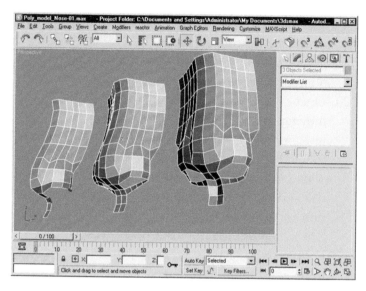

Figure 3.22 *Edge selection highlighted in red. Edges after bridging. Mesh after moving and editing edges and vertices.*

27. This straight configuration isn't a very organic shape, so as before, we are going to move some edges and verts to create a smoother flowing and natural shape. While we are editing edges and verts, let's also create the indent found below the nose (above the middle of the upper lip area) by moving some vertices. Figure 3.22 shows the progression of our mesh.

Almost done; the next steps are going to define the form and give you a finished mesh with a dynamic, flowing polygonal layout. To add more realism to the nostril area, you need to create an additional edge loop.

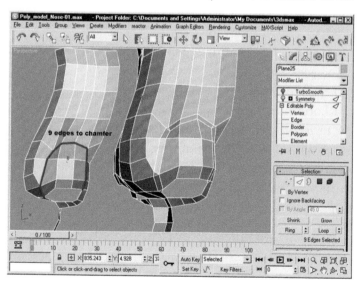

28. Select the nine edges that create the curve between the nostril (Figure 3.23) and the bridge (center section)

Figure 3.23 *Edge selection highlighted in red and edge selection after being chamfered.*

of the nose. Once you have the edges selected, you will chamfer them. The value required is scale dependent, so depending on the size of your model you are going to need to adjust your value. Regardless of the scale of your nose model, your chamfered edge should visually/proportionally appear as it does in the screen capture in Figure 3.23.

NOTE: The importance of proper scale when modeling will be covered in a later chapter.

This chamfer results in the additional loop required to define the area, but also creates some triangles and *N*-gons (polygons consisting of more than four sides). You can visually spot five triangles in our mesh, and next to every triangle is a five-sided polygon … so much for keeping our mesh all Quads. Not to worry, a couple of quick edits will bring us back to where we want to be. Figure 3.24 shows the triangles and *N*-gons highlighted.

Figure 3.24 *Triangles highlighted in blue, N-gons highlighted in orange.*

29. Select the three edges shown in Figure 3.25, and collapse them (left mesh).
30. Next, to eliminate the two triangles on the rim of the nostril opening, use Collapse on two sets of two vertices (Figure 3.25, right mesh).

With these two steps we have effectively returned to an all-Quad mesh and created a directional flow of edges that cleanly subdivides. Throughout this project you should be checking your

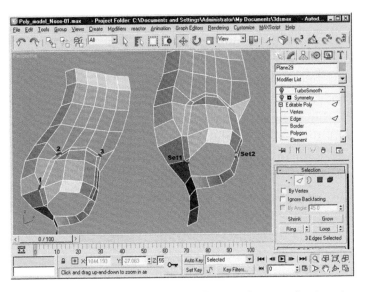

Figure 3.25 *Three edges selected prior to collapsing and two sets of vertices prior to collapse.*

mesh in a subdivided state to see the end result of your work. From time to time I have mentioned "moving" or "editing" edges and vertices; these steps are the steps that add finesse to your model's shape. This isn't something that can easily be put into words; you simply need to look at your model. If necessary turn on all of your modifiers to execute your edits with the Show End Result toggle on for real-time visual feedback.

Let's try the next edit with all of the modifiers on and the Show End Result toggle on as well.

Using the Border subobject selection level, select the nostril opening (it will turn yellow in your viewport because we have Show End Result toggled on). Using the shift–drag technique, clone the border upward to form the interior of the nostril. Pay close attention to the softness of the bottom edge as you move this cloned border. Figure 3.26 shows the border selection before and after the shift–drag.

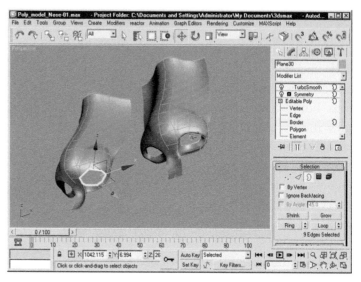

Figure 3.26 *Border selection before and after shift–drag. Note the orange cage resulting from the Show End Result toggle being active.*

Again, look in the mirror, or look over some reference to get the best results. Turn on all of your modifiers to see the end result of this exercise. I am going to end this lesson at this stage; if you wish to continue, please do so. With a few more steps you can form the transition of the upper lip and refine your mesh or add more details. The accompanying file for this exercise includes several extra steps and a more finished product for you to study (Figure 3.27). The Zip

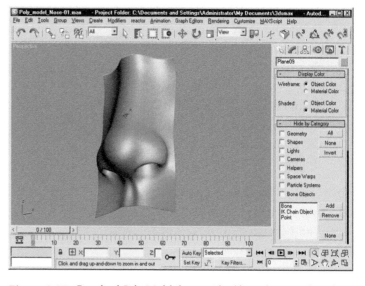

Figure 3.27 *Completed Poly-Modeled nose with additional steps performed.*

file containing the step-by-step meshes for this exercise, and other modeling exercises, can be found at http://www.todddaniele.com/FocalPress.htm.

After completing the nose exercise, I hope you are beginning to see the potential and flexibility of Poly-Modeling. The combination of shift–drag with the different subobject levels offers us precision and a high level of editability. Well, believe it or not, there are more things we can do to increase the amount of control we have over our model when using all of the shift–drag techniques. With this Poly-Modeling information fresh in your brain, let's explore the use of constraints. Constraints are a wonderful way to move vertices, edges, or any subobject level while also limiting or guiding their movement along the normal of the nearest faces or edges (depending on which option you select). I constantly use Edge Constraints in my work flow. While holding Shift for the shift–drag technique, I often toggle the Edge Constraints with the assigned keyboard shortcut Shift+X. This works flawlessly because my hand is already positioned on the left side of the keyboard for the shift–drag modeling process. You may be wondering, "Why use constraints, what is the benefit?" Well, the ability to slide your selections, while maintaining the shape of the existing geometry, is the most valuable attribute of this option. Figure 3.28 shows the different

end results when moving an edge selection both with and without edge constraints. Think back to our nose model for a second; if some of the verts were too close together and we wanted to maintain our model's overall shape, but create some distance between edge loops, Edge Constraints would allow us to do so. If your model has creasing or hard edges where you want softer flowing shapes, then moving subobjects with edge constraints is one of the best remedies.

Edge constraints do have drawbacks. When your mesh has directional changes, sometimes moving vertices along an edge will not work as expected. If there is a big change in the direction of the surface normals, or directional flow of an edge loop, this is likely to happen. To combat this situation you may need to select vertices in sets. I usually move the entire selection, see where the first vertex to act in an unexpected manner is, then undo the move, and select all of the verts that react as expected.

Figure 3.28 *Different results of moving an edge-loop selection without edge constraints and with edge constraints.*

Now moving these verts is more predictable, and when the move is complete, I then select the verts that were acting erratic and move them either as a set or, in some cases, one by one. You also have the option of using Face Constraints, although I find Edge Constraints fills 99.9% of my needs when modeling. I assign Face Constraints to Ctrl+Shift+X, so my left hand can stay in place on the keyboard during the modeling process. We are not going to cover Face Constraints, but take a few minutes on your own to become familiar with how it functions.

As we turn our attention to some of the other modeling tools, it is important to keep in mind that much of the information I present throughout this book is cumulative—everything you've read and learned about so far can be applied and/or combined with everything I am going to demonstrate later.

Once you have established a bit of your model's general detail and mass, you are inevitably going to need to add more detail. Aside from the shift–drag technique, you also have some fantastic tools available to you for just this purpose. Most of these have been around for a while in 3ds Max, so let's cover the more familiar tools first.

Whether Box-Modeling or Poly-Modeling, there is no denying the usefulness of the Inset, Bevel, Chamfer, and Bridge tools. Many of the modeling tools included in the standard 3ds Max edit menus have the ability to work interactively as you click and drag on the applicable subobject level in the viewport, as well as the ability to click on the Settings box to bring up a dialog box with more options and numerically scalable value input windows.

> **Inset:** At the Polygon subobject level this is a great way to create round holes and openings in an existing mesh. It is also well suited to creating additional loops when preparing to add arms, branches, or offshoots from your base mesh. We will see the true power of Inset when we are modeling some of the more advanced models in later chapters. Inset is a perfect tool to create changes in the direction of our mesh flow. *Note: To mimic the Inset tool while using the shift–drag technique, you could simply delete a polygon and use a border selection along with shift–scale as mentioned in an earlier part of this chapter.*
>
> **Bevel:** A useful tool for modeling in an additive manner, Bevel can also be used to create geometry for dimples, dents, and other subtractive features of your model.
>
> **Chamfer:** Easily one of my most used tools. Absolutely every time I model a product, car, or anything with man-made or hard edges, I use this tool extensively. Why? Because this is such an effective way to add geometry in areas where it is needed. This functionality is what gives your hard-edge models their hard edges.
>
> **Bridge:** This is a more recent addition to the 3ds toolset, fantastic for bridging gaps between edges, borders, and polygons. Aside from the numeric input and option presented you can also use this tool interactively. The obvious use is to select even numbers of edges

that are near each other and click Bridge. The not-so-obvious use? This is something I haven't seen documented anywhere: you can click the word "Bridge" and then, using Ctrl+left mouse button, just click from edge to edge, as many times as you need to, and in multiple directions. A dashed line will show the start and end edges as you click. This is a great tool implementation, powerful and simple!

Some other tools you may want to consider adding to your work flow are outlined below. Some are old familiar friends, and some are newer tools added in more recent versions of 3ds Max.

Cut: As the name would indicate, a simple but effective tool for cutting your meshes. When Poly-Modeling I admittedly don't use this tool very often, although I do use it quite a bit when Box-Modeling to quickly cut in edges that determine the overall directional flow of a mesh.

Insert Vertex: This is incredibly useful at the Edge subobject level. Inserting vertices allows you to create verts quickly that you can then connect to create new loops or rings in your mesh. At the Polygon subobject level, this tool is something I plan to use much more. To be honest I hadn't used this before researching and experimenting for this book. Using this tool, you can place a vertex at any point within a polygon with a decent amount of accuracy. Now it may seem like a drawback, as you now will have four triangles in your mesh, which are generally a bad thing. To eliminate the triangles you can just chamfer the vertex you just inserted and be left with all Quads. My assessment—similar to using Inset on a polygon but with additional steps. Used on a polygon next to an open border, this tool may create some useful geometry in a quick manner.

Quickslice: A tool to add linear slices interactively to your mesh. I personally am not a fan of this one; it feels a bit undeveloped and rudimentary. I encourage you to give it a try, and form your own opinion.

Collapse: This is a useful tool when you have two or more verts that you want to merge quickly into one. Similar to Weld, but without a threshold adjustment … so proceed with caution to avoid welding unintended vertices. I also like the way this works with edges, it feels intuitive. You can also use this tool on polygons and borders, not something I would recommend in most circumstances.

Weld: This is a staple in my modeling arsenal. I assign this function to a hot-key for ease of use (Shift+W to weld vertices). Useful for joining verts of a contiguous mesh or joining verts from elements. Weld can also be used at the Edge subobject level.

Target Weld: Similar to Weld, but at the Edge subobject level this is a useful Poly-Modeling tool. We can create a new edge with shift–drag and, using Target Weld, weld it to another existing edge to bridge an opening quickly. Target Weld also functions incredibly well with vertices.

Connect: Get ready to assign another hot-key; Connect is constantly used when Poly-Modeling. I use Ctrl+Shift+E as my keyboard shortcut but you can assign whatever combination you are comfortable with. Connecting vertices and edges is so easy to do with this tool. You can easily add edge loops or directional edge flows to your mesh.

Split: Split is used at the Edge subobject level. I don't see any real useful purpose for this tool; it seems like you can create a messy mesh pretty quickly with this one.

Hinge from Edge: This is another tool I feel needs more development. The angle value input doesn't feel like enough to me. Try it for yourself, and form your own opinion. This should work more like the next tool in our list, Extrude along Spline.

Extrude along Spline: I think this is a case in which the tool feels powerful and very user friendly. For best results you want to use the Settings rollout and experiment with all of the values and options. I do use this from time to time, and enjoy it every time I do. If you want to make some creepy trees, give this a go!

Selections and Conversions

Now that you have so many modeling options to add detail to your models, you are going to need some quick, efficient techniques to manage your edges, polygons, and verts. In most cases selection can be a straightforward process, but as your models evolve, and the geometry that creates them increases, selection can become a bit more difficult. The most important thing to remember is you have the ability to convert your selections. To demonstrate a typical situation in which conversion is the most viable option, we are going to use a spring from the Dynamic Objects rollout. This is a rather rudimentary example, but just apply what you learn to a more complex situation, for instance, managing vertices of a complex human head model.

1. In the top viewport create a spring, then go to the Spring Parameters rollout, and input a Height value of 12, Diameter value of 9, and Turns value of 5.75. Under Segs/Turn input 24, input a Diameter of 1, and set Sides to 10.

2. Right-click and convert the object to an Editable Poly. Switch to the perspective viewport. Let's say you want to select all of the vertices along a single edge loop. The best method is to do your initial selection at the Edge subobject level by selecting an edge and invoking the Loop tool (Alt+L).

3. With the edge loop selected, convert the selection to a vertex selection by either right-clicking the object (to bring up a Quad menu) or going to the Selection rollout and with Ctrl+left mouse button clicking the vertex icon. If you opt for the Quad menu option, you will see "Convert to Vertex" toward the upper left. To select the verts using only the Vertex subobject level would be a painfully slow and tedious process. With a couple of simple clicks we have made this selection.

Whenever you have a difficult selection to make, think of the available options that may allow you to create the selection easily through conversion. Figure 3.29 shows the Edge selection and the conversion to Vertex subobject level.

1. In the same file, in the perspective viewport, create a cylinder object, a little smaller than the existing spring you already created. Keep all of the settings at the default (segments, sides, etc.)

2. Convert the primitive to an Editable Poly object.

3. Select one of the edges that encircles the top polygon of the cylinder. Hit Alt+L to create a loop selection … didn't work, did it? See Figure 3.30 (left mesh).

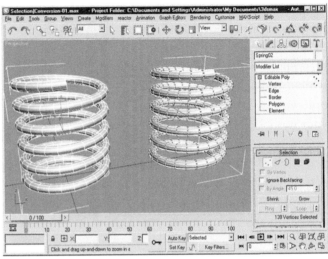

Figure 3.29 *Edge selection and the same selection converted to a Vertex selection.*

If we want to create a nice chamfer on the top edges we have a couple of options. We could go to the side viewport, and do an edge selection, and then subtract unwanted edges until we are left with our desired selection. We could select them one by one manually, which will also work but isn't very efficient. We are talking about selection conversion; let's give it a try again.

4. Select the top polygon at the Polygon subobject level, and right-click the polygon to convert to an Edge selection (Quad menu). In two clicks we have our desired selection, and we could easily perform the chamfer on the edges (Figure 3.30). *Note: You could also Ctrl+left-click the Vert icon in the Selection rollout.*

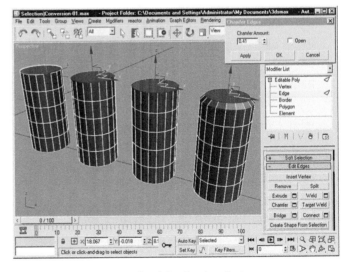

Figure 3.30 *Four steps to chamfering the edge selection.*

This is a very basic example, but it shows the effectiveness of the approach. Figure 3.30 shows the stages of the selection conversion as well as the final resulting chamfered edge selection.

If you are using shift–drag often in your work flow (and you should be), you are likely to be presented with a situation in which you have a border selection you would like to inset. If your model has an irregular shape, shift–scale may not give you what you are looking for. In certain sit-

Figure 3.31 *Polygon and shape after shift–dragging edges.*

uations, you will end up with a new border that is "skewed" in relation to the border you used to create it. You can try scaling in different directions, moving your pivot or pivot center, but I have found this takes longer than it should and produces varying results. Let's try something to demonstrate this.

1. In the top viewport, create a plane object with one length and one width segment. Convert it to an Editable Poly object.

2. Shift–drag a shape similar to the one shown in Figure 3.31. It looks like a segmented fish body. (If you want to use the accompanying file you can download it at http://www.todddaniele.com/FocalPress.htm.)

3. Next take the inner border and pull it upward to give our shape some depth (Figure 3.32).

4. Let's try shift–scaling the top border selection to create an even inset … you can see for yourself the result is not what you were expecting (Figure 3.33, middle).

Figure 3.32 *Depth added to model.*

5. Take this a step further; try scaling the new border in one direction to compensate or adjust its shape ... still not what we want, is it? See Figure 3.33.

6. Delete the new border as it isn't helping anything (Figure 3.34).

7. Select the original top border, and Cap it (Figure 3.34).

8. Select the new top polygon, and use an Inset on it (Figure 3.34).

9. Delete the new polygon, and you have just solved the problem (Figure 3.34).

Combining constraints and shift–dragging, you have the ability to model anything you can imagine. In later chapters we will be using this combination along with other tools and tricks to develop more complex models. The Zip file for all of the lessons and examples in this chapter can be downloaded at http://www.todddaniele.com/FocalPress.htm.

The last thing I am going to touch on in this chapter is the Edit Poly modifier. This modifier gives you the ability to animate subobject transforms and parameters. You can also retain your base mesh and add this modifier to add geometry that you can toggle

Figure 3.33 *Original mesh (left), shift–scaled border (center), border after nonuniformly scaling (right). None of these results is desirable.*

Figure 3.34 *Base mesh, capped border, inset, and final mesh with polygon deleted.*

on and off. This can be very handy if you have a mesh that you want to develop, but also want the ability to return to an earlier stage in the modeling process to edit or alter the model. This modifier operates almost exactly like an Editable Poly object does, but gives you the freedom to animate and return to a lower level mesh if needed. If you are modeling explicit objects, you probably aren't going to need this. If you desire editability and animation flexibility, this could

come in very handy. For my work flow I generally stay away from Edit Poly, mostly because it changes all of your modeling keyboard shortcuts when it is active, something I really don't care for. Figure 3.35 shows a mesh (our turtle from an earlier lesson) with additional detail added with the Edit Poly modifier. The mesh on the left has the modifier toggled off, the right mesh is toggled on.

In the next chapter we are going to discover some interesting ways to use some of the other available 3ds Max modifiers to generate very clean results when modeling.

Figure 3.35 *Additional detail created with the Edit Poly modifier toggled off (left) and on (right).*

Chapter 4

Modifiers—Letting Max Do the Work for You

In this chapter we are going to discover the benefits of using modifiers to create complex meshes. Even with the power of the techniques I outlined in the last chapter, there are going to be instances in which allowing 3ds Max to do its job through the use of modifiers will produce cleaner results in a shorter period of time. We will also discuss instances in which using a modifier may not be the best choice.

Not long ago I was working on a project that required me to model a popular video game console. I had to model this rather quickly, and came up with the idea of modeling the detailed front face in a flat position even though it had curvature in two directions. I had limited reference available initially (front view only), so modeling this flat and using modifiers to add the curve later theoretically made sense to me. It was time to put the theory to the test. With only a front-view reference and no idea of the profile of the curves the object possessed, I began the modeling process. Creating the details with the model flat made things go a lot quicker than they would have if I had to worry about adding details to a curved object. Later in the day I was provided with reference images with other views of the game console; time to see if this theory was a waste of time or a success. Using the Bend modifier I was able to create the curving shapes that weren't there in the initial model. I actually used two Bend modifiers to create compound curves (running in two directions—top to bottom and side to side) on the console's faceplate. Some experimentation showed that placing the Bend modifiers above a TurboSmooth gave a cleaner, crease-free result while maintaining the same final poly count. I was pleased with the result, to say the least. As I studied the mesh, I also discovered that by using the Bend modifier, 3ds Max and my workstation had done a better job of averaging the vertex positions with the higher density mesh and creating a smooth bend along the detailed areas than I ever could

have done. Although I have a good ability to model, and am very familiar with shift–drag and edge constraints, the same result would have taken longer and not been nearly as clean. The conclusion I made that day? If you model a quality mesh with an adequate polygon count, modifiers will give you amazing results and the ability to edit your mesh. I finally understood the practical application of modifiers. At the end of this chapter, I am confident you will see the benefits of using modifiers in your Poly-Modeling work flow.

Let's get started. I am providing the base mesh along with the drawn reference plate just in case you want to do the initial modeling yourself. The accompanying file will contain the mesh in various stages. Upon opening the bend_console-01 file you will see the full model of the base mesh sitting in front of the reference image (Figure 4.1).

Figure 4.1 *Base mesh and reference plate. Base mesh has been modeled flat for this demonstration.*

The mesh has been modeled flat to demonstrate how modifiers will affect it.

1. First, apply a Bend modifier, with an angle of 84.5 and a bend axis of X. Our console now has a nice curve to the front face (Figure 4.2).
2. Let's compound this with a change to the side profile. Add another Bend modifier, with an angle of −23.5 and X as the bend axis. At first this doesn't affect our mesh as expected, but with a 90°

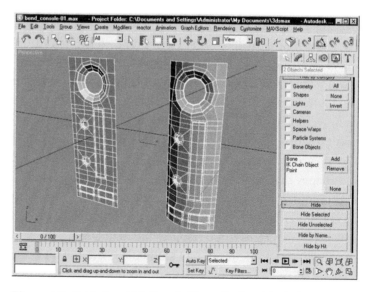

Figure 4.2 *Original model (left), and with one Bend modifier (right).*

rotation of the gizmo along the Y-axis we have created a curve from top to bottom (Figure 4.3).

3. Add a TurboSmooth, and we are presented with a smoothed version of our mesh; however, there are apparent flaws or pinches showing. Our mesh was built quickly and has a reasonable poly count for the amount of detail we are trying to depict, but for this technique to show its true potential we are going to have to make an adjustment.

4. Grab the TurboSmooth modifier in the stack, and drag it below the two Bend modifiers. Figure 4.4 shows the modifier stack before and after moving the TurboSmooth modifier.

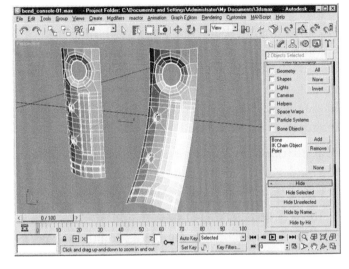

Figure 4.3 *Mesh with one bend (left), and with a second Bend modifier (right).*

You should see an instant visual difference in the appearance of the model in the viewport (Figure 4.5).

Figure 4.4 *Modifier stack before and after dragging the TurboSmooth modifier.*

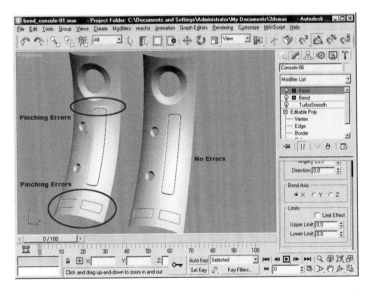

Figure 4.5 *Mesh before and after moving the TurboSmooth modifier in the stack.*

Where you were seeing pinches or irregularities, you are now seeing a smooth mesh. Why? Well we are giving the Bend modifiers much more information in the way of more polygons, vertices, and edges to work with. So, when Bend is moving the points it is averaging more information and, consequently, producing a better result. I would like to point out that the mesh was modeled very quickly and is not all Quads. I took the liberty of terminating edges where I knew they wouldn't affect the final output to save time, which is something I do when modeling for production as well.

Also, use this technique with a bit of discretion. If someone is going to be animating the shape of the model or modifying your model at a later time, this may not always be the best route to take. If you need to make a clean product mesh quickly, this is a nice trick to have in your arsenal.

In this example additional steps would need to be taken to restore the perfect circular shape at the top of the console, as the Bend modifier did create a bit of distortion. *Note: If you are going to UV-unwrap a mesh like this, you may want to collapse it down with one iteration of TurboSmooth below the two Bend modifiers (Collapse All).* You will have a bit higher initial poly count, but the end result will be the same. Adding a TurboSmooth on top with an iteration of 1 will bring your final mesh back to the same poly count as the original model with two iterations.

Taper, Twist, Skew, and Spherify can all be quite useful when used in a similar fashion. I do not use most of these modifiers during the modeling process, but on occasion when I animate a model I do put them to good use. The nice thing about modifiers is that almost all of them have parameters that can be modified and animated. The FFD set of modifiers is great, especially when a mesh is going to be animated via morph targets. Recently I worked on a project that required me to model and animate a blooming rose. As the flower bloomed it was also transforming from a spinning earth into the blooming flower. I used morph targets along with Spherify (for the transform from the planet to the flower) and FFD modifiers to create a nice natural animated sequence (FFD to add some randomness and control). Modifiers are great tools when you think of creative ways to use them in your work flow. Give them all a try to see what works best for your needs and modeling situation. Figure 4.6 shows the rose in different stages.

Figure 4.6 *Rose model in different stages. Modifiers were used to deform the mesh during animation.*

There are some other modifiers that I use often when building and texturing a mesh. For now we are going to focus on the modifiers that lend themselves nicely to modeling.

Displace: Before we had the robust render engines that are available today, this modifier provided us with the ability to displace meshes for terrain and other highly detailed objects. I still use this from time to time, but with options in V-Ray and mental ray for render-time displacement I usually opt for a lighter scene. Adding the Displace modifier requires a pretty dense mesh to achieve aesthetic results, so unless you want a bloated/heavy scene, I would opt for one of the render engine options.

Lattice: This is great for making architectural elements like geodesic domes or exposed beams and other industrial details. A practical use in my work flow is creating grills for car models as well as vents in buildings. Figure 4.7 shows the result of using Lattice on different base meshes.

Noise: Sometimes we don't want everything to be smooth and perfect. When you desire some surface disruption the Noise modifier is a great option. Rippling water or rolling hills are a snap with this modifier. Figure 4.8 shows a plane primitive converted to Editable Poly with a Noise modifier and a TurboSmooth modifier applied. This can easily be used as turbulent water or rolling hills just by changing the texture map and materials.

Optimize: Combined with other modifiers this is a great way to make crystals, or anything with angled or chiseled details.

Figure 4.7 *Lattice modifier.*

Figure 4.8 *Noise modifier applied to a plane object.*

Figure 4.9 *Base mesh with a Chamfer (left), Optimize and other modifiers applied (center), and with some edge/vert tweaks to the model (right).*

I used this to make a chocolate block for a cell-phone commercial; the results were great. Figure 4.9 shows a box mesh converted to Editable Poly, with TurboSmooth, Noise, Optimize, and Smooth applied. Adding Smooth to the stack is necessary to have a faceted effect. The resulting mesh can be collapsed and further developed with Poly-Modeling techniques.

Shell: Every time I model something with hard edges, I use this modifier. This is great for adding thickness and depth to your models. I recommend using the material ID override so you can easily delete unwanted polygons later. Open the lesson file Shell_door-01, and you will see three car doors lined up. The first is the door without any depth. The second is the door with a Shell modifier applied and Override Material ID checked with the IDs set to 1, 2, and 3, respectively. This second door looks much better, but also has an abundance of extra polygons that will never be seen when rendering.

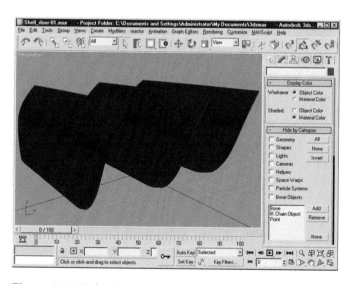

Figure 4.10 *Mesh without Shell (left), with Shell and extra polygons (center), and with unwanted polygons deleted (right). Final mesh has nearly one-half the poly count of the middle example.*

The third example is the door with the extra interior polygons removed to reduce the poly count drastically (nearly half the polygons). Setting the Override Material ID and then collapsing the mesh to an Editable Poly allows you to select the unwanted polygons (in this case Mat ID 1) with a single click; all that is left to do is delete the selection (Figure 4.10).

Symmetry: This is another modifier that you should use constantly. Whether modeling a product, vehicle, or character, this modifier can effectively cut your workload in half. Any changes made to the original half of the model are mirrored when using

Symmetry. Hard-edge or man-made objects will often be symmetric in nature, so why not work on half the model and have a perfectly symmetric model? When it comes to organic modeling, you may not want a perfectly symmetric model. Using Symmetry to establish the base model you can later collapse the stack and create the features that make your character unique or asymmetric. Figure 4.11 shows the mesh without Symmetry, with Symmetry, and finally with Symmetry and an edit to the base mesh. Note that the left side is mirroring the edit.

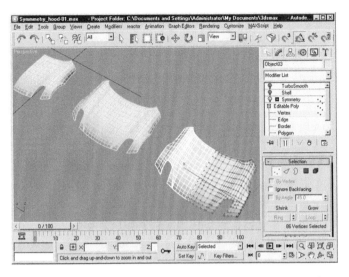

Figure 4.11 *Illustration of the use of the Symmetry modifier. Mesh without modifier (left), with modifier (center), and with a vertex edit mirrored to the opposite side of the mesh.*

TurboSmooth and MeshSmooth

The last modifiers I am going to cover are TurboSmooth and MeshSmooth. These are among the most used, and overused, modifiers available to us. Any sub-D model is going to require a smoothing modifier, that is a given, but there are many instances in which you can get away without the use of either TurboSmooth or MeshSmooth. A simple but effective example is a box with chamfered edges. I've seen people create unneeded geometry and subdivide their models with TurboSmooth just

Figure 4.12 *Subdivided model and lower polygon chamfer box primitive. Note the additional polygons in the example on the left. We have flat surfaces subdivided for no reason.*

to create a chamfered box. Just because the modifier is there, it doesn't mean you have to use it every time you model something. Figure 4.12 shows a modeled sub-D chamfered box with 3072

polygons and a simple old chamfer box extended primitive with 492 polygons. In my opinion the 492 polygon mesh looks better. Whereas we are talking about a single box in this example, let's say your project requires you to animate hundreds of these. The polygon count would grow exponentially, and the sub-D chamfer box would make scenes a nightmare to work with, at nearly 10 times the polygon count.

To illustrate better the idea I am trying to convey to you, we are going to take a look at a piece of a model I made quite some time ago and do a quick exercise to replicate the result. I modeled a watch to get in some modeling practice. The watch had an interesting bezel with N, S, E, and W embossed in it. Initially I had planned to bump or displace this detail with a map. As I thought more about it, I decided modeling this would be a bit of a challenge. How am I going to create these letters and have good topology for subdividing? Well, I am not going to subdivide it, that's how! The shape is generally a circle with a few bits of detail added; why would I smooth it and create a bunch of unneeded polygons? So, after a couple of tries, I came up with a working solution. Starting with a higher poly count in my base mesh, I wouldn't have to worry about segmentation. The higher poly count also afforded me the luxury of using ShapeMerge (or, depending on your 3ds version, ProBoolean), along with some simple spline text. After the ShapeMerge or ProBoolean, a little additional work is required in the form of welding vertices and removing edges. In my opinion the end result is worth it. Let's give it a try. I am going to provide the base mesh for this exercise to speed things up. The file including the meshes for this exercise can be downloaded at http://www.todddaniele.com/FocalPress.htm.

1. Open the No_TurboSmooth_Watch-01 file. You will be presented with the mesh in several stages, including the mesh I created when I developed this approach (to show the cleaned-up result). The meshes in the file progress from left to right in the viewport. I have also added text labels for easy identification (Figure 4.13).

2. The first mesh is our base mesh with no thickness.

3. The next mesh is the same mesh with a Shell modifier and Smooth modifier applied.

Figure 4.13 No_TurboSmooth_Watch-01 file upon opening.

4. Next up is the same mesh with spline letters floating above it. These letters are used for the ShapeMerge function.

5. Next up is the base mesh with the Shell and Smooth modifiers collapsed down.

6. The last mesh is exactly the same, only the spline letters have changed. I extruded them so we can use them for a ProBoolean example.

7. The last four meshes are the meshes we will use in this exercise. I've made them green to avoid confusion.

8. Start by clicking on the left green mesh. If Wireframe Display isn't active, enable it. Displaying the wireframe will help you see the result of the operations we are about to execute (consult the manual if you aren't familiar with how to change the viewport display).

9. Under the Geometry rollout, pick Compound Objects (Figure 4.14).

10. Click the ShapeMerge button to bring up the list of options (Figure 4.14).

11. Set the Operation to Merge (Figure 4.14).

12. Click the Pick Shape button (Figure 4.14).

13. With Pick Shape active, pick the Spline text object. You should see new edges on the base mesh in the shape of the letters. *Note: In some cases you may need to make some minor adjustments to placement if the result isn't as expected.*

Figure 4.14 *Important ShapeMerge options highlighted.*

14. Convert the base mesh (now listed as ShapeMerge in the modifier stack) to an Editable Poly object.

15. Select the polygons that make up the letters (they should already be selected when you click on Polygon in the Sub-Object list) and use Extrude to give them a little depth. I used −0.01 as the Extrude value in my example.

What you are left with is a pretty clean result. You can remove edges and vertices that aren't needed, chamfer edges, and apply a Smooth modifier if needed. That is Smooth, not TurboSmooth or MeshSmooth.

In my original example I also chamfered the ring edges to create a slightly rounder transition between surfaces. In the end you have a detailed mesh that can stand up very well to close-up renders. The best part is you didn't need to think about modeling the details so they would subdivide nicely. With the shapes of the text used, that would have been quite a tedious bit of modeling.

The process for doing this with ProBoolean is almost identical. There are only a few differences in the process. The text is now an extrusion rather than a spline object, and the extrusion needs to intersect the base mesh (make sure it goes all the way through the object). From there the process is just about identical.

1. Pick the left green mesh above the label ProBoolean.
2. Go to Compound Objects under the Geometry rollout (Figure 4.15).
3. This time, click ProBoolean to bring up the list of options (Figure 4.15). If Wireframe Display isn't active, enable it.
4. Click the Start Picking button (Figure 4.15), and select the extruded text object. You should see new openings on the base mesh in the shape of the letters.
5. Convert the base mesh (now listed as ProBoolean in the modifier stack) to an Editable Poly object.
6. Select the open border of each letter; select only the borders that face you, not the backside borders.
7. Cap the borders with the Cap function.
8. Select the newly capped polygons that make up the letters and use Extrude to give them a little depth. I used −0.01 as the Extrude value in my example.

Figure 4.15 *Important ProBoolean options highlighted.*

Again, what you are left with is a pretty clean result. You can remove edges and vertices that aren't needed, chamfer edges, and apply a Smooth modifier if needed. That is Smooth, not TurboSmooth or MeshSmooth. Figure 4.16 shows the resulting mesh from both the ShapeMerge and the ProBoolean approaches.

Figure 4.16 *Resulting mesh from the ShapeMerge and ProBoolean exercise.*

Figure 4.17 shows the rendered finished watch.

We are going to end this chapter here, but I do recommend taking a little additional time to explore all of the other object–space modifiers. Knowing how all of the modifiers in the list work will inevitably help you when you need to problem-solve in the future. The Zip file for all of the lessons and examples in this chapter can be downloaded at http://www.todddaniele.com/FocalPress. htm. In the next chapter we are going to take a look at using existing mesh elements to create new models and elements.

Figure 4.17 *Render of my watch model.*

Chapter 5

Derivative Modeling and Other Techniques to Speed Up Your Poly-Modeling Work Flow

In Chapter 5, we are going to see how we can derive other elements of our models from existing mesh. We are going to generate new models by detaching elements and altering existing models. Many times in production you will need to model variations of a certain type of object or have several options to show a client; when applicable this technique will help you get things done quickly.

For the first example I am going to use a basic model to show the technique. In the same file I have included a more developed model to show the "real-world" application of the technique. Before we begin, you are going to need to download the TubeCap script from my web site: www.todddaniele.com. TubeCap is a scripted primitive created and authored by Martijn van Herk; thanks, Martijn! I use this script and primitive obsessively! TubeCap provides a nice base mesh you can model almost anything from. I use it for organic models and hard-edge models alike. Co-workers joke that when I hand over a scene it will be full of models named TubeCap.

Install TubeCap. Once installed it can be found in your Create panel under MhV Primitives. Take a few minutes to see how the script and primitive work. As with most 3ds Max primitives, you have the option of using numeric inputs to create your ideal segments, etc.

Now that you are up and running, let's get started by modeling a basic keypad section from any modern electronic device. We will model the faceplate first, then "derive" the buttons from the existing geometry.

1. Go to the top viewport, and create a TubeCap. You don't need to worry about scale right now, as this is just an exercise. I used an inner radius of 8, an outer of 12, and eight segments (Figure 5.1).

2. Convert the TubeCap to an Editable Poly, then shift–drag it to create two clones, one to the side of the original and one to the top. Space the three pieces evenly as seen in Figure 5.2. *Note: Be sure to select Copy, not Instance, when creating the new geometry, otherwise you will not be able to use the Attach tool later on.*

Figure 5.1 *TubeCap primitive with eight segments.*

The next steps require us to bridge the gaps between the three TubeCaps to create a single continuous surface.

Figure 5.2 *Clones arranged evenly. These are currently three separate objects.*

3. With the top tube mesh selected, use the Attach tool on the other two meshes so that all three elements are part of a single Editable Poly object. Once you have completed this step, we will bridge the gaps between the three TubeCaps. Because each tube contains the same amount of segments, our task here should be an easy one.

4. Select the four edges seen in Figure 5.3 and bridge the space between them with a Bridge segment value of 2.

5. In Vertex mode, Target Weld the vert at the top of the newly created bridge to the bottom vert of the middle tube (Figure 5.4).

6. In Edge mode, bridge the diagonal two edges to the left and then the two edges to the right of the point we just welded. You must do one set at a time for this to work as expected (Figure 5.5).

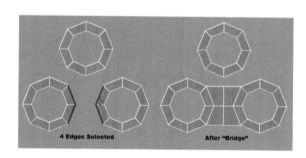

Figure 5.3 *Edge selection and resulting bridge.*

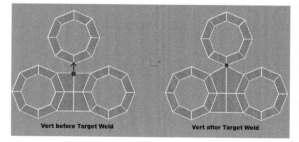

Figure 5.4 *Vertex before and after Target Weld.*

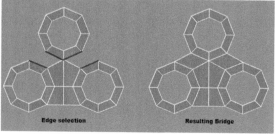

Figure 5.5 *Edge selection and bridged result.*

7. As we begin to shift–drag edges in the next steps, it is important to keep in mind how many existing edges we have available to create new polygons. To speed up the modeling process, delete one-half of the mesh and use the Symmetry modifier. This will allow you to make modifications to half of the model and have them reflected to the other symmetric side. For many of the following steps I left Symmetry toggled off; you can toggle it on and off as you feel necessary (Figure 5.6).

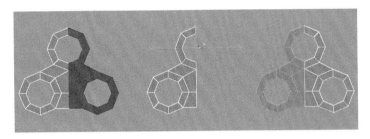

Figure 5.6 *Polygon selection to delete, resulting mesh, and mesh with Symmetry modifier and Show End Result toggled.*

8. Select the edge seen in the Figure 5.7 and shift–drag it two times to match the number of edges existing below on the mesh. We are left with an even number of edges, which is ideal for creating the new Quad polygons our mesh requires.

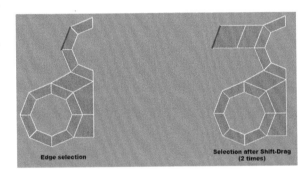

Figure 5.7 *Edge selection to be shift–dragged and resulting new polygons.*

9. The new edges are slanting a bit diagonally; use Make Planar to straighten them. In my example I made them planar in the X direction. *Note: You want to use Make Planar on one edge selection at a time* (Figure 5.8).

10. Using the Bridge function, fill the gaps between the newly cloned edges and the corresponding existing edges (Figure 5.9).

Figure 5.8 *Make Planar doing its job. Select one edge at a time.*

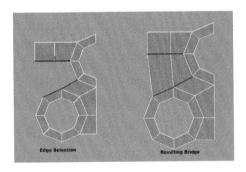

Figure 5.9 *Edge selection and result after bridging the selected edges.*

11. Next shift–drag two edges from the bottom of our mesh to create a clean edge to our object (Figure 5.10).

12. To straighten the resulting edges on a single horizontal level, go to the Edit Geometry rollout, next to Make Planar, and click Y to average the edges to a straight configuration (Figure 5.11).

13. There is a work-flow pattern developing here; can you see it? Use the Bridge function to fill in the open spaces between our new edges (Figure 5.12).

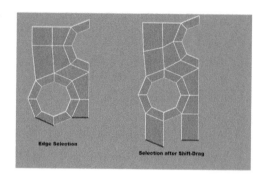

Figure 5.10 *New polygons created by shift–dragging edge selection.*

Figure 5.11 *Uneven edges selected. Edges straightened using Make Planar "Y".*

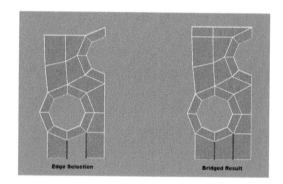

Figure 5.12 *Edge selection and resulting bridge.*

14. Rather than creating additional unneeded geometry, we are going to use some existing edges to create straight side edges for our object. Select the uneven edges (Figure 5.13) and use Make Planar "X" to straighten them.

15. Now is a great opportunity to turn on and collapse our Symmetry modifier so we can begin working on the mesh in the collapsed state. In your modifier stack go to the word "Symmetry." Make sure the modifier is toggled on and then right-click on it and select Collapse To. Figure 5.14 shows our mesh with Symmetry toggled off, Figure 5.15 shows it with Symmetry toggled on, and then collapsed to.

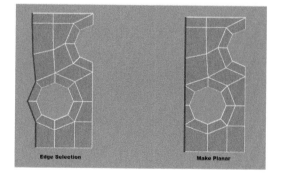

Figure 5.13 *Make Planar to straighten and clean our edges.*

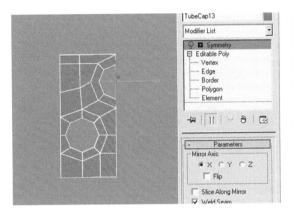

Figure 5.14 *Symmetry turned off.*

Figure 5.15 *Symmetry collapsed to. You now have a single two-sided symmetric mesh to work with.*

16. Go to the Border subobject level, and select the three circular openings. You can select them one by one, or use Ctrl+A to select all borders, and then simply deselect (Alt+left-click) the outer border to leave the three desired borders selected. Under Edit Borders click the Cap button to fill the openings (Figure 5.16).

17. Activate the Polygon subobject level and select the three new polygons you just created. Under the Edit Geometry roll-out, click Detach and select Detach To Element (Figure 5.17).

18. With the polygons still selected, go to the Scale tool, and in the rollout next to it, select Local from the list.

19. Click on the Outline settings button in the Edit Polygons rollout. Use a negative value for the outline amount to achieve a result similar to the one seen in Figure 5.18. With the last few steps we derived new geometry (keys or buttons) from existing geometry (faceplate) with a great deal of precision. The nice thing about

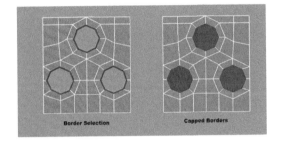

Figure 5.16 *Border selection and capped result.*

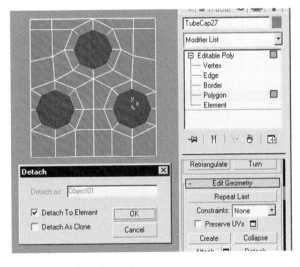

Figure 5.17 *Detach To Element.*

this process is that the derived geometry can be easily edited, detached, mapped, further detailed, or altered in many ways.

20. At the Border subobject level, select all the borders using Ctrl+A, and then subtract the outer border by using Alt+left-click. Go to the Edit Borders rollout, and click on the Settings box next to Chamfer. You will be presented with a dialog box, and some new red edge loops on your mesh in the viewport. I used the default value of 1.0; if your model is scaled differently you may need to adjust this value. A simple way to adjust the value is by right-clicking the slider in the dialog box to "zero" it out and going up from 0.0 with the slider (Figure 5.19). Your final result should appear as it does in Figure 5.20. Also note that, because our mesh is Quad-based, the chamfer had predictable, and desirable, results.

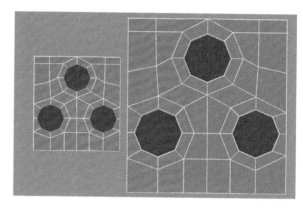

Figure 5.18 *Detached elements before and after scaling locally.*

Figure 5.19 *Right-click to "zero" the value.*

21. Exit Subobject mode. Add a Shell modifier, with two or more segments (four should be the most you will ever need), and an inner *or* outer amount to give your model thickness. Above the Shell modifier, add a TurboSmooth modifier with two iterations to see your subdivided result (Figure 5.21).

Figure 5.20 *Border selection before and after chamfering.*

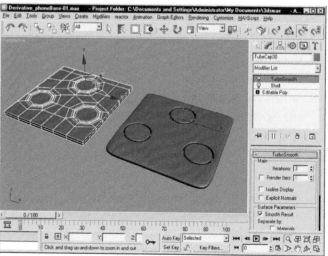

Figure 5.21 *Base mesh and smoother result with Shell modifier and TurboSmooth applied.*

22. With your object still selected, go down the stack to the Editable Poly > Element subobject level and select the three buttons. Using the Move tool, move them up a bit to raise them a little from the faceplate surface. Note that the derived buttons are not fully Quad based at this stage. You can connect edges to create all Quads; however, in this case it doesn't have a huge impact on our final result (Figure 5.22).

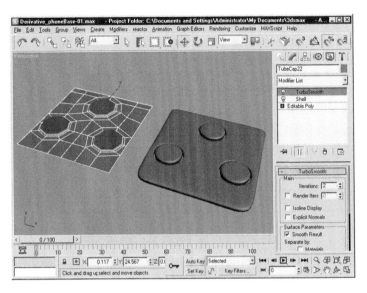

Figure 5.22 *Buttons raised up from the faceplate.*

We are going to conclude this exercise here; feel free to experiment or take this further if you wish. This is just a simple example of a technique you can use when modeling more complicated models. Figure 5.23 shows the model from this exercise with some additional steps, as well as part of a finished cell-phone model created with this technique as its basis. I have also used this technique to model elements of cars, products, and architectural elements with great success. The Zip file for this lesson can be downloaded at http://www.todddaniele.com/FocalPress.htm.

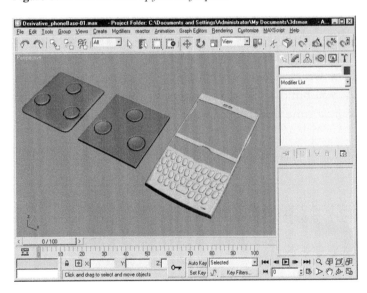

Figure 5.23 *Model from exercise, same model with additional steps, and a more detailed model built using this technique.*

The detailed model contained in the accompanying file does contain some non-Quad geometry. On a flat surface this isn't a major issue. The entire phone was modeled and textured in just under two days . . . if I had longer it would absolutely be modeled with all Quads.

A render of a detailed phone I modeled using this derivative modeling technique is shown in Figure 5.24.

In addition to deriving geometry to be used as an element or part of your existing models, you can also clone and/or derive geometry and then alter it to create unique, new geometry. This can be handy for creating repeating patterns of geometry that aren't identical by nature. Creating variations of a mesh is a quick way to add large amounts of detailed parts to a complex object. This

Figure 5.24 *A finished model created using the derivative modeling technique.*

technique is something that can be used to convince the viewer that your model is in fact a valid object, without necessarily modeling a thousand different parts. It is up to you as the modeler to determine how exact every detail will be; sometimes it is necessary to compromise to save time, especially when modeling with a deadline. Figure 5.25 shows how repetitive geometry can create impressive detail in a model. The finned sections are variations of a single base mesh with elements scaled and rotated to create unique components. Figure 5.26 shows how we can clone a mesh and, with a few modeling steps, create something new and unique. As you build a collection of models there will be times when altering an existing model will be a great time saver; deriving a new model from an existing one is an effective option.

Figure 5.25 *Cloned variations of a single mesh add impressive detail.*

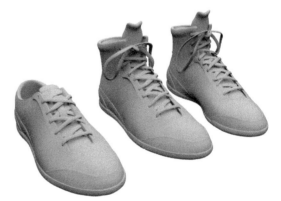

Figure 5.26 *Existing soccer shoe model (left) and new boxing shoe models created from the soccer base mesh.*

In the next chapter we are going to take a look at basic theory and application, specifically edge loops, edge rings, subdivision modeling, vertex proximity, mesh flow, and redirecting a mesh flow.

Chapter 6

Theory and Application

In this chapter we are going to first discuss some Poly-Modeling elements and theories and then experiment with how to apply these ideas to your work flow. Rather than talk about algorithms and other technical data that at times I myself find a little confusing, I am going to give you useable information needed to Poly-Model. If you feel the need to investigate the technical data, simply use your favorite search engine and search for Subdivision Algorithms, Catmull and Clark, Doo-Sabin, or Charles Loop to get started.

First I am going to discuss subdivision surfaces. When we model, we build a polygonal mesh known as a control mesh that we can later subdivide into a smoother, denser, and more refined surface. The mesh we build contains less polygonal detail than the subdivided result, making it easier to manipulate and manage the polygons, vertices, and edges as we build. The lower polygon (lighter) framework also allows for better performance in the viewports and/or workspace. The low polygon mesh also makes it easier for the animator(s) to work with your model should it need to be animated.

There are factors we need to consider when building our control mesh (also known as a base mesh). Because of the way subdivision algorithms work, the placement and geometric properties of our subobject elements (verts, edges, polygons) can have a dramatic effect on how our mesh reacts when subdivided. There should be a direct correlation between the amount of detail your final model is going to have and the density of the polygons in your base mesh. More detail equals a denser base mesh, less detail a base with fewer polygons.

N-gons, polygons with vertex counts of either three or five, or more, can wreak havoc on a subdivided model. As you model, there are going to be situations that create *N*-gons whether you anticipate them or not; it is inevitable, and later in this chapter we will cover some techniques to eliminate them. Most of the time you want to do your best to avoid consciously using *N*-gons. There are specific situations in which I use *N*-gons in my work flow, and there are times

when the results they produce can be desirable. Figure 6.1 highlights a five-sided *N*-gon. Figure 6.2 shows a three-sided Tri (*N*-gon).

Another by-product of the Poly-Modeling process is known as the "pole." A pole is a vertex that has an edge count greater or less than four. Poles occur when you extrude surfaces, inset polygons, and/or have directional changes in your mesh. When modeling man-made or rigid objects, poles in general aren't a major concern. However, poles can be an issue when you are modeling deformable, organic models; location and animated deformation are factors in determining where a pole is acceptable. Poles are going to occur; you cannot have a complex, defined model without having some poles in the mix. Directional changes in a mesh are guided by poles, so they are indeed a necessary component of the modeling process. Figure 6.3 shows a five-sided pole and a three-sided pole. These poles are guiding the directional flow of our mesh. *Note: Most times when you see a three-sided pole there will be a five-sided pole in close proximity.*

Figure 6.1 *Five-sided N-gon. (Vertex divides one side into two.)*

Figure 6.2 *Three-sided N-gon.*

Now that you are a little familiar with poles and *N*-gons you may be asking yourself, what do I do with these things? Well, one simple way to deal with both is to put them in areas where they aren't going to be very visible. On an animated organic model the best approach is to try to move them to an area where there isn't going to be much deformation.

Many times a pole or *N*-gon can be eliminated or moved to a more desirable location. Adding edge loops, slicing edge rings, and using a "four-sided Tri" are all methods we are going to explore and implement. I just mentioned edge loops and edge rings; let's take a look at both for those of you who may not be familiar with them.

When you are modeling organic models, edge loops are a must for clean deformations. Why? Well, there is a direct correlation between the flow of your mesh and how it will deform when animated. A loop will flow smoothly; edge loops are uninterrupted flowing groups of edges (you can also have loops of polygons). Edges in an edge loop will touch at each end until they form a continuous loop. Edge loops will create realistic forms and, as a result, natural deformations. Think of your eye opening and closing as an example; there isn't an area you can keep from moving when you blink is there? Your eye is basically a loop. The same goes for your

Figure 6.3 *Five- and three-sided poles.*

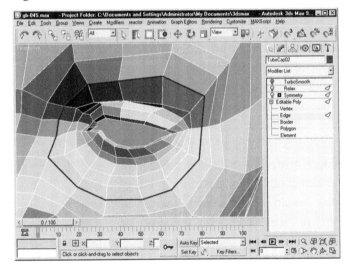

Figure 6.4 *Highlighted edge loop.*

mouth; when you break it down to its most basic form it is a circle, or loop. A well-modeled human head (and body, for that matter) will be composed of loops for all of the moving areas. Modeling with edge loops will allow quick selections, clean deformations, and evenly spaced polygons. In Figure 6.4 an edge loop is highlighted.

In addition to the edge loop, your models are also composed of edge rings. Edge rings are groups of edges that are on opposite sides of a given polygon(s). We can think of edge rings as the steps of a ladder. Visually they are configured and ideally spaced in similar fashions. Edge

loops are a great help in selecting subobjects in 3ds Max. Splitting edge rings is a very effective way to add detail to your models. Figure 6.5 shows an edge-ring selection.

Vertices, edges, and polygons are the most basic building blocks that make up your mesh, but it doesn't end there. The proximity of any of these subobjects plays a big role in how your model reacts to subdividing. Edge proximity has a huge affect on your mesh. When modeling hard-edge models, subdividing can turn your model to a soft, nondescript blob. Chamfering edges will create the clean, crisp edges that give your model its detail. The reason this works is the proximity of the edges in your base mesh in conjunction with the subdivision algorithm. As a rule you want to keep all of your model's edges as evenly spaced as possible in all directions. This makes for predictable results when subdividing. Even spacing also makes the processes of texture mapping and animating your models much more predictable. When you want to sharpen an area the most common way to do this is by adding

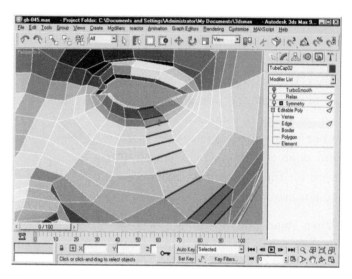

Figure 6.5 *Edge-ring selection.*

Figure 6.6 *Box and subdivided result.*

geometry, i.e., adding edges, thereby changing the spacing of your edges in a specific area. When the mesh is subdivided the closer spacing of these edges lessens the area between edges that the algorithm is dividing, resulting in a sharper result. To demonstrate this idea let's do a little experiment.

1. In 3ds Max, activate your top viewport, and create a box primitive. Leave the segments at 1, 1, 1. Convert it to an Editable Poly object and add a TurboSmooth modifier with two iterations. Figure 6.6 shows the box base mesh and the subdivided result

(TurboSmooth with two iterations). Notice that the box base mesh turns to a sphere when subdivided.

2. Let's take the original box and clone it to a new object (shift–drag). Expand the Box level in the modifier stack, select an edge as shown in Figure 6.7, and hit Alt+R or click the Ring button to create a ring selection.

3. Click the Connect button to create a new edge loop on your model (Figure 6.8).

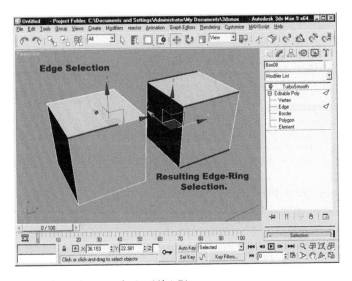

Figure 6.7 *Edge selection and resulting edge-ring selection (Alt+R).*

Figure 6.8 *New edge loop after using the Connect function on our edge-ring selection.*

4. Repeat this process two more times so you are left with a cube with four polygons on each face. Turn on TurboSmooth and examine the result. Figure 6.9 shows the divided base mesh and the resulting subdivided model.

The difference between the first box and this example is obvious. We have more edges, in closer proximity to each other, and the resulting subdivided shape is more defined. Let's take this a step further.

Figure 6.9 *Divided base mesh (Connect) and the resulting subdivided model (TurboSmooth).*

5. Go back to the original box from this experiment. Clone it again to create a base mesh for the next experiment.

6. As in the previous example, make an edge selection, and then use Alt+R or Ring to create a ring selection from the edge (Figure 6.10).

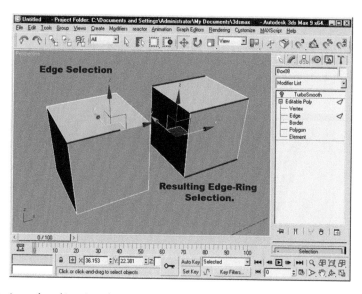

Figure 6.10 *Edge selection and resulting ring selection.*

7. With the edge ring still selected, click on the Settings box next to the Connect button on the right of your screen. Figure 6.11 highlights the button.

8. A dialog box will pop up. For the Segments value I put a value of 2, and for the Pinch value 93. Figure 6.12 shows the settings I used for this example. Figure 6.13 shows the impact of this action on our base box mesh.

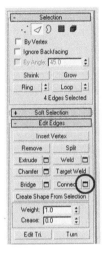

Figure 6.11 *Connect settings button.*

Figure 6.12 *Connect Edges dialog box with values typed in.*

Figure 6.13 *New edges created with Connect Edges dialog.*

9. Repeat the last steps with the same Connect Edges value in two other directions to complete our base mesh. Turn on TurboSmooth to see the end result. Figure 6.14 shows the base mesh with additional connects and the subdivided result.

Note that the subdivided result of our last box has clean, sharp edges even when subdivided. This is due to the closer edge proximity in the base mesh.

Figure 6.14 *Base mesh with new edges and the subdivided result.*

Figure 6.15 shows the three variations from this experiment side by side. Base meshes are in the back row, subdivided meshes are in the front row. This is a very effective illustration of how edge proximity can affect a subdivided model.

In Chapter 3 we covered the use of edge constraints. Combining edge constraints with the technique we just covered will allow you to localize and control the detail in your models. Let's do an experiment. Using the file from

Figure 6.15 *Base meshes and resulting subdivided meshes (TurboSmooth).*

the last exercise, we are going to space or "fan" vertices out to soften some of the detail we created in a localized area.

1. Take the last cube (the one with the sharp edges) and clone it to a new object.
2. Select the three vertices shown in Figure 6.16 and activate Edge Constraints by hitting Shift+X.

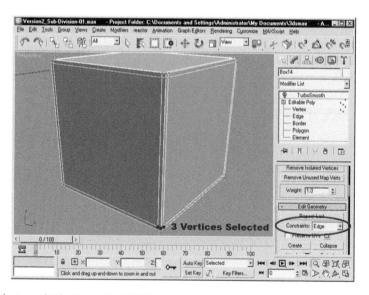

Figure 6.16 *Vertex selection and Edge Constraints highlighted.*

3. Using the gizmo, move the vertices up along the Z-axis. The vertices will follow the edges because of the constraint. Move them about halfway up the length of the edges (Figure 6.17).

4. Select either of the side vertices from the group you just moved (one at a time), and move it approximately halfway across the face it is laying on (Figure 6.18).

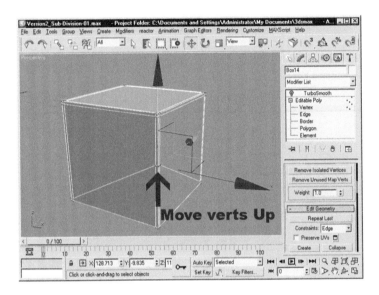

Figure 6.17 *Verts moved up along the Z-axis.*

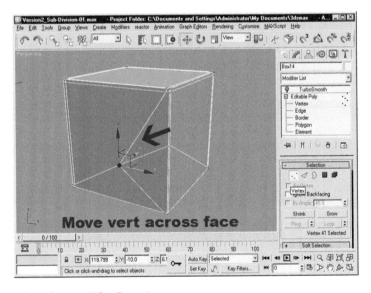

Figure 6.18 *Vert moved along edge using Edge Constraints.*

5. Repeat the last step, only this time on the other side of the cube (Figure 6.19).
6. Move the corresponding vertices at the bottom of the cube approximately the same distance along the bottom edges using Edge Constraints (Figure 6.20).
7. If you turn on your TurboSmooth modifier, you will see that the bottom corner that was once sharp is now rounded and softer. The vertices are spaced farther apart and the result reflects

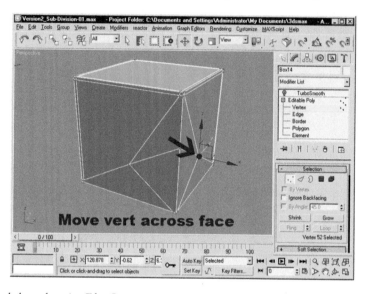

Figure 6.19 *Vert moved along edge using Edge Constraints.*

Figure 6.20 *Lower verts moved along edges using Edge Constraints.*

their relation to one another. Due to the small number of polygons you may want to add one more iteration of TurboSmooth (three total) to see a cleaner subdivided result (Figure 6.21).

Try the same technique on the other corners of your base mesh. Vary the vertex spacing to see what impact spacing has on the end result. Figure 6.22 shows the base mesh with varying results at the corners.

Figure 6.21 *Subdivided mesh after spacing, or "fanning out," the vertices.*

Figure 6.22 *Box mesh with variations created by spacing verts with Edge Constraints enabled.*

Poly-Modeling with 3ds Max

With the same principles we just used, you can also create holes and openings in your meshes. Figure 6.23 shows some variations. The last two examples are the most applicable, so I am going to focus on them next.

Let's create some openings in the mesh.

1. Go back to the base box mesh we cloned to begin our last exercise, and clone it again.
2. In the Polygon subobject level, select the top and bottom polygons of the box. Inset the polygons to create a result similar to the one seen in Figure 6.24.

Figure 6.23 *Our base mesh with various holes introduced.*

Figure 6.24 *Inset polygons on the top and bottom polygons. Bottom is not visible in this view.*

3. Delete the newly formed polygons to create open borders at both the top and the bottom of your mesh (Figure 6.25).

Figure 6.25 *Polygons deleted.*

4. Using the Bridge function, we are going to bridge the gap between the open borders. Select the two borders that were created when you deleted the polygons. With the borders selected, click the Bridge settings box. Figure 6.26 shows the Bridge dialog box. Figure 6.27 shows the bridged border selection.

5. Select one of the edges bordering the top of the new opening and use Alt+R to create a ring selection. Figure 6.28 shows the edge-ring selection.

6. Use Connect (Ctrl+Shift+E) to create a new division to the edge-ring selection. You should be creating only a single new edge loop; if not, then reset your Connect settings box (Figure 6.29).

Figure 6.26 *Bridge dialog box.*

Figure 6.27 *Bridged border selection.*

Figure 6.28 *Edge-ring selection.*

Figure 6.29 *Edge ring after using Connect to create a new loop of edges.*

7. Do the same for each of the remaining three edges that make up the top of the new opening. Create a ring selection, then use Connect on each ring selection. You should use Connect on one selection at a time. Figure 6.30 shows the mesh after repeating the process on the other ring selections.

Figure 6.30 *Resulting mesh after connecting the edge-ring selections.*

8. Go to the top viewport, and select the vertices that make up the new edge loops you just created. The selection will appear as if it is made of four vertices; in actuality it is eight (four at the top, four at the bottom [Figure 6.31]).

9. In the perspective viewport use the plane handles to scale the vertices in the X and Y directions. The result should be an octagonal opening as seen in Figure 6.32.

Figure 6.31 *Eight vertices selected in top viewport.*

Figure 6.32 *Scaled vertices, as well as the highlighted plane handles (yellow) used to scale them in the X- and Y-axes.*

10. Switch your viewport to Wireframe mode, and select the top and bottom edge loops as shown in Figure 6.33. Select a single edge from each loop and hit Alt+L on your keyboard.

11. Use Chamfer on the edge selection with a value of 0.18 (Figure 6.34). Activate TurboSmooth (three iterations) to see the final result. Figure 6.35 shows the final mesh as it should appear in your viewport.

Figure 6.33 *Top and bottom edge loops selected in the wireframe perspective viewport.*

Figure 6.34 *Mesh after performing Chamfer on edges.*

When making a circular opening in a mesh I like to try to have at least six sides to the circle in my base mesh, and I prefer to work with eight sides when possible. You can get a circular result with fewer sides, but there will be flat spots in the subdivided mesh. A four-sided circle can be used for small details that aren't going to be the focus of your object.

To make a square opening the process is almost identical.

Figure 6.35 *Resulting mesh with cylindrical hole created in it.*

1. Go back to the box base mesh we cloned to begin our last exercise, and clone it again.
2. Repeat steps 2–5 from the previous exercise.
3. Use the Connect settings dialog box to create two new divisions to the edge-ring selection. Set the Segments to 2 and the Pinch value to 94. Figure 6.36 shows the dialog box with the proper settings. Figure 6.37 shows the resulting new edge loops.

Figure 6.36 *Connect settings dialog box with proper settings highlighted.*

Figure 6.37 *Two new edge loops, Pinch value of 94.*

4. Do the same for each of the remaining three edges that compose the top of the opening. Create a ring selection, then use Connect on each ring selection. You should use Connect on one selection at a time. Figure 6.38 shows the mesh after repeating the process on the other ring selections.

5. Switch your viewport to Wireframe mode, and select the top and bottom edge loops. Select a single edge from each loop and hit Alt+L on your keyboard. Chamfer the loops with a value of 0.18. Figure 6.39 shows the result of the selection and the chamfer.

Figure 6.38 *All edge-ring selections after using Connect.*

Figure 6.39 *Edges chamfered with a value of 0.18.*

If you turn on your TurboSmooth modifier right now, you would see you have a square opening, but you also have some strangeness near the corners of the opening. To remedy this, we are going to do some moving of edges, with Edge Constraints active.

6. Select the five edges shown in Figure 6.40.
7. Set the constraint to Edge mode (Figure 6.41).

Figure 6.40 *Edge selection, five edges total.*

Figure 6.41 *Edge Constraints highlighted.*

8. In the top viewport move the edge selection with the Move tool so that the selected edges are aligned with the inside edges of the opening in a straight manner (Figure 6.42).

9. Repeat this process for all of the new edges (select five at a time), creating a square edge configuration at each corner (Figure 6.43).

10. Turn on your TurboSmooth and you will see the result is cleaner.

11. For a crisper edge, there is one last thing to do. Select the edges that run along the inside of the square opening (Figure 6.44).

Figure 6.42 *Edge selection moved to align with the inner edge of the square opening (blue highlight).*

Figure 6.43 *Edges are now spread out at the corners, creating four visible square segments in your wireframe (top viewport).*

Figure 6.44 *Edge-ring selection.*

12. Use Connect with a Segments value of 2 and a Pinch value of 94.
13. Turn on TurboSmooth to see the impact the new edges have (Figure 6.45).

We are going to end this exercise here, but with a couple of additional steps, you can achieve an even cleaner result. The accompanying file has the base mesh with additional steps performed.

Figure 6.45 *Subdivided mesh.*

Now that you have some experience with subdivisions and edge constraints, we are going to touch on some of the by-products that can be produced as you model. Let's take a look at N-gons, those odd-sided polygons that can occur when modeling. First let's explore the three-sided N-gon, also known as a Tri.

1. Activate the top viewport, and create a plane object with seven segments in each direction (Figure 6.46).

Figure 6.46 *A 7 × 7-segment plane object converted to an Editable Poly object.*

2. Convert the object to an Editable Poly object.
3. In the Edge subobject level, select the four edges shown in Figure 6.47, and use Connect to create a new set of edges.
4. In the Vertex subobject level, select the four vertices seen in Figure 6.48. Use Connect to create a new diagonal edge between them. The two new polygons are triangles, three-sided polygons called *N*-gons or Tris.

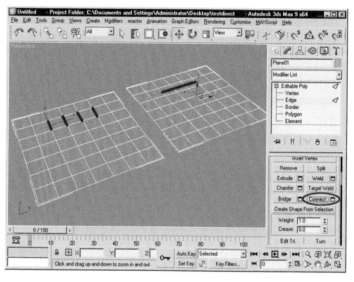

Figure 6.47 *Edge selection and new edges resulting from Connect.*

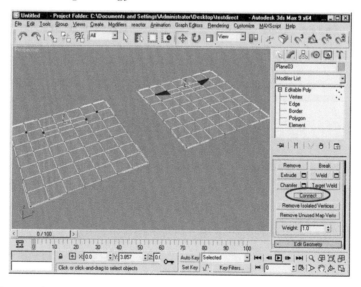

Figure 6.48 *Vertex selection and resulting Tri after performing Connect.*

In the last four steps we have intentionally created a three-sided *N*-gon. As your models become more complex, this Tri situation is something that will occur whether you intend it to or not. I am about to show you several ways to eliminate a Tri.

5. Clone this mesh two times using Copy as your setting in the Clone options dialog box.
6. Select the first copy.
7. At the Edge subobject level, select the edge shown in Figure 6.49.
8. Use the Ring button or

Figure 6.49 *Edge selection.*

Alt+R to create a ring selection composed of four edges.
9. Use Connect on the edge selection. Figure 6.50 shows the result of the connect.

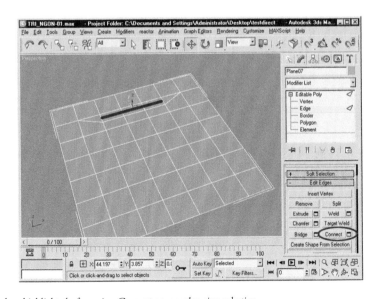

Figure 6.50 *New edges highlighted after using Connect on an edge-ring selection.*

The result of using Connect is a four-sided triangle ... the Tri has just become a Quad without any change to the surrounding geometry. Beyond restoring a Quad mesh, this is a great technique if you need to add localized detail, such as wrinkles, or sharper indents if you add more geometry. Figure 6.51 shows the two resulting four-sided Tris/Quads.

Let's move along to the next copy of the original mesh we created. Aside from splitting the triangle in the direction we just did, we can also use the same technique

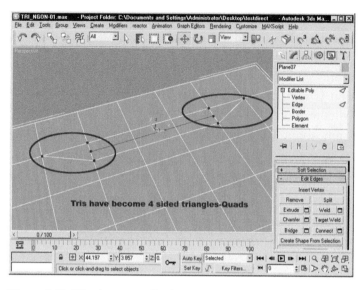

Figure 6.51 *Triangles are now Quads.*

to split any of the edges that compose the outline of its shape.

1. At the Edge subobject level, select the two edges shown in Figure 6.52 and use Ring or Alt+R to create a ring selection of two edges per side, four edges in total.

Figure 6.52 *Edge selection and resulting selection after using Ring–four edges in total.*

2. Use Connect on the ring selection and once again you are left with a four-sided Tri (Figure 6.53).

In this last example, we'll work on the last copy of the original mesh.

1. At the Edge subobject level, select the two edges shown in Figure 6.54 and use Ring or Alt+R to create a ring selection of seven edges per side—fourteen edges in total.

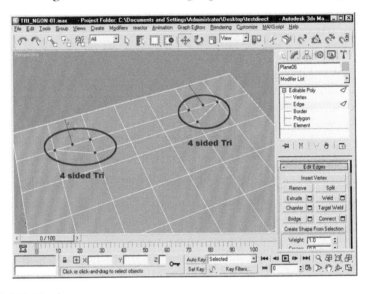

Figure 6.53 *Four-sided Tris/Quads.*

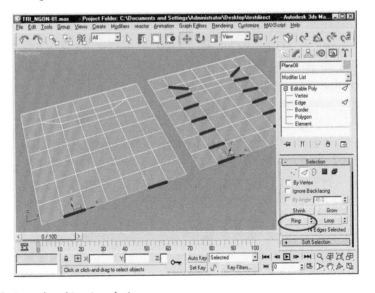

Figure 6.54 *Edge selection and resulting ring selection.*

2. Use Connect on the ring selection(s) and once again you are left with a four-sided Tri (Figure 6.55).

There you have it, a quick, easy way to eliminate a Tri (N-gon) with only a couple of steps. There is always more than one way to achieve results; the same technique can be executed by using the Cut tool. Experiment with these tools to find out which method works best for you. Also remember the information you learned earlier; using Edge Constraints and fan-

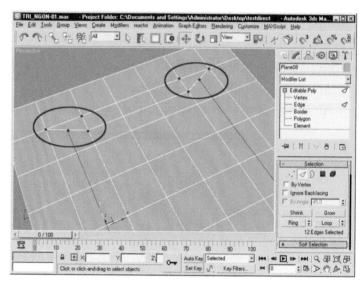

Figure 6.55 *Four-sided Tris; they are now Quads.*

ning vertices will work incredibly well with vertex placement in the exercises we just finished. Let's move on to the five-sided N-gon.

I have to start by saying I don't find a five-sided polygon to be such a bad thing (most of the time). Five-sided polys are a great way to terminate a line of edges created by localized geometry. Sometimes you may not want to continue your edge owing to mesh density or mesh flow, and this can be an effective way to end the line. With this in mind, you do not want to create groups of five-sided polygons, nor do you want to use them if they can be avoided. I am going to take you quickly through a few scenarios involving a five-sided N-gon.

1. For this exercise I have given you the base files in a 3ds Max scene available for download at http://www.todddaniele.com/FocalPress.htm.

2. In 3ds Max open the file you just downloaded, "the_5-SIDED_Ngon." You will be presented with several clamshell-shaped meshes.

3. The first mesh seen in Figure 6.56 shows a wireframe view of a mesh

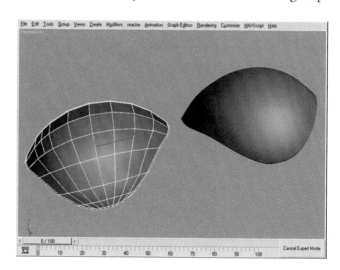

Figure 6.56 *Five-sided N-gon and resulting subdivided mesh.*

with a five-sided *N*-gon, as well as the resulting TurboSmoothed mesh. In my opinion this is a very good subdivided result with no real visible pinching or bumping.

4. The next set of meshes shows what happens if we were to continue the edge line to the end of the mesh. The meshes in Figure 6.57 show that the change of edge proximity does cause a crease or wrinkle in the mesh. This happens often, so you need to think carefully when routing your edges. In this instance, you can adjust the spacing of the edges and be left with a more than acceptable result (Figure 6.58).

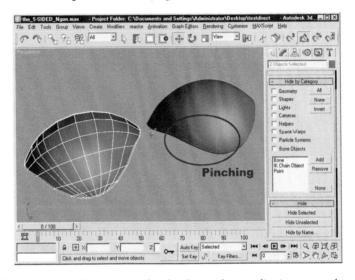

Figure 6.57 *Five-sided* N-*gon eliminated by continuing the edge along in the same direction; unwanted creasing occurs.*

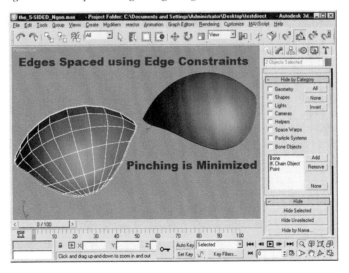

Figure 6.58 *Adjusting edge spacing with Edge Constraints minimizes the appearance of creasing.*

The last method for eliminating a five-sided polygon that I am going show you involves rerouting your mesh flow. We are effectively going to change the direction of the flow of our edge loop, while maintaining a Quad-based mesh. The following technique is useful for rerouting your mesh in any situation, not just when a five-sided polygon is involved.

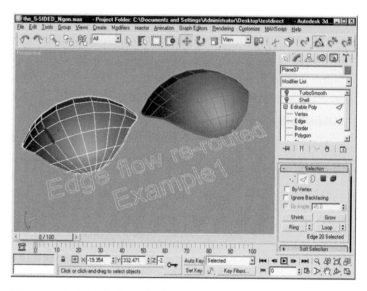

Figure 6.59 *Select the highlighted edge.*

1. In the same 3ds Max file, move over to the meshes labeled "Edge flow re-routed Example 1" in the viewport (Figure 6.59).

2. Select the edge highlighted in Figure 6.59.

3. Create a ring selection as shown in Figure 6.60. Note that the edge ring stops at the five-sided polygon rather than continuing across the entire span.

4. Use the Connect button to create a new loop. Figure 6.60 (right side) shows the newly created edges.

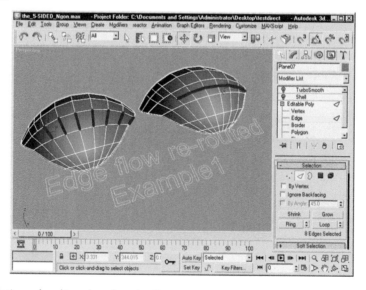

Figure 6.60 *Edge selection and resulting edges after using Connect.*

5. Select the two vertices shown in Figure 6.61 and use Connect to create a diagonal edge. The new edge results in a Tri *N*-gon and a five-sided *N*-gon neighboring each other; not to worry, in the next step we will eliminate both.

6. Using the Cut tool, we are going to create an edge from the vertex shown in Figure 6.62 to the midpoint of the diagonal edge we just created. The result is an all-Quad mesh. You are left with one four-sided Tri and two other newly created Quads.

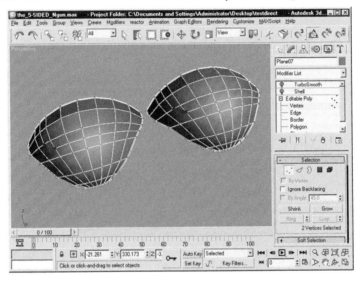

Figure 6.61 *Vertex selection and resulting edge after using Connect.*

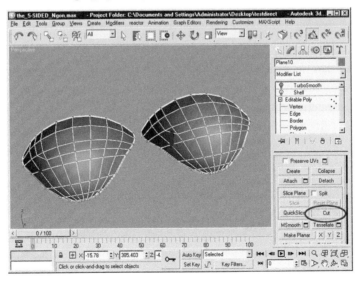

Figure 6.62 *Starting vertex, highlighted, and diagonal edge created using the Cut tool.*

7. The last thing to do is to move the vertex shown in Figure 6.63 to a new position to create a more even spacing of the vertices. As we discovered earlier, spacing affects the final output when the mesh is subdivided. Note the presence of three- and five-sided pole vertices where our mesh changes direction. This reaffirms the information we started the chapter with, that directional changes in a mesh are often accompanied by a pair of three- and five-sided pole vertices.

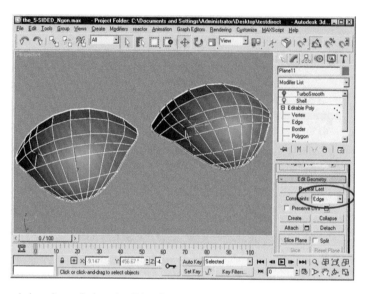

Figure 6.63 *Vertex moved along diagonal edge using Edge Constraints.*

Remember that this last technique is something you can use whenever you want to add a directional change in your mesh. Also note that you can route the mesh to either the left or the right to suit your needs in a given situation. Although all of these techniques do work, and result in clean end results, I think we have seen that a five-sided *N*-gon is not a terrible thing. The five-sided *N*-gon also yielded the best-looking result with the least amount of effort in this experiment.

The information in this chapter should give you the ability to better control the output of your mesh when subdivided. As your skills develop, much of this information will become second nature. As a result your models will become cleaner and more efficient and will look better with less effort. In the next chapter I will show you some helpful tips to use when you begin any modeling project.

Chapter 7

Preparation

In this chapter we are going to cover preparation for a big project: reference collection, resources for reference, setting up blueprints, image manipulation, and applications that aid in the process. I am also going to touch on setting up a job/directory template, something that makes things go a bit smoother when you are working on projects that will have other artists accessing your files.

Let's start with the last item I mentioned, the job/directory template. Whether working with others in a studio, working remotely, or working on a personal project, having an organized hierarchy of folders will prove to be one of the most valuable steps you can take. Establishing good work habits just makes the process go smoother and makes for a more professional work flow. In general we usually set up a named project folder with subdirectories for 3D models, maps, scenes, references or resources, as well as output folders for 2D renders, comps, etc. 3ds Max has a Set Up Project Folder utility that is very useful for just this purpose. It's under the File menu and it automates the process of setting up a working hierarchy of folders.

Any time I am going to model something, the first thing I do is search the Internet for images and information that will give me some insight into how it is made and what it looks like from all angles. Depending on the complexity of the model you are required to build, this can be a short process or, in some cases, something a bit more involved. I have modeled a jet engine three times in the past couple of years; this is something you would want to know a little about before jumping into the modeling process. By the third time I found it much easier, as I had a good database of images as well as a basic knowledge of how things look and work. I am no engineer, but the ability to sell the target audience on the idea that what they are looking at is feasible is all it takes. Remember, 98% of the population is not going to know (or care) that the

model isn't accurate. If you've done your job well, they are going to buy into it or wonder how someone was able to make that jet engine pop out of that gaming computer. The point I am trying to make is that the more prepared you are, and the more reference you have, the easier it will be for you to produce detailed, high-quality models. A great majority of the time Google will fill the bill for finding reference. Between their Image search and Web search you can find just about everything you are going to need. I also frequently use howstuffworks.com, YouTube, and flickr. The best possible scenario is client-provided reference . . . if you get that lucky. For organic reference, fineart.sk seems to be emerging as the only true quality resource. fineart.sk is a pay site, so be prepared to pay a monthly fee. If you have the time and budget, photographing or filming your own reference gives you more control over the final product. For cars, planes, and other vehicles there is smcars.net; they have blueprints for almost any car you can think of, and best of all, smcars is a free site. Googling "Mustang blueprints" or going to Ford.com would also fill your needs, as most manufacturers offer photos and 360 views.

So, you have collected or created your reference. What's next? I like to bring any reference I plan on using in 3ds Max into Photoshop or a similar image editor and prepare it for use. Cropping, scaling, and color adjustments are frequent requirements when dealing with free reference. As an example, vehicle blueprints are often all on a single sheet, so cutting them into individual images that you can later apply to image planes is a good idea (Figures 7.1 and 7.2).

Figure 7.1 *Downloaded blueprints. All four images are currently one image.*

Keep in mind you may be viewing your reference in the Max viewport, so color and contrast adjustments can be extremely helpful. In the case of dark pho-

Figure 7.2 *Side view after being cropped in your image editing software of choice.*

tos or lower resolution images, you may want to use your pen tools in Photoshop or Illustrator (if you have it available) to draw bold-stroked splines on your image to make the shapes and contours more visible. On the 3ds Max end of things, making your image maps 60% to 100% self-illuminated makes them easier to see. In your Max preferences you should choose the best

driver configuration for your hardware and configure the driver for optimal results. I use Direct 3D as my driver and turn off Display All Triangle Edges. In Appearance Preferences I check Enable Antialiased Lines in Wireframe Views. For Background Texture Size, using the highest settings is the way to go, so I set the value to 1024 and tick Match Bitmap Size as Closely as Possible. For the Download Texture Size, I set the value to 512 and also tick Match Bitmap Size as Closely as Possible. Figure 7.3 shows the driver configuration with the settings I just mentioned.

OK, let's say you have collected your reference and have made any cropping or adjustments you feel are necessary in your image editor. I am going to go briefly through the process of setting up your references in your 3ds Max scene.

1. In Max, activate the left viewport and create a rectangular plane object. By default your plane will have four segments in each direction. You can reduce the segments to 1, 1 if you wish, as this object is going to be used solely to display our blueprint. I have kept the default four segments in my example (Figure 7.4).

Figure 7.3 *Direct 3D settings highlighted.*

Figure 7.4 *Plane object in left viewport.*

2. Select the Move tool, then go to your Transform type-ins at the bottom of the screen (three boxes with numeric values below the Timeline slider). Figure 7.5 shows the Transform type-ins.

Figure 7.5 *Transform type-in boxes.*

3. Right-click on the spinner for each of the three boxes to zero it out. This will place your plane object so that it is centered at the origin as seen in Figure 7.6. The origin is the place where the bold lines on the viewport grid intersect. The origin is located at 0, 0, 0.

4. With the left viewport still active, hit the P key on your keyboard to switch to the perspective viewport, and zoom into your object a little (scroll wheel on your mouse; Figure 7.7).

Figure 7.6 *Plane moved to origin.*

Figure 7.7 *Plane object viewed in perspective viewport.*

5. Hit the M key to bring up the Material Editor. Select the top left material slot and leave it as a Standard material (regardless of what renderer you are using; Figure 7.8).

6. Click on the small box next to the Diffuse color in the Material Editor, and double-click Bitmap from the list to the right of the window. You will be presented with the Select Bitmap Image File dialog box. In the Look in drop-down box, navigate to the directory with your blueprint images and select the side blueprint image (BP_side in the accompanying files). Before you click Open take a look at the statistics information listed at the bottom left of the dialog box. Here you will see the image size of your blueprint image; in my example its dimensions are 555 × 188 pixels. Make a note of this size, as it will be very helpful in the next steps. Figures 7.8 and 7.9 show the items discussed in this step.

7. Click Open to import your image into the Diffuse slot of the active Max material. In your Material slot, the sphere will now be displaying the BP_side image on its surface. Click on the Go to Parent arrow and in the Self-Illumination box change the value to 100. Click the Assign Material to Selection button to apply the material to your plane object.

Figure 7.8 *Material Editor, Standard material, and Diffuse slot where we are adding our blueprint image.*

Figure 7.9 *Bitmap slot, resulting dialog box, and statistics showing the image size in pixels.*

Figure 7.10 shows the material with the image displayed on its surface in the Material Editor, the Go to Parent arrow, and the Self-Illumination box with a value of 100.

Figure 7.10 *Material with Map applied in the editor, the Go to Parent arrow, and the Self-Illumination box with a value of 100.*

8. You will notice that your plane object has changed color, but isn't displaying the BP_side image. In the Material Editor, click the Show Map in Viewport button (checkered box below the material slots). Your plane should now be showing the side blueprint image mapped on the plane. Figure 7.11 shows the plane with the image displayed on its surface.

9. Earlier I mentioned you should take note of the image size; in my sample file the image is 555 × 188 pixels. To have your image plane match the scale and proportions of the blueprint image you just mapped, you can scale the plane to a value that reflects the image size value. You can scale the plane to 555 × 188 or 55.5 × 18.8 as a starting point.

If you know the real-world dimensions of your object you can scale your plane again to reflect the size. The initial scaling should be done as I just outlined to create a plane object with the correct proportions. From this point you can do a little math and uniformly scale according to the real-world dimensions. Figure 7.12 shows the plane before (bottom) and after (top) scaling.

Figure 7.11 *Plane object with the side image mapped to it in the viewport.*

I have outlined the basic process for you; now you can repeat this process with each of the other blueprint views to create an effective work environment. Create a new plane for each image, create a new material with the corresponding image map in the Diffuse slot, set the illumination value, and finally scale each plane to match the image dimensions. *Note: You can clone the side plane and rotate it to create a base for the top plane. The same can be done with the front and rear planes once you have created them.*

When you have all of the planes in your viewport you can position and align them to make

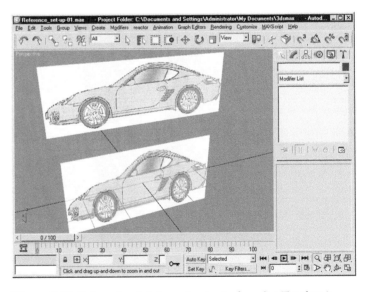

Figure 7.12 *Bottom plane is before scaling, top is after scaling. Top plane is scaled to 55.5 × 18.8; from here you can scale to achieve real-world scale values.*

sure they line up matching positions of unique design features for best results. I recommend zeroing the Transform type-ins for each plane and aligning from that position. There are two basic configurations for laying out blueprints, in my experience: the H configuration and the

T configuration. Figure 7.13 shows the blueprints laid out in an H format, and Figure 7.14 shows a T format.

There are a couple of additional tricks I use when working with blueprints to make sure they aren't interfering with object selection or test renders.

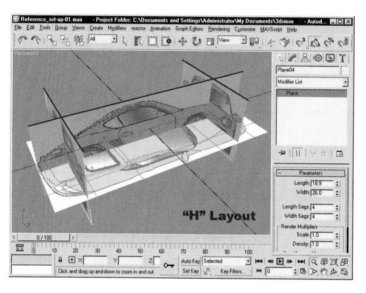

Figure 7.13 *The H layout.*

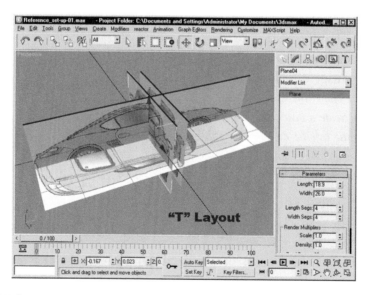

Figure 7.14 *The T layout.*

10. First, select all of the planes and right-click on them to bring up a Quad menu. From the Quad menu, click the Object Properties text to bring up the Object Properties dialog box. Uncheck Show Frozen in Gray, and also uncheck Renderable. Figure 7.15 shows the Object Properties dialog box with the desired settings.

11. The final step: with all of the planes still selected (select them if they aren't already), open the Layer Manager and click Create New Layer (containing selected objects), and name the new layer "Blueprints." To the right of the layer name, you will see columns for Hide, Freeze, etc. Click the Freeze slash to "freeze" the blueprint layer (slash will turn into a snowflake). Close the Layer Manager. What you are left with is blueprints displayed in your viewport that are frozen and not selectable or renderable. This is great because you can also toggle the visibility of the blueprints independent of the other objects in your scene by using the Layer Manager. Because the objects are frozen (and unselectable), there will be no confusion when selecting objects. When working on a complex project the last thing you want to do is render a test render without remembering to hide your blueprints. By unchecking Renderable you don't need to concern yourself with this. Figure 7.16 shows the Layer Manager configured as described above.

Figure 7.15 *Object Properties dialog box with selections unchecked.*

Figure 7.16 *Layer Manager with the Blueprints layer frozen.*

Now that your scene is optimally set up for you to begin the modeling process, you may want to refer to images other than the blueprints. A good habit to get into is looking at reference photos as you model. Blueprints give you an explicit reference for the overall shape of your model; however, they are still flat images. There are absolutely going to be features that you will not see by using blueprints as your sole source of reference. Earlier in the chapter I mentioned collecting images. For our example we would have a directory full of images of the sports car ready to look at. I for one don't enjoy toggling between applications to check the reference as I model. Well, with the use of ACDSee I no longer have to manage my application windows. I can look at reference material and model at the same time. I am far from well versed in all of the features of this software; I know just enough to use it in my work flow with great results. Different from an image editor like Photoshop, ACDSee is an image viewer. It allows you to browse through directories with speed and ease. The true strength of this application is the

ability to set it to Always on Top. What does this do? It keeps the ACDSee application window in front of any other application you have running. Now you can be modeling in 3ds Max with a scalable, accessible window in the foreground. This window will not be moved behind your other applications as you work in them. You can position this window so it doesn't interfere with your 3ds Max interface and refer to your image collection as you model. You can also browse the image directory with your mouse wheel. This is a fantastic, inexpensive piece of software that will have a great impact on the way you work in Max, as well as any other application you use to create content. Figure 7.17 shows ACDSee in front of the 3ds Max user interface.

Figure 7.17 *ACDSee in front of the 3ds Max user interface. Always on Top is active.*

That wraps up this chapter. In the next chapter we are going to do some hard-edge modeling.

Chapter 8

Hard-Edge Modeling

In this chapter I am going to show you some hard-edge modeling techniques you can use when modeling every man-made object. I use this approach when I model products, cars, and any hard-edge surface that will require the use of TurboSmooth to subdivide the final mesh. Many of the techniques used in this exercise are covered in earlier chapters; be sure you are familiar with the techniques before starting this exercise.

Let's jump right in and start modeling the Future Bike project. I strongly recommend using a search engine to collect basic reference materials to help with the technical aspects of this project.

Modeling the Body Panels

1. I have provided a simple hand-drawn reference for the profile of our motorcycle. In the left viewport create a plane object. You are going to map the side blueprint I provided onto the plane using the technique outlined in Chapter 7. To be sure your reference is scaled properly, use the Tape helper to check the height of the front wheel. In my example the front wheel is approximately 24 inches tall.
2. In the left viewport, create a TubeCap (scripted primitive mentioned in Chapter 5) with 18 segments, an inner radius of 5.00, and an outer radius of 5.75. This will be used to create the body panels of the bike model. Convert the tube to an Editable Poly object. Figure 8.1 shows the tube with its parameters highlighted.

Figure 8.1 *Tube with 18 segments placed in front of the side blueprint.*

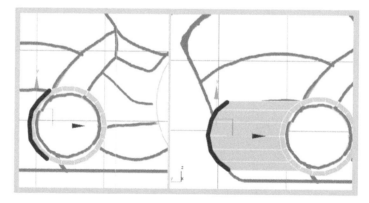

Figure 8.2 *Edge selection (left) and new polygons after performing shift–drag (right).*

3. In Edge subobject mode select the six edges shown in Figure 8.2 (left) and shift–drag them to the left to create a new span of polygons (Figure 8.2, right).
4. Convert the edge selection to a vertex selection, and using the Move tool move the vertices to match the diagonal edge in the provided blueprint. *Tip: Using Alt+X you can toggle*

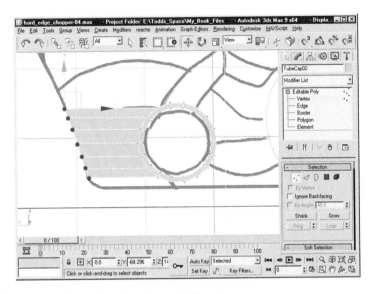

Figure 8.3 *Vertices after using the Move tool to align them to the blueprint.*

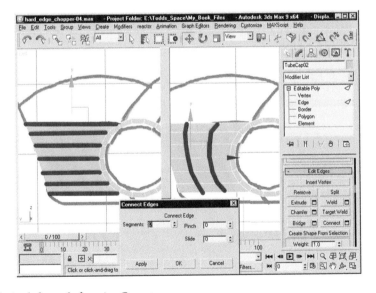

Figure 8.4 *Edge selection before and after using Connect.*

the transparency of the object, which may be helpful for this action. Figure 8.3 shows the result of moving the vertices.

5. Select the seven edges shown in Figure 8.4 (left) and use the Connect settings to create two new rows of edges (Figure 8.4, right).

Figure 8.5 *Mesh flow after moving vertices to match blueprint.*

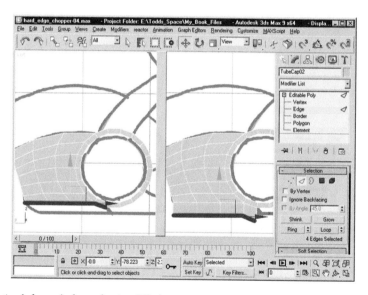

Figure 8.6 *Edge selection before and after performing shift–drag.*

6. Using the Move tool and toggling transparency, move some of the new vertices so they conform to the shape in the underlying blueprint. Figure 8.5 shows the resulting mesh after moving vertices.

7. Select the four edges shown in Figure 8.6 (left) and use shift–drag to create a new row of polygons (Figure 8.6, right).

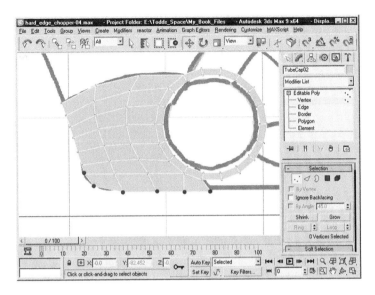

Figure 8.7 *Vertices after using the Move tool to adjust their position.*

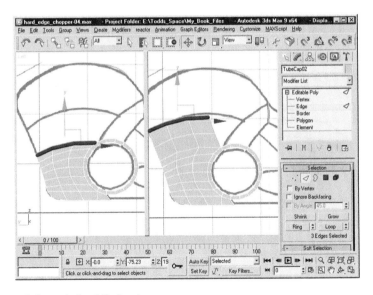

Figure 8.8 *Edge selection before and after shift–dragging.*

8. Using the Move tool and toggling transparency, move the new vertices so they conform to the shape in the underlying blueprint. Figure 8.7 shows the resulting mesh after moving vertices.
9. Select the three edges shown in Figure 8.8 (left) and use shift–drag to create two new rows of polygons that roughly match the blueprints (Figure 8.8, right).

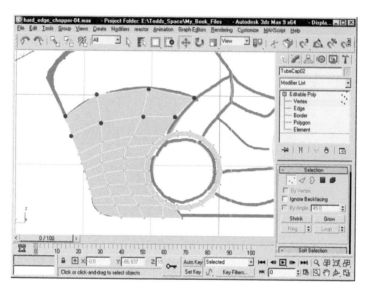

Figure 8.9 *Mesh after moving vertices to match blueprint.*

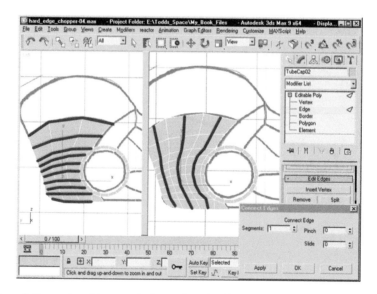

Figure 8.10 *Edge-ring selections and resulting new edge loops after using Connect.*

10. At the Vertex subobject level, move the new vertices created by the last step so they match the blueprint a bit better. Figure 8.9 shows the mesh after moving the vertices to their new locations.

11. At the Edge subobject level, select the three edge rings shown in Figure 8.10 (left) and use Connect settings to create three new edge loops (Figure 8.10, right).

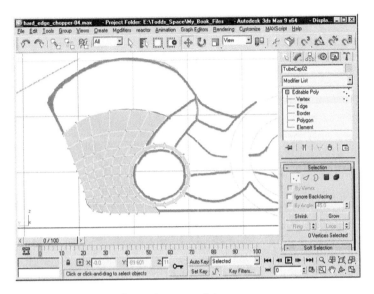

Figure 8.11 *Vertices and edges after adjusting to form a cleaner curved shape.*

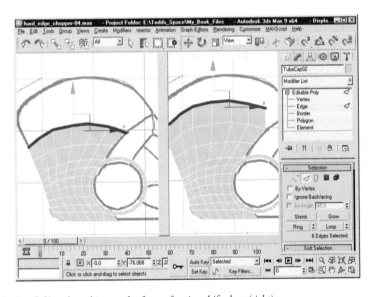

Figure 8.12 *Edge selection (left) and resulting mesh after performing shift–drag (right).*

12. The new edges that were just created will create flat spots when the mesh is subdivided, so adjust the new vertices as seen in Figure 8.11.

13. Select the edges seen in Figure 8.12 and shift–drag them upward to continue building the body work of the bike. The next set of shift–drags will block in the overall shape of the fuel tank.

14. At the Vertex subobject level move the new vertices to better match the shapes seen in the blueprint (Figure 8.13). There is a work-flow pattern developing: shift–dragging to create new edges and polygons, followed by moving subobjects (vertices and edges) to create the desired shapes.

15. Before performing the next shift–drag, add a Bend modifier with a Bend value of 26.5 and check the X radio button to give the mesh a slight curve from front to back. This serves

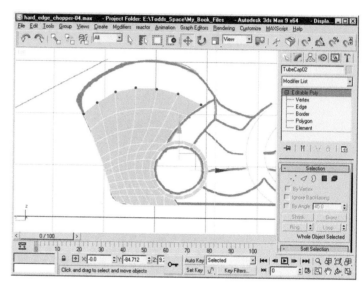

Figure 8.13 *Mesh after moving vertices and edges to create a better mesh flow.*

a couple of purposes: first, it physically makes sense that the bike's body would not be perfectly straight. Second, the slight curve will result in better reflections later on when it comes time to render this model. Figure 8.14 shows the mesh with Bend applied as well as the Bend settings.

16. Select the Bend modifier in the modifier stack, right-click it, and select Collapse To.

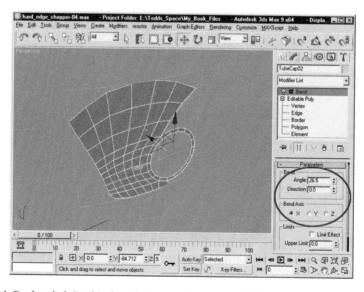

Figure 8.14 *Mesh with Bend applied. Bend is along the X-axis with a value of 26.5.*

17. At the Edge subobject level, select the top row of edges and shift–drag them upward to create a new row of polygons. Figure 8.15 (left) shows the edges after being shift–dragged.

18. Adjust the position of the new vertices to match the blueprints with the same method we have used in all of the stages so far (Figure 8.15, right).

19. With the top row of edges selected, shift–drag them to the approximate location of the top line of the fuel tank in the blueprint. Use the Move tool to position the vertices so they match the line on the blueprint. Figure 8.16 shows the new edges after adjusting the vertex positions.

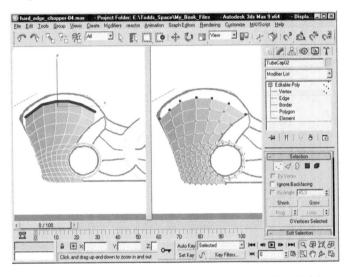

Figure 8.15 *Edges after performing shift–drag (left), and mesh after adjusting vertex positions (right).*

Figure 8.16 *New edges after adjusting vertex position to match reference image.*

20. Select the top two rows of edges, and in the perspective viewport, drag them back to create some depth to the fuel tank. Figure 8.17 shows the edge selection as well as the mesh in various stages.

21. In the top viewport, at the Edge subobject level, select the edges shown in Figure 8.18 (left). Use Make Planar along the Z-axis to create a straight row of edges (Figure 8.18, right).

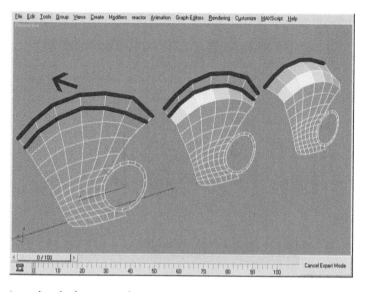

Figure 8.17 *Edge selection and mesh after moving edges to create depth.*

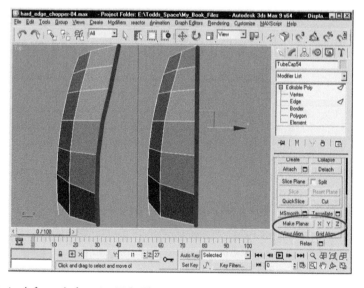

Figure 8.18 *Edge selection before and after using Make Planar.*

22. Still in the top viewport, select the edge ring shown in Figure 8.19 (left) and use Connect to create a new row of edges (Figure 8.19, right).

23. In the perspective viewport, adjust the positions of the new edges that were just created with the Move tool to create a rounder curve to the fuel tank. Figure 8.20 shows the edge position before and after the move.

24. Now that the base of the mesh is pretty well established, let's add a Symmetry modifier. Select the mesh in the perspective viewport and click on the modifier list. Scroll down the

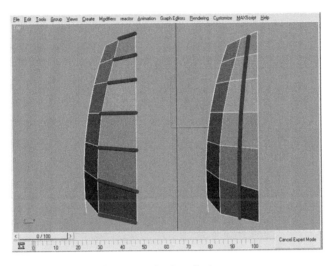

Figure 8.19 *Edge selection and mesh after using Connect on the ring selection.*

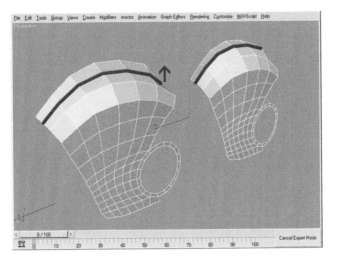

Figure 8.20 *Edge selection before and after moving with the Move tool.*

list and add a Symmetry modifier. Turn off Slice Along Mirror and select Z as the mirror axis. Figure 8.21 shows the mesh in the viewport after adding the Symmetry modifier, as well as the highlighted settings.

25. Click the word "Symmetry" in the modifier stack (it will turn yellow), and adjust the position of the mirror axis in the viewport so that your mesh appears as it does in Figure 8.22.

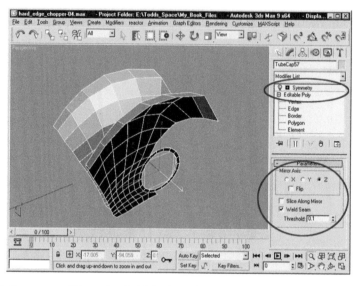

Figure 8.21 *Mesh with Symmetry modifier, settings highlighted in red.*

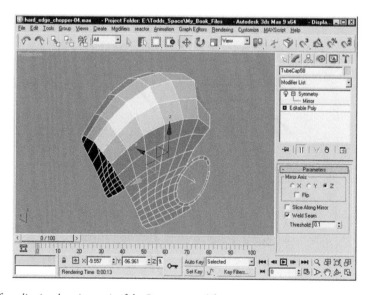

Figure 8.22 *Mesh after adjusting the mirror axis of the Symmetry modifier.*

All changes made to the mesh from this point forward will be reflected on both sides of the object.

26. Select the seven edges seen in Figure 8.23 and use the Chamfer settings dialog box with a value of 0.04 and the Open checkbox checked to create a space and a second row of edges with the same flow (Figure 8.24).

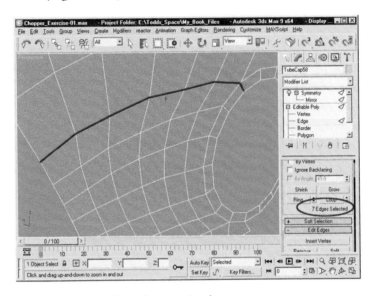

Figure 8.23 *Edge selection and edge selection after performing a chamfer.*

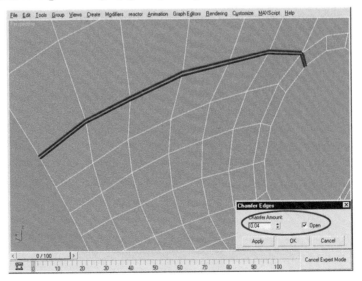

Figure 8.24 *Edge selection after performing an open chamfer with a chamfer amount of 0.04.*

27. The last action created an unwanted "gap" directly above the circular shape we used to start our mesh. The gap needs to be eliminated. Select the vertices seen in Figure 8.25 (left) and use Collapse to remove the gap (Figure 8.25, right).

You are going to want to check the progress of your mesh as it develops, so let's add a couple of modifiers that will help you preview the end result of your modeling.

28. Add a Shell modifier with two segments and an Inner Amount of 0.23.

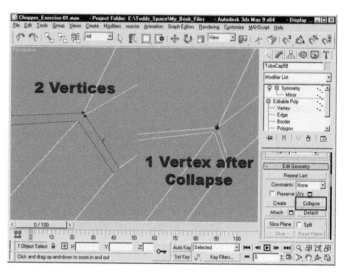

Figure 8.25 *Vertex selection before and after using Collapse. The gap has been eliminated in the mesh on the right.*

29. Add a TurboSmooth modifier, with two iterations. You can toggle both new modifiers from time to time to make sure your model is going to look correct when subdivided.

Repeat the process we just used in steps 26 and 27 to create separate "panel" elements to the mesh. This process will break the single mesh into several pieces that interlock. Just a note, some of the edge selections seen in the screen captures from this point forward may appear to be edge-ring or edge-loop selections, *but* with the gaps that are being added to your mesh, you will need to create multiple ring/loop selections to select all of the edges. Edge-ring/edge-loop selections will not continue across or over areas where polygons have been deleted. I am going to refer to the selections simply as "edge selections."

30. Select the edges shown in Figure 8.26 and use the Chamfer settings

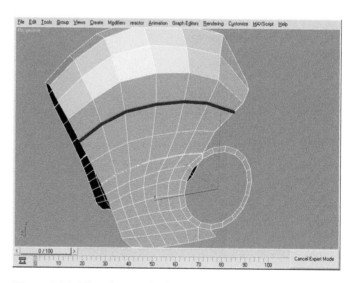

Figure 8.26 *Edge selection to be chamfered.*

dialog box with Open checked and a value of 0.04 to create a gap and another row of edges as seen in Figure 8.27.

31. At the Edge subobject level, select the five edges seen in Figure 8.28 (left) and shift–drag them to form additional polygons that follow the lines of the blueprint image. Figure 8.28 (right) shows the mesh after performing the shift–drag.

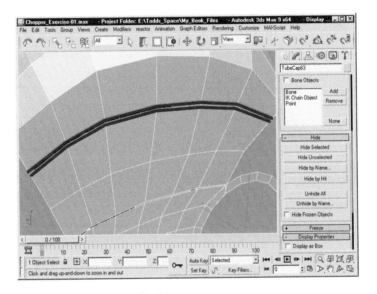

Figure 8.27 *Edge selection after performing an open chamfer.*

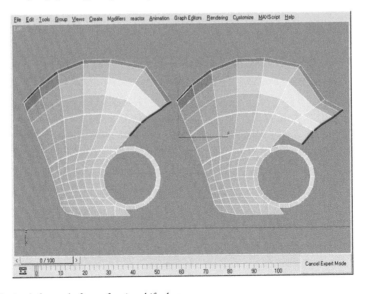

Figure 8.28 *Edge selection before and after performing shift–drag.*

32. Select the edges shown in Figure 8.29 (left) and use the Connect settings dialog box with one segment and a Slide value of −95 to create a new row of edges as seen in Figure 8.29 (right).
33. Select the edges shown in Figure 8.30 and delete them, creating a new gap between the panels in the process. Figure 8.31 shows the mesh after deleting the edges.

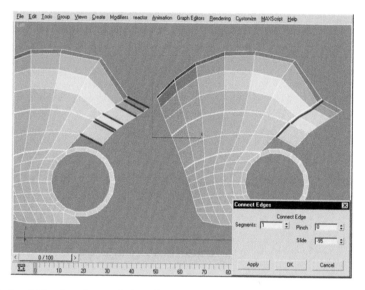

Figure 8.29 *Edge selection (left) and newly created edges after using Connect with settings shown (right).*

Figure 8.30 *Edge selection to be deleted.*

Figure 8.31 *Mesh after deleting the edges shown in Figure 8.30.*

Figure 8.32 *Edge selection and resulting mesh after using Connect settings.*

Figure 8.33 *Edge selection and resulting new polygons after using Bridge on the selection.*

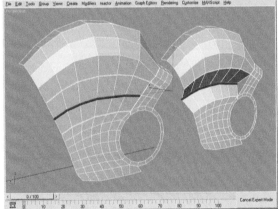

Figure 8.34 *Edge selection before and after moving with the Move tool.*

34. At the Edge subobject level, select the edges shown in Figure 8.32 (left) and use the Connect settings dialog box to create two new rows of edges (Figure 8.32, right).

35. At the Edge subobject level, select the six edges shown in Figure 8.33 (left) and use Bridge to create three new polygons between them as seen in Figure 8.33 (right).

36. At the Edge subobject level, select the row of edges seen in Figure 8.34 (left) and use the Move tool to move them back, creating a "V" shape as seen in Figure 8.34 (right).

37. Select the edge rings shown in Figure 8.35 (left) and use Connect to create two new rows of edges (Figure 8.35, center).

38. With the Move tool selected, move the two rows of edges (positive X-axis) to create a curved shape as seen in Figure 8.35 (right).
39. Select the four edges seen in Figure 8.36 (left) and shift–drag them to create the new polygons seen in Figure 8.36 (right).
40. At the Edge subobject level, select the edge ring seen in Figure 8.37 (left) and use the Connect settings dialog box to create two new rows of edges as seen in Figure 8.37 (right).
41. At the Vertex subobject level, select the eight vertices seen in Figure 8.38 and, using Weld, weld them into four verts (you may need to increase the weld threshold). This step has made a continuous surface out of the two sections we started with (Figure 8.39).

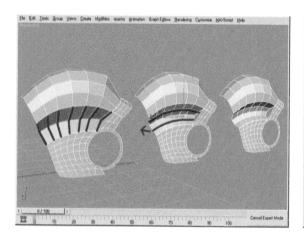

Figure 8.35 *Two edge rings selected, two new rows of edges after using Connect, and resulting mesh after moving the two rows of edges.*

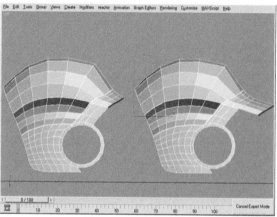

Figure 8.36 *Edge selection and resulting mesh after performing shift–drag.*

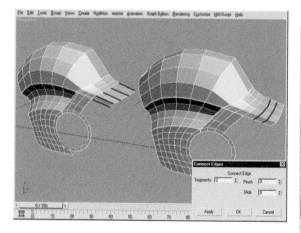

Figure 8.37 *Edge-ring selection and resulting mesh after using Connect with the settings shown.*

Figure 8.38 *Vertex selection. A total of eight vertices are selected.*

42. Select the 22 edges seen in Figure 8.40 (left) and use the Chamfer settings with a Chamfer Amount of 0.16 to create a second set of edges with the same directional flow (Figure 8.40, right).

As a result of the chamfer operation in the last step, the mesh has a newly created Tri N-gon. This is nothing to worry about, in the next step it will be eliminated.

43. At the Edge subobject level, select the edge seen in Figure 8.41 and use Collapse to eliminate it and the Tri (Figure 8.42).

44. Select the 22 edges shown in Figure 8.43 (left) and, using the Move tool, move them back (along the positive X-axis) to create a small recessed area in the tank and seat panel (Figure 8.43, right).

Figure 8.39 *Vertex selection after using Weld. The vertex count is now four, and the surface is continuous.*

Figure 8.40 *Edge selection and resulting mesh after using Chamfer with the settings outlined in step 42.*

Figure 8.41 *Edge selected; the edge is part of a Tri N-gon.*

Figure 8.42 *Mesh after using Collapse on the edge selection.*

I just want to mention that as I model, I make small adjustments to the mesh as I feel they are needed. You should take it upon yourself to do the same if you are not pleased with what you see in the viewport; these are subtle adjustments. As an example, in step 44, I moved the edges back as instructed, but I took it upon myself to lessen the depth as the edges moved toward the back of the tank.

If you haven't been toggling your Shell and TurboSmooth modifiers, this would be a good time to take a look at the progress you have made. With both modifiers active you will

Figure 8.43 *Edge selection and resulting mesh after moving the edges to create an indentation in the tank.*

notice that the mesh is starting to take shape. The shapes should be smooth and flowing … if not, make adjustments. Notice that the corners of the panels are not retaining their sharpness. The corners "round off" owing to the proximity of the vertices. As you recall, we covered this in an earlier chapter. There is no need to worry about this as I will take you through the process of cleaning it up in later steps. Let's get back to modeling!

45. At the Edge subobject level select the edge seen in Figure 8.44 (left) and move it to the location seen in Figure 8.44 (right).
46. At the Edge subobject level, select the two edges seen in Figure 8.45 (left) and use the Connect settings dialog box with one segment and a Slide value of −81 to create a new edge as seen in Figure 8.45 (right).

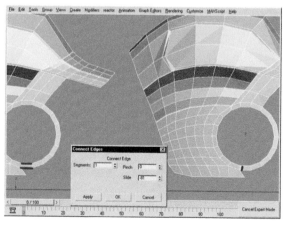

Figure 8.44 *Single edge selected (left) and moved to a new location (right).*

Figure 8.45 *Edge selection and resulting new edge after using Connect.*

47. Select the two edges that were just created (Figure 8.46) and delete them, leaving a new gap in the mesh (Figure 8.46, red highlight).
48. In the top viewport, select the edges seen in Figure 8.47 (left) and use Connect to create the line of new edges seen in Figure 8.47 (right). *Note: I also moved and spaced the edges a little using the Move tool both with and without Edge Constraints active. Edge constraints are covered in Chapter 6.*

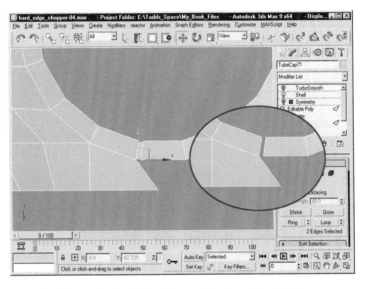

Figure 8.46 *Edge selection and resulting mesh after deleting the two edges shown (in red circle).*

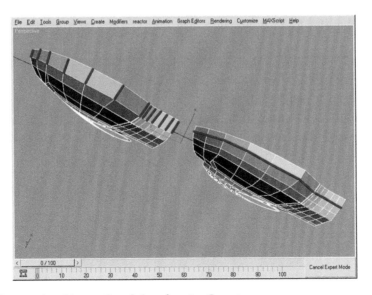

Figure 8.47 *Edge selection and resulting new line of edges after using Connect.*

49. In the top viewport, select the vertices in the seat area (Figure 8.48, left), and with the Move tool move them to create the configuration seen in Figure 8.48 (right). This creates a taper to the seat area.

50. In the perspective viewport, select the edges shown in Figure 8.49 (left) and use the Connect settings box with Segments set to 2 to create two new rows of edges as seen in Figure 8.49 (right). The two additional rows of edges will create a sharper detail when TurboSmooth is turned on.

Figure 8.48 *Vertices to select and move (left) and resulting mesh (right).*

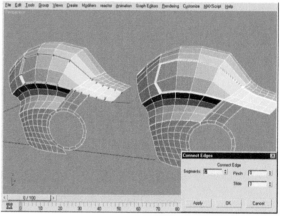

Figure 8.49 *Edge selection and resulting mesh with two new rows of edges added using Connect.*

51. In the left viewport, select the edge seen in Figure 8.50 (left) and use the shift–drag technique to clone the edge six times, following the blueprint image to guide the new geometry (Figure 8.50, right).

52. In the left viewport, select the six edges shown in Figure 8.51 (left) and, using edge constraints along with the Move tool, move them upward to make the polygons you just created thinner (Figure 8.51, right).

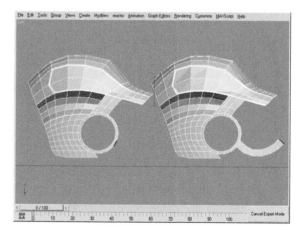

Figure 8.50 *Edge selection (left) and newly created polygons after using shift–drag while following the blueprint (right).*

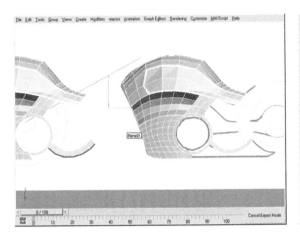

Figure 8.51 *Edge selection (left) and mesh after moving edges to create thinner polygons (right).*

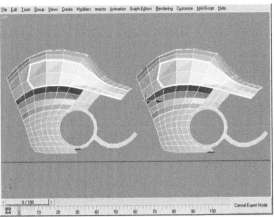

Figure 8.52 *Edge selection (left) and result after shift–dragging the edge (right).*

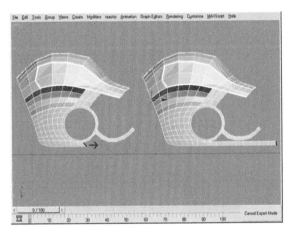

Figure 8.53 *Edge selection (left) and resulting mesh after using shift–drag eight times (right).*

Figure 8.54 *Vertices to be welded using Target Weld (left) and result of welding (right).*

53. In the left viewport, select the edge shown in Figure 8.52 (left) and shift–drag it down to line up with the bottom of the existing mesh (Figure 8.52, right).
54. Select the edge seen in Figure 8.53 (left) and shift–drag it eight times to produce the result seen in Figure 8.53 (right).
55. Select the lower vertex in Figure 8.54 (left) and use Target Weld to weld it to the vertex above it (Figure 8.54, right).

56. At the Edge subobject level, select the edges shown in Figure 8.55 (left) and use Bridge to create new polygons between them (Figure 8.55, right). *Note: You may need to do them in pairs as opposed to all at once to get desirable results.*

57. Select the two edges seen in Figure 8.56 (left) and use the Connect settings dialog box with a Segments setting of 2 to create two new edges (Figure 8.56, right).

58. Select the three edges seen in Figure 8.57 (left) and shift–drag them upward (Figure 8.57, right).

59. With the three edges still selected (Figure 8.58, left), move them so they correspond to the shape seen in the blueprint (Figure 8.58, right).

Figure 8.55 *Edges to be bridged (left) and resulting mesh after performing Bridge (right).*

Figure 8.56 *Edge selection before (left) and after using Connect (right).*

Figure 8.57 *Edge selection (left) and selection after performing shift–drag (right). An additional row of edges has been created.*

Figure 8.58 *Edge selection (left) and mesh after moving edges and vertices to correspond to the blueprint (right).*

60. Select the two vertices in the location highlighted in Figure 8.59 and use Weld to weld them, resulting in one vertex remaining.

61. Select the edges seen in Figure 8.60 (left) and, using the Move tool, move them so that they form an arc in the mesh as seen in Figure 8.60 (right). *Note: Move the edge selections one group at a time for best results.*

Figure 8.59 *Two vertices at this location. Use Weld to weld them into one vertex.*

Figure 8.60 *Edge selection (left) and mesh after using the Move tool to form an arched shape (right).*

62. Select the eight edges seen in Figure 8.61 (left) and use the Move tool to reposition them so they create a curve back (along the positive X-axis) toward the Symmetry axis (center) of the bike (Figure 8.61, right).

Remember that earlier I mentioned that the corners round off owing to the proximity of the vertices when toggling TurboSmooth? Well, in the next series of steps we are going to fix that.

63. Select the edges highlighted in *blue* in Figure 8.62 and use the Chamfer settings dialog box with a Chamfer amount of

Figure 8.61 *Edge selection before (left) and after moving inward to create a curve (right).*

0.16 to create two new rows of edges that flow parallel alongside the original selection.

64. Select the edges highlighted in *orange* in Figure 8.62 and use the Chamfer settings dialog box with a Chamfer amount of 0.16 to create two new rows of edges that flow parallel alongside the original selection.

It is very important to chamfer these edges with two separate operations. Chamfering all at one time would create a different end result—rounded corners. This is fine in some circumstances, but at this point in this exer-

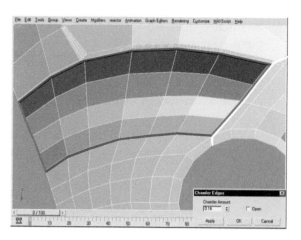

Figure 8.62 *Two separate edge selections highlighted. Use Chamfer on these selections one at a time to achieve the desired result.*

cise sharpening the corners of the mesh is the goal. Figure 8.63 shows the subdivided result of chamfering with two operations (left) and with a single operation for all edges (right).

65. Select the two rows of edges seen in Figure 8.64 and use the Chamfer settings dialog box with a Chamfer amount of 0.16 to create two new rows of edges that flow parallel alongside the original selection. *Note: Whenever chamfering an edge to create crisp corners, use a consistent value, in this exercise 0.16.*

Figure 8.63 *Different end results creating using Chamfer. Left example is chamfering with two separate edge selections (crisp corners). Right is the result with all edges selected and a single operation (rounded corners).*

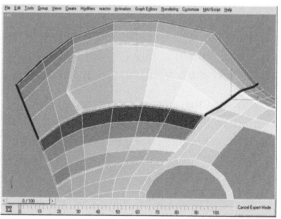

Figure 8.64 *Edge selections to be chamfered with a value of 0.16.*

66. Repeat the process of chamfering with the same value. The next few figures (Figures 8.65–8.67) are going to show edge selections for you to chamfer in groups. The chamfer in Figure 8.67 produced an oddly placed vertex; this needs to be fixed.

67. Figure 8.68 shows a close-up of the vertex before and after moving with the Move tool and Edge Constraints active. This area still needs a little attention; if you toggle the Shell and TurboSmooth modifiers, you will see the corner is not "squared" yet. Let's fix it!

Figure 8.65 *Edge selection to be chamfered.*

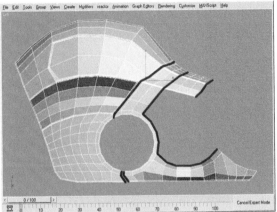

Figure 8.66 *Edge selection to be chamfered.*

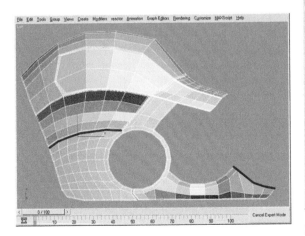

Figure 8.67 *Edge selection to be chamfered.*

Figure 8.68 *Oddly placed vertex before and after moving with Edge Constraints active (red circle).*

68. Using the Cut tool make a cut as illustrated in Figure 8.69 (left). Starting from the bottom of the red dotted line, cut to the vertex and then to the top edge. Figure 8.69 (right) shows the final result. Almost what you want, but not quite there yet.

69. Again using the Cut tool, cut an edge as shown in Figure 8.70 (left) and then delete the diagonal edge highlighted in *yellow* in Figure 8.70 (right) to restore an all-Quad corner. *Note: Some moving of edges and vertices may be required.*

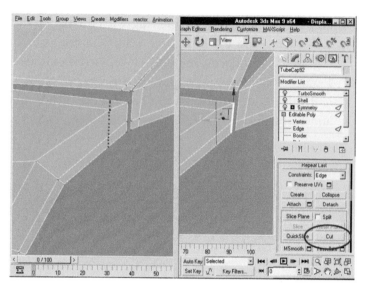

Figure 8.69 *Dotted line illustrates the edge you want to create with the Cut tool. Start at the bottom and work up from there. On the right is the mesh after completing the cut.*

Figure 8.70 *Dotted red line illustrates the cut to be made (left). Yellow dotted line represents the edge to remove (right).*

The process of chamfering the edges in Figures 8.65–8.67 produced three small Tri *N*-gons. In the next step the Tris will be removed.

70. Select the three edges shown in Figure 8.71 and use Collapse to eliminate the edges, as well as the Tris.

Figure 8.71 *Edge selection. Using Collapse eliminates the edges as well as any N-gons in the area.*

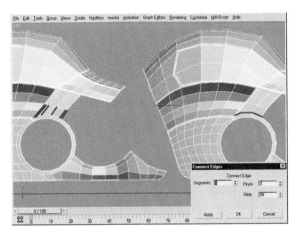

Figure 8.72 *Edge selection and resulting mesh after using the Connect dialog to create a new row of edges.*

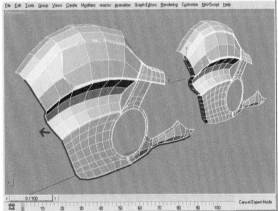

Figure 8.73 *Edge selection and resulting mesh after using the Move tool to reposition the selection. It is important to omit the two edges not highlighted in the image.*

71. Select the edges seen in Figure 8.72 (left) and use the Connect setting dialog box with a Slide value of 88 to create a new row of edges as seen in Figure 8.72 (right).
72. Select the edges seen in Figure 8.73 (left) and, using the Move tool, move them toward the Symmetry axis (center from left to right) to create some depth to the mesh we have created (Figure 8.73, right).

73. Select the two edges seen in Figure 8.74 (left) and use the Move tool to reposition them to the location seen in Figure 8.74 (right). I also did some moving of vertices with Edge Constraints active to make a smoother shape when subdivided.

Figure 8.74 *Edge selection before (left) and after moving with the Move tool (right).*

Toggle on all of the modifiers in the modifier stack. What you should have is a very clean and relatively detailed mesh. You can add as much detail as you like—this is totally up to you. I am going to walk you through the process of adding detail on one area and have you do the rest on your own.

74. Select the edges seen in Figure 8.75 and use the Chamfer settings dialog box with a Chamfer Amount of 0.06 to create a parallel row of edges that follows the same path as the original selection.

75. Step 74 created a Tri *N*-gon toward the back of the selection. Use the technique we used earlier to eliminate it (Collapse Edge).

76. Select the edges seen in Figure 8.76 (top) and move them out away from the body of the mesh to create a "ridge" with a little depth (Figure 8.76, bottom).

77. Select the two rows of edges seen in Figure 8.77 and use the Chamfer settings dialog box with a Chamfer Amount of 0.02 to create two more rows of edges that are in close proximity to the original edge selection.

Figure 8.75 *Edge selection. Use Chamfer settings with a value of 0.06 to create a new row of edges.*

Figure 8.76 *Edge selection before and after moving with the Move tool.*

78. The previous step created a Tri *N*-gon toward the rear of the mesh. Use the Collapse technique we used earlier to eliminate the *N*-gon. Figure 8.78 shows the edge to be collapsed.

Continue detailing this piece of the model on your own. Drawing on the information from this chapter as well as information from the earlier chapters, you should have no problem creating additional detail elements. When you are done detailing the model, click on the Symmetry modifier in the stack, and select the Collapse To option from the

Figure 8.77 *Edge selection. Use the Chamfer settings to create two additional rows of edges.*

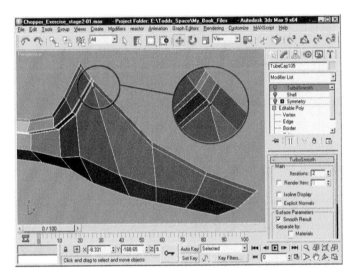

Figure 8.78 *Edge selection to be collapsed. Collapsing the edge restores all Quads to the area.*

menu. Remember Derivative Modeling? Well that technique is going to come in handy for the gas cap and for some of the other elements you are going to create on your own later. I will walk you through adding the gas cap.

1. Select the edges seen in Figure 8.79 (left) and use Connect to create the three new rows of edges seen in Figure 8.79 (right).
2. The additional rows of edges that were just created are going to cause "flat" spots in the model when it is subdivided. Using the Move tool, adjust the positions of the vertices seen

in Figure 8.80 (left) so they match the mesh seen in Figure 8.80 (right). *Note: Toggle your TurboSmooth modifier to check the results as you move the vertices.*

3. Turn on Edge Constraints. At the Edge subobject level, select the edges highlighted in Figure 8.81 (left) and, using the Move tool, move them to the left a bit. Repeat the process by selecting the corresponding edges on the right side of the mesh and moving them right. Figure 8.81 (right) shows the mesh after both sides have been adjusted.

4. At the Vertex subobject level, select the vertex shown in Figure 8.82 (left) and use the Chamfer settings dialog box with a Chamfer Amount of 2.00 to create the new diamond-shaped polygons seen in Figure 8.82 (right).

Figure 8.79 *Edge selection before and after using Connect.*

Figure 8.80 *Vertex selection (left) and mesh after moving selection upward to eliminate flat spots (right).*

Figure 8.81 *Edge selection before (left) and after moving (right).*

Figure 8.82 *Vertex selection (left) and new polygon created by chamfering the vertex (right).*

5. Using the Cut tool, create the new diagonal edges seen in Figure 8.83 (right). The new edges should run from the outer corner to the midpoint of the edges of the polygon you just created. When using the Cut tool your cursor will appear differently when you are over a vertex or edge; you want to try to have your cut go from vertex to edge, so pay close attention to the visual feedback the cursor gives you.

6. In the top viewport, create a new cylinder primitive. Give the cylinder a radius and height of 2.0, and a Sides value of 8. Keep all other segment values at their default, 1.0.

Figure 8.83 *Polygon before and after adding new diagonal edges with the Cut tool.*

7. In the top viewport, align the cylinder with the polygon for the gas cap in the base mesh. Figure 8.84 shows the cylinder aligned to the polygon in the top viewport. I made the cylinder transparent to illustrate the position better. This cylinder is going to be a "guide object" for creating a clean circular detail in the base mesh.

8. If you haven't done so, select the cylinder primitive and make it transparent in the viewport by hitting Alt+X.

9. Select the base mesh, and activate Edge Constraints.

10. In the top viewport, use the Move tool to move the vertices of the gas cap polygon to match the positions of the cylinder guide object. Figure 8.85 shows the base mesh before and after aligning the vertices to the guide object.

Figure 8.84 *Cylinder primitive aligned to gas cap polygon of the base mesh.*

Figure 8.85 *Vertex positions before and after using Move tool to align with the guide object. Edge Constraints must be active for this to work properly.*

11. With Edge Constraints still active, select and move one by one the vertices seen in Figure 8.86 (left) so that they are configured as they are shown in Figure 8.86 (right). This "spacing" of the vertices will give a cleaner result.

12. At the Polygon subobject level, select the polygon shown in Figure 8.87 (left) and use the Inset settings dialog box with an Inset Amount of 0.1 to create the result seen in Figure 8.87 (right).

Figure 8.86 *Vertices before and after moving with Edge Constraints active.*

Figure 8.87 *Polygon selection before and after using Inset.*

13. With the same polygon selected (Figure 8.88, left), use the Extrude settings with an Extrusion Height of −0.1 and Local Normal checked. Before clicking OK to finish the extrusion, click Apply to create a second extrusion with the same amount. Click OK to exit. You should be left with the result seen in Figure 8.88 (right).

14. Again, working on the same polygon, use the Inset settings dialog box with an Inset Amount of 0.1.

15. With the polygon still selected (Figure 8.89, left) shift–drag it upward and select Clone to Object from the pop-up dialog box to create a new mesh that will be the

Figure 8.88 *Polygon selection before and after performing Extrude (×2).*

gas cap of the fuel tank. Figure 8.89 (right) shows the new object floating above the original mesh we used to "derive" the new part from.

16. In the perspective viewport, deselect the original mesh and select the new object (gas cap). At the Polygon subobject level, select the one polygon that makes up the object.

17. With the polygon selected (Figure 8.90, left), use the Inset settings dialog box with an Inset Amount of 0.1 to create new geometry (Figure 8.90, right).

18. Add a Shell modifier with an Inner Amount of 0.18 and three segments to give the gas cap object a bit of thickness. Figure 8.91 shows the gas cap with the Shell modifier settings highlighted.

Figure 8.89 *Polygon before (left) and after shift–dragging to a new object (right).*

Figure 8.90 *Polygon before and after using Inset to create new geometry.*

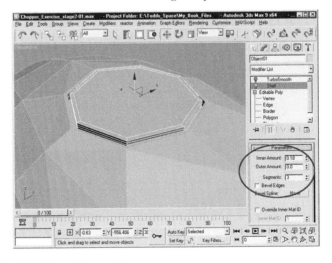

Figure 8.91 *Gas cap object with Shell modifier applied.*

19. Apply a TurboSmooth modifier to the gas cap object with two iterations and toggle on the modifiers of the other mesh to see the end result (Figure 8.92).

Figure 8.92 *Base mesh with gas cap mesh fitting neatly into it.*

Even with the body of the bike complete there is still a bit of work to do. Many of the parts are quite simple; with what you have learned up to this point you should easily be able to create all of the basic parts. Handle bars, grips, front forks, exhaust, and transmission are all basic primitives or lathed/extruded splines with minor additional modeling adjustments. Other parts, like the seat and the trim found at the front of the bike, are created with the Derivative techniques that I covered earlier in the book. Rather than go in depth for each and every part, I am going to skip ahead to modeling one of the more complex parts that remains—the wheels.

The next few images show the basic parts with and without TurboSmooth.

As you can see, none of the parts from Figures 8.93, 8.94, and 8.95 are terribly complex, so let's model those wheels!

Figure 8.93 *Transmission mesh without and with TurboSmooth applied.*

Figure 8.94 *Handle bar components; headlight meshes.*

Modeling the Wheel

1. In the left viewport, create a tube primitive with the following settings:

 - Radius 1: 10.00
 - Radius 2: 9.2
 - Height: 4.5
 - Height Segments: 4
 - Cap Segments: 1
 - Sides: 48

I chose 48 sides because 48 is divisible by 8. Figure 8.96 shows the tube with the settings highlighted.

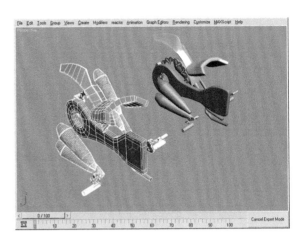

Figure 8.95 *Rear parts without and with TurboSmooth applied.*

When creating a wheel for a car or vehicle, make a mental note of the number of spokes it will have. For this exercise I have chosen to go with an eight-spoke wheel, so my outer ring (rim) and inner ring (hub) will both be divisible by 8.

2. Convert the tube primitive to an Editable Poly object by right-clicking and selecting Convert to Editable Poly from the Quad menu.

3. Select the Move tool. At the bottom of the screen, right-click each of the spinners for

Figure 8.96 *Tube primitive with settings highlighted.*

the X, Y, and Z values to zero them all out. This will put the model at the origin, making it easier to align other parts to it as you model.

4. In the left viewport, create a tube primitive with the following settings:

 - Radius 1: 0.969
 - Radius 2: 2.43
 - Height: 2.25

- Height Segments: 2
- Cap Segments: 1
- Sides: 16

I chose 16 sides because 16 is divisible by 8. Figure 8.97 shows the tube and the settings highlighted.

Figure 8.97 *Tube primitive with settings highlighted.*

5. With the second tube selected, select the Move tool. Go to the bottom of the screen and right-click each of the spinners for the X, Y, and Z values to zero them all out. This will put the model at the origin, centered in the first tube that you created.

6. In the top viewport, use the Align tool and position XYZ, center to center. Figure 8.98 shows the positioned smaller tube.

7. Select the larger tube object.

8. In the Edit Geometry rollout, select the Attach button and click in the viewport

Figure 8.98 *Small tube centered from side to side with larger tube object.*

on the smaller tube object. The two tubes are now one Editable Poly object. Figure 8.99 shows the tubes before and after using Attach.

9. At the Polygon subobject level, select the polygons seen in Figure 8.100 (left). Use Bridge with the default settings to create spokes that span from the outer tube to the inner tube as seen in Figure 8.100 (right). *Note: When selecting the polygons on the inner tube mesh, alternate every other pair of polygons. On the outer tube mesh select two*

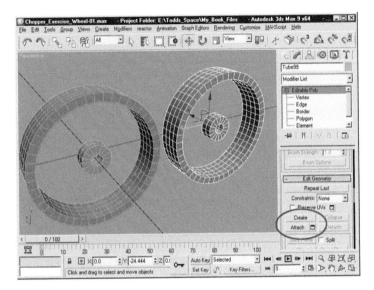

Figure 8.99 *Tube objects before and after using Attach to make them a single Editable Poly object.*

polygons, then skip five rows and select two more polygons. Repeat the process until you have 32 polygons total, 16 on the outside, 16 on the inside. Make a conscious effort to have the inner polygons and outer polygons line up with each other. At first it may be easier to create one spoke at a time.

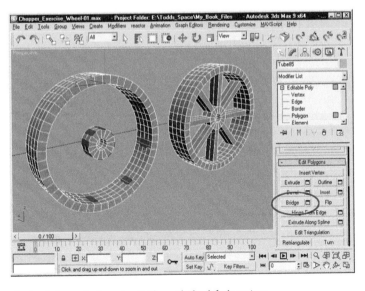

Figure 8.100 *Polygon selection before and after using Bridge with the default settings.*

10. Add a TurboSmooth modifier and toggle it from time to time to see the effect additional steps have on the mesh.

11. At the Edge subobject level, select the edges seen in Figure 8.101 (left) and use the Connect settings with two segments and a Pinch value of 89. Figure 8.101 (right) shows the resulting mesh.

12. Select the edges seen in Figure 8.102 (left) and use the Connect settings with a Segments value of 2 to create the new edges seen in Figure 8.102 (right).

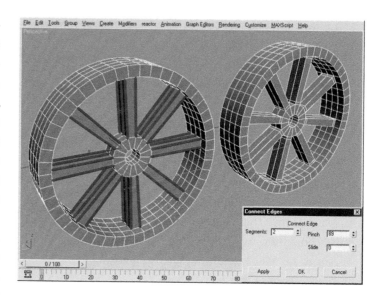

Figure 8.101 *Edge selection and resulting mesh after using the Connect settings to add new edges.*

13. Select the edges seen in Figure 8.103 (left) and use Chamfer with a Chamfer value of 1 to create the result seen in Figure 8.103 (right). One line of edges is now two lines that are placed closer to the front and back of the mesh.

14. At the Edge subobject level, select the edge ring seen in Figure 8.104 (left) and use the Connect settings with one segment and a Slide value of −70 to create a new edge loop as seen in Figure 8.104 (right).

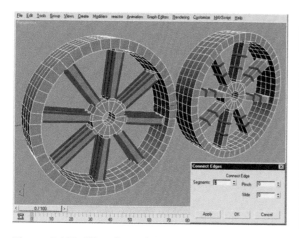

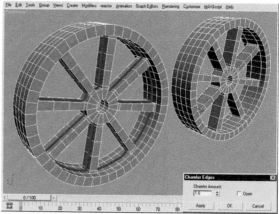

Figure 8.102 *Edge selection before and after using Connect to add two new rows of edges.*

Figure 8.103 *Edge selection before and after using Chamfer.*

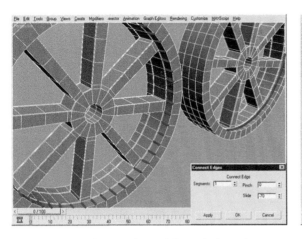

Figure 8.104 *Edge-ring selection before and after performing Connect with a Slide value of −70.*

Figure 8.105 *Edge selection before and after using Chamfer.*

15. Repeat the process from step 14 on the edge ring on the opposite side of the spokes. When using Connect on the selection, the slide value will need to be changed to 70 instead of the −70 value used in the last step.

16. Repeat the process used in step 13 (with the same Chamfer value of 1) on the edge loop in the center of the wheel hub (small opening) (Figure 8.105).

17. At the Polygon subobject level, select the polygons seen

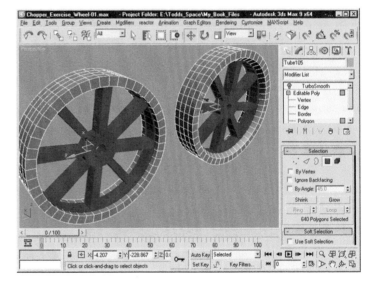

Figure 8.106 *Polygon selection before and after scaling.*

in Figure 8.106 (left) and scale them to 93% using the Scale Transform Type-In. Figure 8.106 (right) shows the resulting mesh after scaling.

18. At the Edge subobject level, select the two edge loops seen in Figure 8.107 (left) and use the Chamfer settings with a Chamfer Amount of 0.05 to create four edge loops as seen in Figure 8.107 (right).

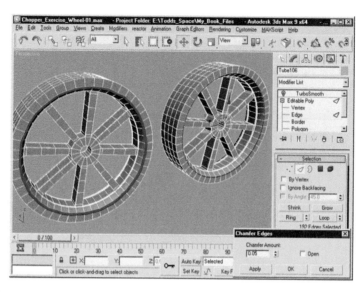

Figure 8.107 *Two edge-loop selections (left) and four edge loops after using Chamfer settings on the selection (right).*

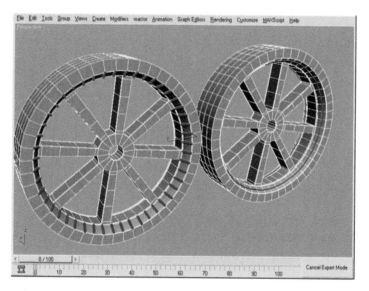

Figure 8.108 *Edge-ring selections and resulting mesh after using Connect to create two new edge loops (one in front of the spokes, and one behind).*

19. Select the edge-ring selection seen in Figure 8.108 (left) and use the Connect settings with one segment and all other values at 0 to create the mesh seen in Figure 8.108 (right). *Note: Although you can't see it in the screen capture, the same edge ring is selected on the other side of the spokes.*

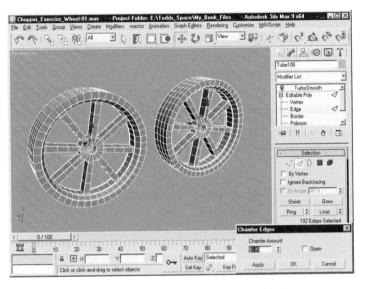

Figure 8.109 *Edge selection before and after using Chamfer to create two additional edge loops.*

20. Select the two new edge loops that were just created (Figure 8.109, left), and using the Chamfer settings dialog box with a Chamfer Amount of 0.05, create new additional edge loops that flow right alongside the original selection (Figure 8.109, right).

21. If they aren't still selected, select the four edge loops you just created (Figure 8.110, left). Use the Scale Transform Type-In and scale the loops to 102% for the result seen in Figure 8.110 (right).

22. In the top or perspective viewport, select the edge loops seen in Figure 8.111 (left) (one side at a time) and use the Move tool along with Edge Constraints to move them out toward the outer edges as seen in Figure 8.111 (right).

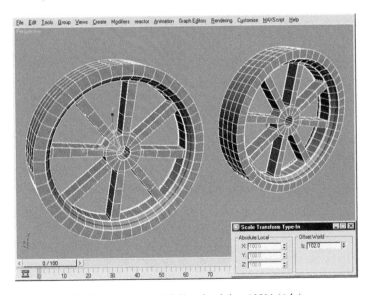

Figure 8.110 *Edge loops selected (left) and scaled to 102% (right).*

159

23. Select the two rows of polygons seen in Figure 8.112 (left) and use the Extrude settings with an Extrusion Height of 0.15 and Local Normal checked to create the result seen in Figure 8.112 (right). *Note: To select the polygons you can make an edge-ring selection and convert it to a polygon selection. See Selections and Conversions in Chapter 3.*

24. Select the two rows of polygons seen in Figure 8.113 and use the Extrude settings with an Extrusion Height of 0.15 and Local Normal checked to create the result seen in Figure 8.113 (right). This extrusion creates a small "lip" on the outer surface of the rim.

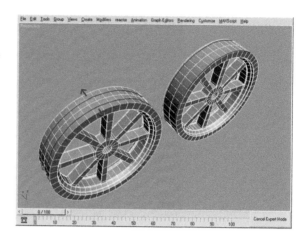

Figure 8.111 *Edge-loop selections (left) and loops after being moved with the Move tool and Edge Constraints (right).*

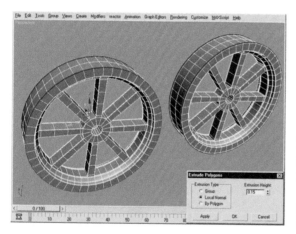

Figure 8.112 *Polygon selection (left) and resulting mesh after extruding the selection (right).*

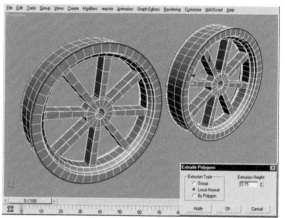

Figure 8.113 *Polygon selection (left, one row is on the backside and not visible) and resulting mesh after using Extrude on the selection (right).*

25. At the Polygon subobject level, select the polygons seen in Figure 8.114 (left) and use the Scale Transform Type-In to scale them to 110% (Figure 8.114, right).

That's it, you have successfully modeled the wheel! I am going to give you a quick overview on how to create a tire profile and lathe it to create the tire; after that you are on your own. I have demonstrated how to create the most difficult elements of the Future Bike; putting

it all together and adding whatever personal touches you like are up to you. You can always refer to the accompanying files which are available for download at http://www.todddaniele.com/FocalPress.htm.

26. In the top viewport, scroll into your wheel.
27. With the Line tool create a line shape similar to that seen in Figure 8.115 (left).
28. Clone the line shape and mirror it. Use Attach to make the two line shapes one.
29. Fuse and weld the center point of the line and convert the vertex to Bezier (Figure 8.115, right).

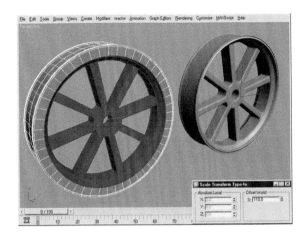

Figure 8.114 *Polygon selection and resulting mesh after scaling the selection.*

30. Lathe the profile using X as the axis, Max as the Align setting, and 64 for the Segments value.
31. Click on the word "Lathe" in your modifier stack (it should be highlighted in yellow), and adjust the position of the axis to create a tire that fits snuggly to the rim. Figure 8.116 shows the modeled result.

For the tread I highly recommend using Render-Time Displacement. You can model the tread, but with today's robust render engines, Render-Time Displacement is the best, most efficient option. See the accompanying files for an example of the tire with displacement.

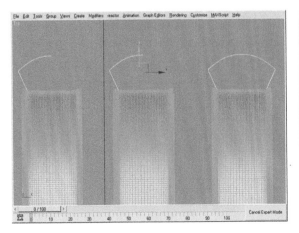

Figure 8.115 *Spline (left), after mirroring and attaching (center), and after Fuse and Weld (right).*

Figure 8.116 *Tire after adjusting the lathe axis.*

Chapter 9

Organic/Soft-Edge Modeling

In this chapter we are going to model an organic form, a Marine Iguana. The techniques we are going to implement can be used to model any organic form, from humans to insects, characters to creatures. As I take you through the process make note of the structure of the mesh and the use of edge loops in critical areas—the areas that would deform when animated. As with any project, you should start by using a search engine to collect reference images that will aid you in the modeling process. Place them in a directory and use ACDSee to look through them as you model. I am including a gray render of a marine iguana as an example of reference.

Let's get started by modeling the head.

Poly-Modeling: Iguana's Head

1. Activate the top viewport, and create a plane object with three length segments and two width segments. Convert the plane to an Editable Poly object. As with the last exercise, remember the importance of proper/realistic scale when modeling. Figure 9.1 shows the plane with its segments and size values highlighted.

Figure 9.1 *Plane object with three length segments and two width segments. The plane is just over 3 inches long and 1.3 inches wide.*

2. Move your edges to create a slight arc shape to your plane as seen in Figure 9.2. You should also adjust the spacing slightly to match the configuration seen in the screen capture.
3. Select the two edges shown in Figure 9.3 (left), and shift–drag them to create the overall shape and placement seen in Figure 9.3 (right).

Figure 9.2 *Edge placement and spacing adjusted to form an arc.*

Figure 9.3 *Edge selection and resulting mesh after shift–dragging the edges.*

4. Add a Symmetry modifier, and uncheck the Slice Along Mirror checkbox (Figure 9.4).

5. If necessary adjust the mirror plane to create a perfectly symmetric end result (Figure 9.5).

6. Select the edge shown in Figure 9.6A (left) and shift–drag it four times to create the shape shown in Figure 9.6A (right). With each shift–drag, adjust the position and rotation of the edges and vertices to form the desired flow of edges. Use Edge Constraints when needed.

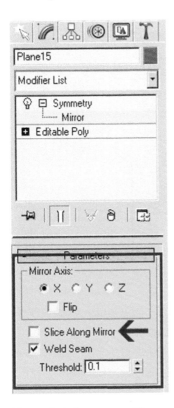

Figure 9.4 *Symmetry modifier with Slice Along Mirror checkbox unchecked.*

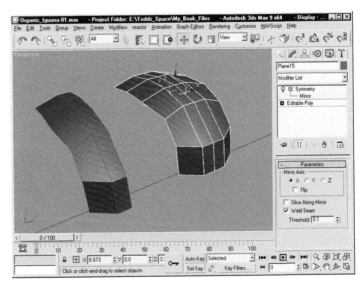

Figure 9.5 *Mesh before and after adding Symmetry modifier.*

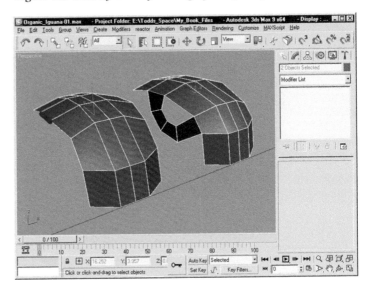

Figure 9.6A *Edge selection and resulting mesh after shift–dragging.*

Edge Constraints were covered earlier in Chapter 6. Figure 9.6B shows a side view with arrows indicating each shift–drag operation.

7. After the last shift–drag, you are left with four vertices that need to be welded to create a single flowing surface. Figure 9.7 shows the verts before and after welding. To weld vertices, simply select them, and click on Weld or the Weld settings button. If Weld alone does not weld them, adjust the Weld Threshold value in the settings dialog box until you get the desired result.

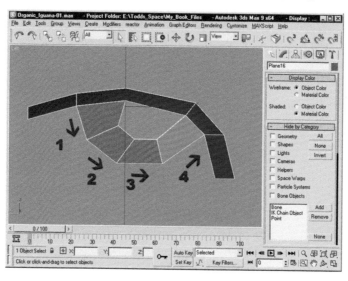

Figure 9.6B *Each arrow represents a shift–drag operation.*

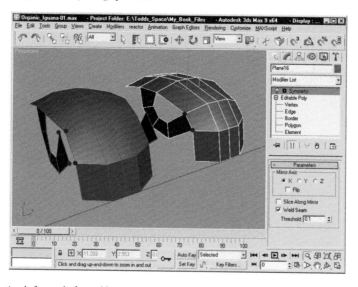

Figure 9.7 *Vertex selection before and after welding.*

8. Select the edges shown in Figure 9.8 (left) and use Connect to create a new row of edges (Figure 9.8, right).

9. Repeat the process in step 8 to create an additional row of edges (Figure 9.9). Adjust the position of the new edges to match the screen capture.

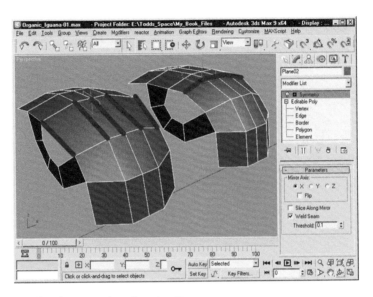

Figure 9.8 *Edge selection and resulting new edges after using Connect.*

Figure 9.9 *Edge selection and resulting new edges after using Connect.*

10. Repeat the process in step 8 to create one more additional row of edges (Figure 9.10). Adjust the position of the new edges to match the screen capture. Moving the edges will create a rounder, more "organic" end result.

11. Go to the Border subobject level, and select the open hole in the mesh (eye opening). Use Chamfer to create a new edge loop (Figure 9.11).

Figure 9.10 *Edge selection and resulting new edges after using Connect.*

Figure 9.11 *Edge selection and resulting new edge loop after using Chamfer.*

12. In step 11 a new edge loop was created, but the Chamfer function also created two new Tri N-gons. To remedy this, select the edges shown in Figure 9.12, and use Collapse to restore an all-Quad mesh.

13. Select the vertices seen in Figure 9.13 and use Connect to create a new edge between them.

Figure 9.12 *Edge selection and resulting loop after using Collapse on the edge selection. The mesh is once again all Quad polygons.*

Figure 9.13 *Vertex selection and resulting new edge (Connect).*

As a result of the last step we have a new diagonal edge, but we also produced two Tris and a five-sided pole vertex in an area where we do not want to have them. We are going to change this! This series of steps may not make sense when you look at the steps one by one, but in the end they will create an all-Quad mesh with dynamic edge flow. The following steps are all shown in Figure 9.14.

14. First select the edge shown in Figure 9.14 (mesh 1). Use the Backspace key to remove the edge. Select the edges shown in mesh 2. Use Connect to create a new edge along the eye border (mesh 3). Use Connect to create the new edge seen in mesh 4 to complete the process.

Step 14 restored some of the Quad polygons in the area, while creating a change in direction of the polygonal flow in the mesh. Step 15 will echo the process on the lower portion of the eye border. The next steps are all shown in Figure 9.15.

15. First select the edge shown in Figure 9.15 (mesh 1). Use the Backspace key to remove the edge. Select the edges shown in mesh 2. Use Connect to create a new edge along the eye border (mesh 3). Use Connect to create the new edge seen in mesh 4 to complete the process.

You can see in Figure 9.15, mesh 4, that what you are left with is a Quad-based mesh, with an angle defining a change of direction in the row of polygons we began with. Steps 14 and 15 show that you are never locked into what you start with. As you get more comfortable with the Poly-Modeling process, you will be able to model without fear; that is when great things will happen.

Figure 9.14 *Step-by-step breakdown of step 14. Mesh progresses from left to right.*

Figure 9.15 *Step-by-step breakdown of step 15. Mesh progresses from left to right.*

16. Select the ring of edges shown in Figure 9.16 (left). Use Connect to create the new row of edges (Figure 9.16, right).

17. It's time to shift–drag some edges. To speed up the process I am going to show you two separate edge selections and the resulting new polygons created when we shift–drag them. Perform a shift–drag on edge selection 1 first (Figure 9.17). Next perform two shift–drags on edge selection 2 to create the new polygons shown.

Figure 9.16 *Edge selection and resulting new edges after using Connect.*

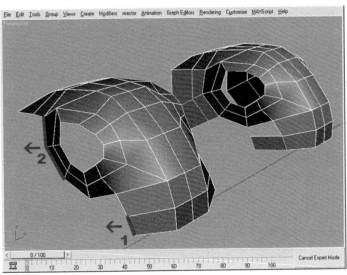

Figure 9.17 *Two separate edge selections and the resulting polygons after performing shift–drag.*

18. Use Weld on the four vertices created in the second shift–drag of the last step. Figure 9.18 shows the verts after using Weld highlighted. *Note: In general you may need to use the Weld settings to access the Weld Threshold value. Depending on the scale of the model and proximity of the vertices, adjustments may need to be made. Also be careful that you don't inadvertently weld unintended vertices by giving the threshold too high of a value.*

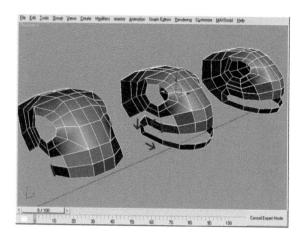

Figure 9.18 *Four-vertex selection welded, resulting in two vertices.*

19. Select the edge seen in Figure 9.19 (left) and shift–drag it seven times to mimic the shape seen in Figure 9.19 (right). As you look at the screen capture, keep in mind that Symmetry is being used, and the last shift–drag operation brings the edge to the mirror axis of the mesh.

20. Select the five edges seen in Figure 9.20 (left) and shift–drag them down to create an additional row of polygons (Figure 9.20, right). I also moved some edges to adjust the shape to my liking; this is based on personal taste, not necessity.

21. Select the edge shown in Figure 9.21 (left) and shift–drag it three times to create the polygons seen in Figure 9.21 (right).

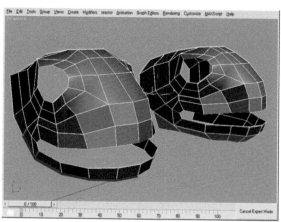

Figure 9.19 *Edge selection and resulting mesh after shift–dragging.*

Figure 9.20 *Edge selection and resulting new polygons after performing shift–drag.*

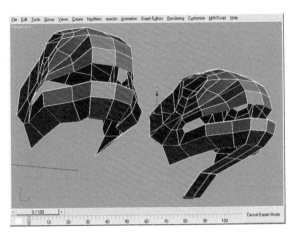

Figure 9.21 *Edge selection and resulting new polygons after performing shift–drag.*

Figure 9.22 *Edge selection and resulting mesh after bridging the selection.*

Figure 9.23 *Border selection (1), shift–dragged inward and scaled down (2), shift–dragged out and scaled down (3).*

Figure 9.24 *Border selection (1), shift–scaled border (2), and shift–dragged border (3).*

22. Using Bridge, fill the gaps between the new polygons we just created and the existing polygons. Figure 9.22 shows the edge selection (six edges) and the bridged result. Note that we create a four-sided Tri.

23. At the Border subobject level, select the eye opening (mesh 1). Shift–drag the border inward to create a recess for the eye socket (mesh 2). Scale the new border to a slightly smaller size. Shift–drag the selected border outward to create the base of the eyelid. Scale this selection down a little as well. Figure 9.23 shows the border selection and the result of the two shift–drag operations.

24. With the border still selected (mesh 1), shift–scale the border selection as seen in Figure 9.24 (mesh 2). Then shift–drag the border selection inward (mesh 3).

25. Select two edge rings as shown in Figure 9.25 (left). Use Connect to create two new rows of edges (Figure 9.25, right).

26. Select the three edges seen in Figure 9.26 (left), and shift–drag them to create three new polygons (Figure 9.26, right).

27. Select the two edges shown in Figure 9.27 (left) and use Bridge to create a new polygon. This polygon is a four-sided triangle (Figure 9.27, center). Select and move the vert seen in Figure 9.27 (right) to create a square polygon.

28. Select the four edges along the top of the mouth opening (Figure 9.28, 1) and drag them down, splitting the distance of the opening in half. Next select the four edges at the

Figure 9.25 *Edge-ring selection and resulting new edges after using Connect.*

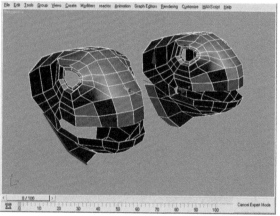

Figure 9.26 *Edge selection and resulting polygons after performing shift–drag.*

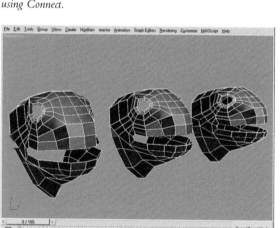

Figure 9.27 *Edge selection (left), new polygon created with Bridge (center), and vertex moved (right).*

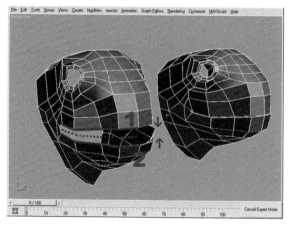

Figure 9.28 *Edge selections and resulting mesh after moving the edges.*

bottom of the opening (Figure 9.28, 2) and move them upward to leave only a small space between the top and the bottom lip (Figure 9.28, right). Remember you can toggle Symmetry on and off to suit your needs.

29. Select the eight edges shown in Figure 9.29 (left) and shift–drag them slightly to the right, making an additional row of polygons that mirrors the edge we just cloned. With the edges still selected move them back a short distance.

30. Select the two edges omitted from the selection in the last step and shift–drag them back. Try to match the approximate distance you moved the edges in the last step (Figure 9.30).

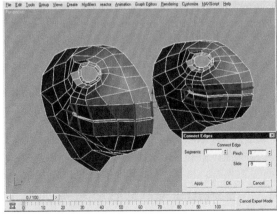

Figure 9.29 *Edge selection and resulting mesh after shift–dragging the edges.*

31. Select the four vertices where the sets of polygons from the last two steps meet and weld them to create a continuous row of polygons.

32. Make an edge-ring selection as seen in Figure 9.31 (left). Using the Connect settings dialog box create a new row of edges as seen in Figure 9.31 (right).

33. Select and move the edges shown in Figure 9.32 to create a curved shape to the lip area.

Figure 9.30 *Edge selection and resulting mesh after shift–dragging the edges.*

Figure 9.31 *Edge-ring selection (left) and new row of edges created with Connect settings shown (right).*

Figure 9.32 *Edge selection (left) and result after moving edges (right).*

Figure 9.33 *Edge selection and result after chamfering the selection.*

34. Select the 12 edges shown in Figure 9.33 (left) and use Chamfer settings to create another row that follows the same path (Figure 9.33, right).

There is a Tri *N*-gon in the mix as a result of the last step. You may have noticed that if you used Loop to make your selection in step 34 it stopped at a five-sided pole vertex. That is where our Tri *N*-gon now sits. This is not a major issue and we will fix it in the next step.

35. Select the edge shown in Figure 9.34 and use Collapse to remove the Tri *N*-gon.

Figure 9.34 *Edge before and after using Collapse.*

I am going to move forward just a little to creating the nostrils; with the steps you've learned so far you should be able to define the jawline and neck by adding rows of edges on your own. All of the other geometry has already been modeled. Some changes were made to the shape of the lip and eyelid by moving existing edges and vertices.

36. Select the two polygons seen in Figure 9.35 (left) and, using the Inset settings dialog box, inset them so they appear as they do in Figure 9.35 (right).

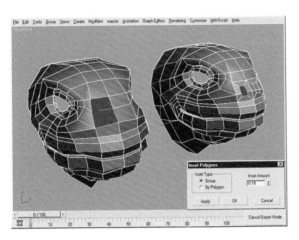

Figure 9.35 *Polygon selection and resulting polygons after performing Inset.*

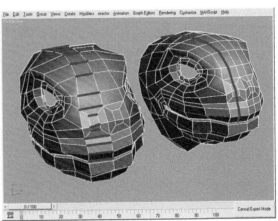

Figure 9.36 *Edge selection and new row of edges resulting from Connect.*

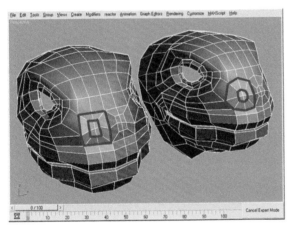

Figure 9.37 *Edge flow before and after moving vertices with Edge Constraints turned on.*

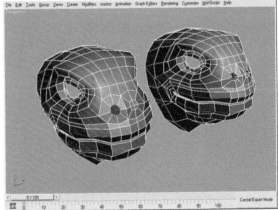

Figure 9.38 *Polygon selection to delete and new border selection after shift–dragging it back into the nostril.*

37. Select the edge ring shown in Figure 9.36 (left) and use Connect to create a new row of edges (Figure 9.36, right).

38. Using Edge Constraints when necessary, move the verts and edges around the nostril to form a more circular flow of edges. Figure 9.37 shows the edge configuration before and after moving verts with Edge Constraints active.

39. Select the polygons seen in Figure 9.38 (left) and delete them. Select the new border created when you deleted the polygons and shift–drag the selection back to give the nostrils some depth (Figure 9.38, right).

40. Select the edges shown in Figure 9.39 (left) and use Chamfer to create an additional edge loop as seen in Figure 9.39 (right).

I am going to conclude the head portion of the exercise here. You can refer to the accompanying file and use the techniques we've used earlier to match the final result. Right now the nostrils are all Quad based, but there are two six-sided pole vertices along the center of the Symmetry axis. I rerouted the edges to remove the poles and opted for some five-sided polygons instead. If you are going to export your

Figure 9.39 *Edge selection before and after chamfering.*

model to an application like ZBrush or Mudbox later on, you may want to retain the all-Quad geometry or perform a few additional steps to restore all Quads with a new edge flow.

Poly-Modeling: Iguana's Body

1. Shift–drag the edges at the back of the neck three times to create the mass of the iguana's body. Adjust the scale and placement of the edges as you clone to create a natural form. Figure 9.40 shows the mesh in several stages.
2. Select the edge ring shown in Figure 9.41 (left) and use Connect to create a new edge loop (Figure 9.41, right). This new geometry will be used to create the area where the front legs branch off of the body.

Figure 9.40 *Base mesh (left), after shift–dragging/moving edge selection (center), and with additional shift–drags performed (right).*

Figure 9.41 *Edge-ring selection and resulting edge loop after using Connect.*

3. Select the four polygons shown in Figure 9.42 (left) and delete them. What you are left with is a square border composed of eight vertices. Move the vertices (one by one) with Edge Constraints to make the opening a circular border (Figure 9.42, right).

4. Select the border and use Chamfer settings to create an additional edge loop as seen in Figure 9.43.

5. The chamfer we just performed created four Tri *N*-gons, so let's fix them. Select the four edges shown in Figure 9.44 (left) and use Collapse to eliminate the triangles (Figure 9.44, right).

Figure 9.42 *Polygon selection to delete and border after moving verts to a circle configuration.*

6. Select the edges shown in Figure 9.45 (left). Activate Soft Selection and adjust the falloff to match Figure 9.45 (right). Use Scale to make the opening and surrounding area (due to Soft Selection) a little larger. This will allow for a little more leg mass when we model the leg.

7. With the selection still active, use Relax once with the default values to soften the area (Figure 9.46).

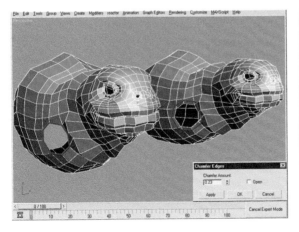

Figure 9.43 *Edge selection before and after chamfering.*

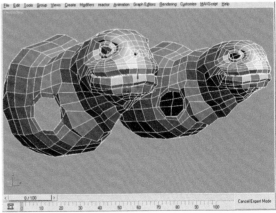

Figure 9.44 *Edges before and after performing Collapse.*

Figure 9.45 *Edge selection (left) and same selection with Soft Selection active (right). The right image is shown after scaling.*

Figure 9.46 *Edge selection after performing Relax with Soft Selection active.*

8. Deactivate Soft Selection, and at the Border subobject level, select the leg opening. Move the border out to begin the process of creating the leg. Scale the border down (smaller) slightly to create a taper (Figure 9.47).

9. With the border selection still active, shift–drag it three times to create more of the upper leg structure. I tend to give a little rotation and scale the edge loops as I model, as I feel it

Figure 9.47 *Border selection before and after moving and scaling.*

Figure 9.48 *Border selection before and after shift–drag (×3). Loops were scaled and rotated during the process.*

gives a more natural appearance. You should also adjust the position of the edges and verts to create the downward slope of the upper leg. Figure 9.48 shows the new polygons created by shift–dragging the border selection.

10. Using the same border selection (Figure 9.49, left), shift–drag the border five times, rotating, positioning, and scaling as you go (Figure 9.49, right).

11. Shift–drag the border selection an additional three times to create the shape seen in Figure 9.50.

Figure 9.49 *Border selection before and after shift–drag (×5). Loops were scaled and rotated during the process.*

Figure 9.50 *Border selection before and after shift–dragging (×3).*

12. Select the three edges seen in Figure 9.51 (left) and shift–drag them forward to establish the top of the foot (Figure 9.51, right).
13. Select the five edges shown in Figure 9.52 (left) and shift–drag them down. Scale the new edges slightly, and move the selection toward the front of the existing foot structure (Figure 9.52, right).
14. Select the three edges shown in Figure 9.53 (left) and shift–drag them downward to roughly the same height/location as the rear edges we created in the previous step (Figure 9.53, right).
15. Select the four verts shown in Figure 9.54 (left) and use Collapse to create a continuous mesh (Figure 9.54, right).

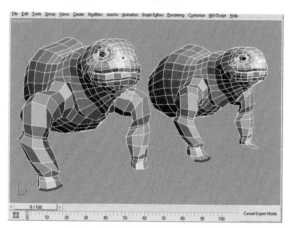

Figure 9.51 *Edge selection before and after shift–drag.*

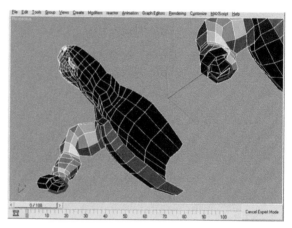

Figure 9.52 *Viewed from below the iguana: edge selection before (left) and after (right) shift–dragging. The selection was also scaled and shifted forward with the Move tool.*

Figure 9.53 *Edge selection before and after performing shift–drag.*

Figure 9.54 *Four vertices selected (left) and resulting vertices (2) after using Collapse.*

16. Select the two edges seen in Figure 9.55 (left) and use the Bridge settings dialog box with a segments value of 2 to create two new polygons that span the space between the selected edges (Figure 9.55, left).

17. Select the edges seen in Figure 9.56 (left) and use the Bridge command to create two new polygons (you will need to do one side at a time for Bridge to work properly; Figure 9.56, center). You are left with two four-sided open borders. At the Border subobject level, select them both and use Cap to fill them. Conveniently, Cap will create two four-sided polygons (Figure 9.56, right).

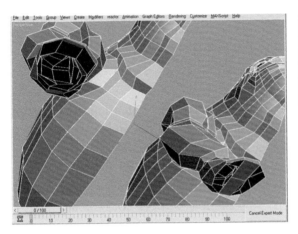 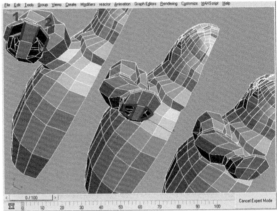

Figure 9.55 *Edge selection (left) and new polygons created using Bridge (right).*

Figure 9.56 *Edge selections (left), after using Bridge (you are left with two open borders; center), and after capping the borders (right).*

18. Select the six polygons that make up the bottom surface of the foot (Figure 9.57, left). Scale them down (smaller), then move them down to give a little more thickness to the foot (Figure 9.57, right).

19. Select the eight edges shown in Figure 9.58 (left) and use Connect to create the new edges seen in Figure 9.58 (right).

20. Using the Cut tool, create the series of edges seen in Figure 9.59 (center). These edges will become direction-changing corners in the next steps and create an all-Quad geometry.

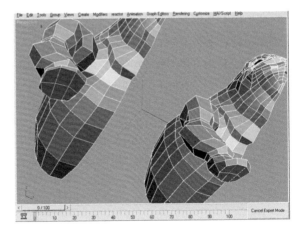

Figure 9.57 *Polygon selection before and after using Scale. Polygons were also moved down to add thickness to the foot.*

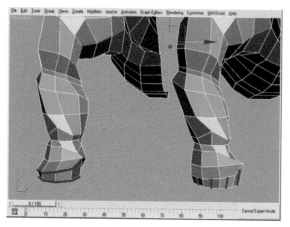

Figure 9.58 *Edge selection and resulting edges after using Connect.*

Figure 9.59 *New edges created using the Cut tool.*

21. *Note: You may want to check the Ignore Back Facing checkbox for this step.* Still using the Cut tool, add the edges highlighted in Figure 9.59 (right). When using Cut the cursor will give you a visual notification when you are over an edge, polygon, or vertex. During this process you do not want to create additional vertices, so pay close attention to the placement of the cursor when you click to cut. I recommend checking all of the newly created vertices when you are finished to make sure there aren't any multiple vertices from the cut process. If there are multiple verts in a given area, simply use Weld to correct the issue.

It is important to repeat the actions in steps 20 and 21 on the bottom side of the foot as well. Remember the goal here is to be left with an all-Quad geometry—if possible. I am leaving this part up to you. Refer to the accompanying file if necessary. I am going to continue on to the creation of the fingers/toes.

22. Now that you have the base foot geometry complete, let's move some vertices to create a rounder profile to the fingers. Figure 9.60 shows the vertex placement before and after moving.

23. Select the two polygons highlighted in Figure 9.61 (left) and use the Extrude settings to create a branch for the first segment of the finger. Select Group for the Extrusion Type, and set the extrusion height accordingly. In my example the distance is just over 1.

Figure 9.60 *Vertices before and after moving with the Move tool.*

Figure 9.61 *Polygon selection and resulting extrusion.*

Figure 9.62 *Polygons in original position (left), moved to new location (center), and after using Extrude (right).*

As a result of using Group for the Extrusion Type, the polygons extrude in a direction that isn't exactly what we wanted. An easy fix; just use the Move tool to relocate the selected polygons to a more natural location. You can also scale and rotate the polygons if you feel it is necessary.

24. Use the Extrude settings dialog box again to create another segment to the finger. Scale the polygons down (smaller) to create a taper effect. Figure 9.62 shows the polygons in their original position (left), after moving (center), and after using Extrude to create another segment of the finger (right).

I am going to demonstrate how to detail a single finger. You can create them all at once or create a single finger/toe that can later be cloned and attached to the foot at the proper locations. This is really up to you; do what makes more sense to your own personal work flow.

25. Select the two polygons seen in Figure 9.63 and use the Bevel settings shown to create the tip area where the claw will grow out of.

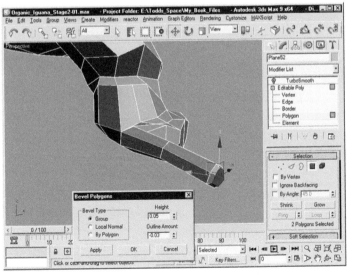

Figure 9.63 *Polygon selection after applying the Bevel settings shown.*

26. With the same polygons selected, use Extrude twice to create the geometry seen in Figure 9.64.

27. With the same two polygons still selected, use Collapse to create the pointy tip seen in Figure 9.65.

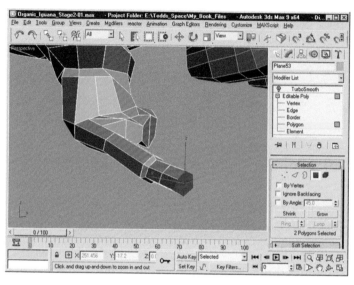

Figure 9.64 *Polygons after extruding twice.*

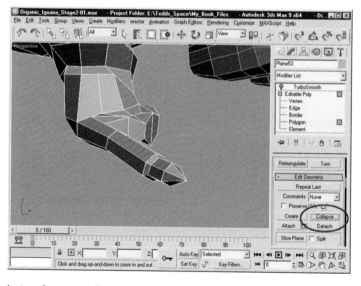

Figure 9.65 *Polygon selection after using Collapse.*

28. Select the edges shown in Figure 9.66 (left) and use the Move tool to move them upward. This move creates a taller profile to the finger (Figure 9.66, right).

29. Select the vertices shown in Figure 9.67 (left) and use the Rotate tool and the Move tool to create a curve to the finger as seen in Figure 9.67 (right).

30. Select the edge ring that makes up the first segment of the finger and use the Connect settings dialog box. Use two segments and a Pinch value of 51 to create two new edge loops as seen in Figure 9.68.

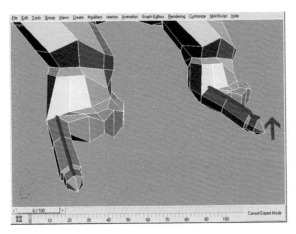

Figure 9.66 *Edge selection before and after moving with the Move tool.*

Figure 9.67 *Vertex selection before and after rotating and moving.*

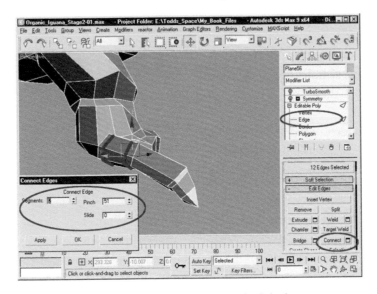

Figure 9.68 *Edge-ring selection after using Connect with the settings seen in the dialog box.*

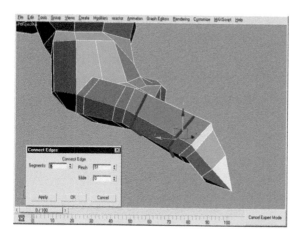

Figure 9.69 *Edge-ring selection after using Connect with the settings seen in the dialog box.*

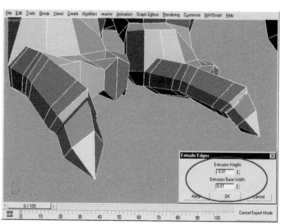

Figure 9.70 *Edge-loop selection (left) and result after using Extrude Edges (right).*

31. Repeat the process outlined in step 30 on the next segment of the finger. Figure 9.69 shows the segment with the Connect settings dialog box and same values from the previous step.

32. Select the edge loop seen in Figure 9.70 (left) and use the Extrude Edges settings with an Extrusion Height of −0.01 and an Extrusion Base Width of 0.01 to create a clean edge where the claw meets the fleshy part of the finger (Figure 9.70, right).

33. All of the geometry needed for the finger is now in place (Figure 9.71, left). Use the Move tool as well as Scale and Rotate to create a more organic shape (Figure 9.71, right).

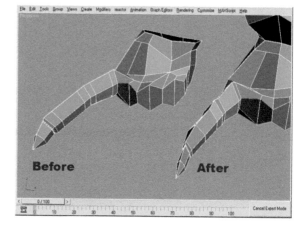

Figure 9.71 *Finger geometry before and after adjusting placement, rotation, and scale.*

In my example, that is the extent of the finger modeling. If you feel you need more detail, feel free to continue working on the area. With the single appendage complete, there is no reason to model the others individually. Cloning this geometry and attaching it to the foot will result in a very useable and aesthetic end result. I am going to demonstrate the process once; it will be up to you to complete the rest of the fingers based on the technique outlined here.

34. Select the two polygons seen in Figure 9.72 and delete them.

35. At the Polygon subobject level, select the 66 polygons that make up the finger (Figure 9.73, left). Use shift–drag to clone the finger (select Element in the dialog box) to a location just forward of the opening in the foot you created in the previous step (Figure 9.73, right).

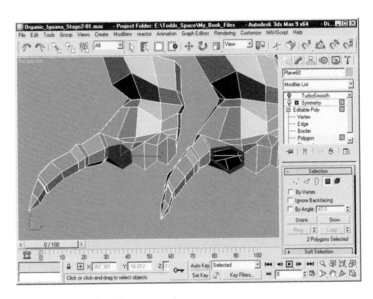

Figure 9.72 *Polygon selection and result after deleting two polygons.*

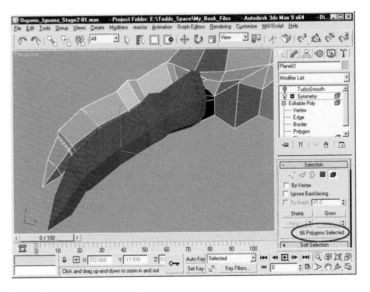

Figure 9.73 *Finger polygons cloned (Element) to new location.*

36. At the Border subobject level, select the two borders highlighted in Figure 9.74 (left) and use Bridge to create new polygons that span the opening (Figure 9.74, right). This results in a new unwanted edge loop.

37. At the Edge subobject level, select the edge ring that composes the new row of polygons (Figure 9.75, left). Use Collapse to eliminate the polygons (Figure 9.75, right).

Figure 9.74 *Border selection and new row of polygons after performing a bridge.*

Figure 9.75 *Edge-ring selection (left) and mesh after collapsing edges (right). A row of polygons has been eliminated.*

Repeat the process for the rest of the fingers. Move, scale, rotate, and modify them as needed to create a natural looking hand/foot. In the end I also used Paint deformation with Push activated to give the fingers more mass. Using this same process of recycling parts of a mesh, I am going to show you how to create the hind legs using the front legs as a base.

38. With the techniques outlined earlier, shift–drag edges at the back of the body to extend the body, shaping it as you go. I am not going to cover this portion step by step as it is the exact process we used at the start of this exercise.

39. Once the body is blocked in, use the technique we used at the beginning of this exercise to create the rear leg opening (steps 3 through 7). Figure 9.76 shows the base mesh and the mesh after extending the body and adding the leg hole.

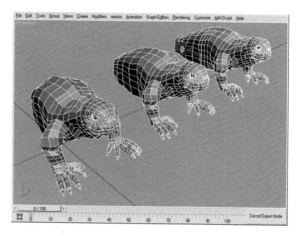

Figure 9.76 *Mesh in various stages. Body has been extended and a leg opening created.*

40. Select the polygons that make up the front leg; be sure you have all of the polygons up to the point at which they meet the iguana's body (Figure 9.77, left). Shift–drag the leg back to the proximity of the rear leg opening created in the previous step (Figure 9.77, right; I recommend selecting Object when cloning this part).

41. With the new leg mesh selected, go to the Hierarchy tab at the top of your modifier stack, and select Pivot. Click the Affect Pivot Only button, then click Center to Object (Figure 9.78).

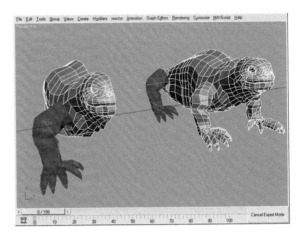

Figure 9.77 *Polygons that compose the leg selected (left) and the newly cloned leg mesh (right).*

Figure 9.78 *New leg mesh with pivot aligned to the center of the leg.*

42. Rotate and move the leg so that it matches a more natural position (refer to the reference images you collected). Figure 9.79 illustrates the leg position in my example before and after rotating and moving.

43. Select the vertices that make up the lower portion of the leg and the foot (you should leave three edge loops in place for the knee area as seen in my example) (Figure 9.80, left).

Figure 9.79 *Leg position before and after rotating.*

Figure 9.80 *Vertex selection (front) and foot after rotating into position (rear).*

Figure 9.81 *Foot before and after moving vertices.*

Figure 9.82 *Edges and verts manipulated to achieve end result (left), viewed from rear of leg.*

Rotate your vertex selection so that the foot is parallel to the ground plane (Figure 9.80, right). I know it looks a little messed up right now, but we are going to move and scale the foot to correct this.

44. Using the Move tool at the Vertex subobject level, move the foot forward to create a more natural looking result (Figure 9.81).

45. Using the Move tool with and without Edge Constraints active, move and rotate edges and vertices to create a more even spacing to the lower leg area (Figure 9.82).

Note: Whenever you are doing this type of adjustment to a mesh or section of a mesh, do not be afraid to use Soft Selection and adjust the settings. This is true for rotating, scaling, and moving subobject elements. The results are often much more natural and predictable, especially with organic models. I constantly use Soft Selection with a bigger radius to adjust proportions on my models as it progresses. Soft Selection is your friend when modeling organics!

46. Select the iguana's body. In the Edit Geometry rollout click Attach, then click on the leg mesh in the viewport (Figure 9.83).

To join the leg to the body we are going to use the same techniques used earlier when attaching the fingers to the hand.

47. At the Border subobject level, select the open leg border on the iguana's body mesh (Figure 9.84, left) and use the Chamfer settings with a Chamfer amount of 0.22 to create an additional edge loop (Figure 9.84, right).

48. As a result of the Chamfer operation there are several Tri N-gons introduced into the mesh. At the Edge subobject level, select the edges seen in Figure 9.85 and use Collapse to eliminate the Tris.

Figure 9.83 *Iguana mesh with leg attached.*

Figure 9.84 *Border selection before and after using Chamfer. Right mesh has an additional edge loop.*

Figure 9.85 *Edge selection to be collapsed. There are four edges, only three are visible in this shot.*

Figure 9.86 *Border selection (two borders; front) and result of bridging the selection (rear).*

49. At the Border subobject level, select the two borders highlighted in Figure 9.86 (left) and use Bridge to create new polygons that span the opening (Figure 9.86, right). This results in a new unwanted row of polygons.

50. At the Edge subobject level, select the edge ring that makes up the unwanted row of polygons (Figure 9.87, left) and use Collapse to eliminate the polygons (Figure 9.87, right).

51. In the modifier stack select the Symmetry modifier, and right-click it. From the drop-down menu, click on Collapse To to create a solid mesh out of the mirrored geometry.

52. Select the border at the back of the iguana's body, and shift–drag it, scaling, rotating, and moving elements to form the tail. I find an "S" curve looks very natural. Figure 9.88 shows the mesh with and without the tail.

Figure 9.87 *Ring selection (left) and mesh after using Collapse on the ring selection (right).*

Figure 9.88 *Border selection (left) and mesh after shift–dragging the tail section (right).*

That concludes this exercise. You can develop the model further if you feel it is necessary. You definitely should put some time into making your model less symmetric; "breaking" symmetry will create a more organic, natural model. Adding wrinkles and changing mesh flow to form muscle structure are steps to consider. Another option to think about is UV Unwrapping and exporting your unsmoothed base mesh to an application such as ZBrush or Mudbox. In a later chapter we will take a look at the process of editing your models in both of these applications. In the next chapter we are going to look at ways to combine the techniques from the previous two chapters.

Chapter 10

Mixing It Up

In this chapter I am going to talk about combining techniques by using elements from both organic and hard-edge modeling to create more natural results. Although the two modeling approaches are quite different, implementing ideas and work-flow elements between them will improve the quality of your models.

With so many products designed by engineers using CAD and other computer software, we are seeing a shift in how products look and feel. Form and function are walking hand in hand. Ergonomics plays a big role, and we have come a long way from the days of "boxy" products. Cars, phones, PC components, and gaming systems are just a few examples that are all likely to possess both organic flowing shapes and hard edges.

On the flip side, when modeling an organic object you may encounter combinations of surfaces as well. There are many animals and insects that are made up of organic surfaces along with hard edges. Turtles, rhinos, and wasps are just a few good examples. Even a human model will benefit from the use of hard-edge techniques; fingernails and toenails are defined using the same chamfering and edge-proximity techniques we use for man-made objects. Let's say you want to add armor to a character. Deriving new meshes from finger, arm or leg segments and adding additional detail using hard-edge techniques are an easy way to do it. Let's give it a try!

Download the accompanying files for this exercise at http://www.todddaniele.com/FocalPress.htm.

Mixing Techniques

1. Open the Mixed_Techniques-01 file. You will be presented with a hand model I made some time ago, as well as other variations of the hand with hard-edged pieces of armor covering the fingers.

2. In the top viewport, select the 70 polygons seen in Figure 10.1.

3. In the perspective viewport, deselect the polygons that compose the lower half of the finger. You should be left with 40 polygons when you are done. You are going to have

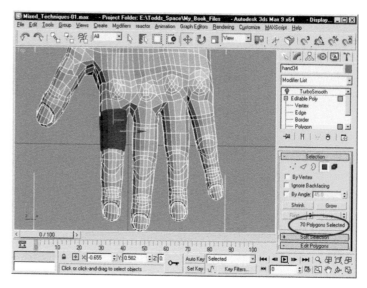

Figure 10.1 *Polygon selection; 70 polygons in total are selected.*

to rotate around the model periodically to deselect the 30 polygons. Figure 10.2 shows the remaining selection in the viewport along with the poly count highlighted.

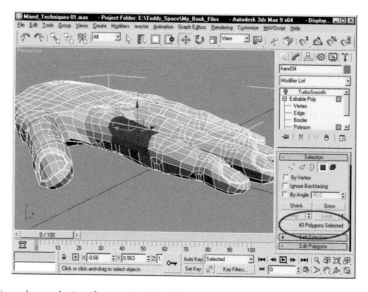

Figure 10.2 *Remaining polygon selection after removing 30 polygons.*

4. Shift–drag the polygon selection up along the Z-axis and select the Clone To Object option. This makes the new group of polygons into a new and separate mesh. This mesh will be the armor for the fingers (Figure 10.3).

5. Exit subobject mode and hide the hand model. Select the object you created by cloning the polygons. At the Vertex subobject level, move the vertex seen in Figure 10.4 (left) so that it creates a more flowing shape (Figure 10.4, right).

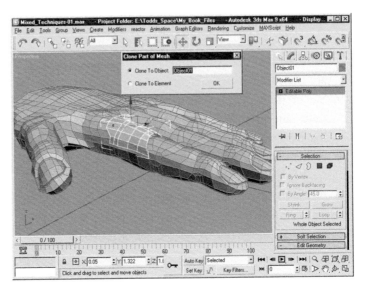

Figure 10.3 *Polygon selection cloned to a new object.*

6. At the Edge subobject level, adjust the spacing of the edges a bit to match (Figure 10.4, right).

7. Select the row of edges that runs down the center of the mesh (Figure 10.5, left) and use the Chamfer settings dialog box with a Chamfer Amount of 0.02 to create a second row of edges that runs parallel to the original selection (Figure 10.5, right).

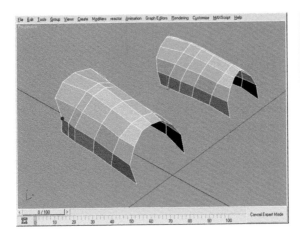

Figure 10.4 *Vertex to be moved (left) and mesh after moving vertex and adjusting edge spacing.*

Figure 10.5 *Edge selection before and after chamfering.*

8. Select the edges seen in Figure 10.6 (left) and use the Chamfer settings dialog box with a Chamfer Amount of 0.08 to create the result seen in Figure 10.6 (right).

9. Select the polygons seen in Figure 10.7 (left) and use the Extrude settings dialog box with an Extrude Height of 0.02 to achieve the result seen in Figure 10.7 (right). *Note: To select the polygons seen in the figure, simply select one edge at the front and one edge at the back and then use Ring or Alt+R to create a ring selection. With*

Figure 10.6 *Edge selection before and after chamfering.*

Figure 10.7 *Polygon selection before and after extruding.*

the edge rings selected, right-click the object in the viewport and select Convert To Face from the Quad menu.

10. Select the four polygons seen in Figure 10.8 (left) and delete them (Figure 10.8, right).

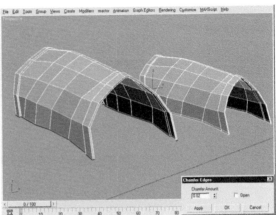

Figure 10.8 *Polygon selection (left) and mesh after deleting polygons (right).*

Figure 10.9 *Edge selection before and after performing Chamfer.*

11. At the Edge subobject level, select the edge loops seen in Figure 10.9 (left) and use the Chamfer settings dialog box with a Chamfer Amount of 0.02 to create the result seen in Figure 10.9 (right).

12. At the Polygon subobject level, select the nine polygons seen in Figure 10.10 (left) and use the Extrude settings with an Extrusion Height of 0.02 to create the result seen in Figure 10.10 (right).

13. Add both a Shell modifier (inner amount 0.02) and a TurboSmooth modifier with

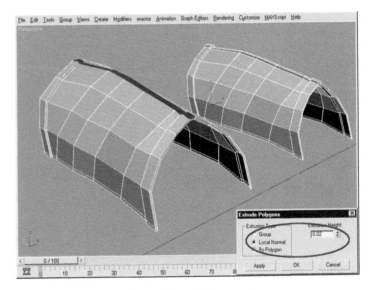

Figure 10.10 *Polygon selection before and after extruding.*

two iterations to the mesh. At any point you can toggle these modifiers on and off to

check the progress of the subdivided mesh. Figure 10.11 shows the modifiers active in the stack as well as the subdivided mesh. It is starting to take shape, but I would prefer to see it a bit sharper, so let's continue.

14. Select the edge rings seen in Figure 10.12 (left) and use the Connect settings with a Slide value of −71 to end up with the result seen in Figure 10.12 (right).

15. At the Edge subobject level, select the edge ring seen in Figure 10.13 (left) and use Connect to create an additional edge loop as seen in Figure 10.13 (right).

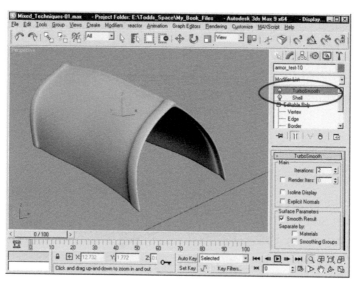

Figure 10.11 *Subdivided mesh and modifiers highlighted in the modifier stack.*

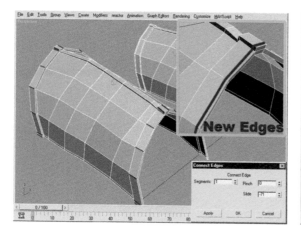

Figure 10.12 *Edge-ring selections and resulting mesh after using Connect.*

Figure 10.13 *Edge-ring selection and resulting mesh after using Connect.*

204

16. Select the edge ring seen in Figure 10.14 (left) and use the Connect settings with a Slide value of −50 to create an additional edge loop (Figure 10.14, center). With Edge Constraints active, adjust the vertex positions as seen in Figure 10.14 (right).

17. Repeat the process from step 16 on the corresponding edges at the front of the mesh. Figure 10.15A shows the edge-ring selection and resulting edge loop after using Connect and adjusting vertex positions.

18. Activate the Shell and TurboSmooth modifiers to see the final result.

Figure 10.14 *Edge-ring selection (left), mesh after using Connect (center), and edge loop after adjusting vertex positions with Edge Constraints active.*

Figure 10.15A *Edge-ring selection and resulting edge loop after using Connect.*

Figure 10.15B *Hand with armor.*

19. Unhide the hand model and clone/scale/rotate the piece of armor to cover all of the fingers.

You're done! While you are at it, take a look at the hand model, particularly the fingernails, another good example of using hard- and soft-modeling techniques in unison (Figure 10.15B).

Softening Hard Edges

Let's discuss and take a brief look at a simple technique that can be used to soften a hard-edged model.

Most hard-edge surfaces have small, rounded corners and edges so that they feel smoother to the touch. This rounded effect is known as a "fillet." A majority of the time a fillet maintains a consistent radius, but there are circumstances in which the radius will change. It is often subtle, but it is a feature that is being used more and more by designers. The change in radius is something that can also be used out of context to make transitions from hard surfaces to soft surfaces.

1. In the top viewport, make a plane primitive with a length of 8.00 and a width of 16.00 units. Give the plane five width segments and two height segments. Figure 10.16 shows the plane in the perspective viewport and the settings highlighted.
2. Convert the plane to an Editable Poly object.

Figure 10.16 *Plane primitive with settings highlighted.*

3. At the Edge subobject level, select the edges seen in Figure 10.17 (left) and shift–drag them twice on the Z-axis to create the result seen in Figure 10.17 (right).
4. With Edge Constraints active at the Vertex subobject level, move the vertices at the top of the mesh seen in Figure 10.18 (left) to the configuration seen in Figure 10.18 (center). Repeat the process with similar spacing on the vertices on the front of the mesh (Figure 10.18, right).

Figure 10.17 *Edge selection before and after using shift–drag two times.*

Figure 10.18 *Vertex selection (left), after moving with Edge Constraints active (center), and repeating on the front facing vertices (right).*

5. Add a Shell modifier with an inner amount of 0.47.
6. Add a TurboSmooth modifier with three iterations.
7. Notice that by varying the proximity of the vertices a variable-radius fillet has been formed. Take note of how the edge goes from a crisp configuration to a softer, rounder configuration. Figure 10.19 shows the final mesh with the variable-radius fillet.

Here are a few images of objects that possess variable-radius fillets (Figures 10.20–10.22).

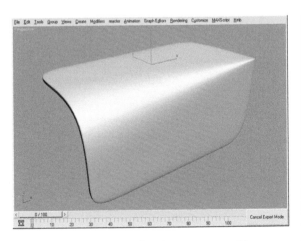

Figure 10.19 *Final mesh after adjusting vertex positions to form a variable-radius fillet.*

Figure 10.20 *Propeller: every other blade has a tighter fillet where it meets the base.*

Figure 10.21 *Hard and soft edges transitioning in a single mesh.*

Figure 10.22 *Organic object transitioning into a hard-edge surface.*

That concludes this chapter. In the next chapter we are going to discuss the use of ZBrush and Mudbox in the modeling work flow.

Chapter 11

Nonmodeled Geometric Detail—Bump and Displacement Mapping

In this chapter I am going to talk a little bit about two applications that are changing the way modelers do their job, ZBrush and Mudbox. These applications are making it possible for artists to model with an incredibly intuitive work flow and with an infinite amount of detail by painting on the model. The basics of these applications can be learned in a day or two; mastering them is more of an artistic endeavor than a technical one. I strongly recommend the use of a Wacom or similar drawing tablet for best results. The Wacom tablet will enable the user to use its pressure-sensitive options when sculpting with either application. Let's get started!

These two applications function in similar fashions, and both do offer time-limited trial versions. To download the ZBrush trial, go to http://www.pixologic.com/zbrush/trial/. To download the Mudbox trial go to http://usa.autodesk.com/ and proceed to the Mudbox section.

Let's look at the user interfaces and tools first (Figures 11.1 and 11.2).

Both applications have different brushes, alphas, and strokes that can be used in endless combinations to create the best brush for each unique situation.

Figure 11.3 shows the brush selections in ZBrush.

Figure 11.4 shows the brush-selection area in Mudbox.

Let's take a look at the alpha options for each application. Alphas are images that determine the shape and texture of the brushes you use when sculpting. Both applications have presets that are included, as well as the ability to import custom alphas created by the user.

Figure 11.1 *The ZBrush user interface.*

Figure 11.2 *The Mudbox user interface.*

Figure 11.3 *Brush-selection rollout in ZBrush.*

Figure 11.4 *Brush-selection area in Mudbox.*

Figure 11.5 shows the Alpha rollout in ZBrush.

Figure 11.6 shows the Stamp section in Mudbox. Stamps in Mudbox do the exact same thing as alphas in ZBrush.

Next up, the stroke options in each application. Figure 11.7 shows the Stroke rollout in ZBrush. Stroke controls the way the brush functions. You can have smooth strokes, scattered strokes, and other variations depending on the settings you select.

Figure 11.5 *Alpha rollout in the ZBrush user interface.*

Figure 11.6 *The Stamp window in Mudbox.*

Figure 11.7 *The Stroke rollout in ZBrush.*

Figure 11.8 shows the Stroke rollout in the Mudbox UI (user interface).

I have shown you enough basic information that you should be able to work with both applications. The best way to learn with either of these applications is to use it. Let's fire up ZBrush first. I am using version 3.1 for this demonstration. If you are using a different version some tools and options may be different; consult the Help files for more information.

ZBrush Basics

Upon launching ZBrush you will receive a "What would you like to do?" screen. The options presented are:

- Load a ZBrush tool
- Import an .OBJ
- Other (Press Esc)

For now let's choose Other so we can run through some simple experiments.

When ZBrush is done loading you are presented with the UI seen back in Figure 11.1.

1. Left-click on one of the tool icons in the Tool menu. A rollout menu featuring 3D meshes as well as 2.5D brushes is presented. Figure 11.9 shows the Tools rollout as well as the icon I clicked to bring up the menu.
2. We are not going to concern ourselves with the 2.5D brushes at this time. If you wish to experiment with them you can always return to them later. In the Startup 3D Meshes section click on

Figure 11.8 *The Stroke rollout in Mudbox.*

Figure 11.9 *The Tools rollout. To bring up this rollout you can click on any of the Tool icons on the right of the ZBrush UI.*

the Plane3D object. Note that the Plane3D thumbnail now appears in the Tool menu at the right of the screen. Figure 11.10 shows the Tool menu with the Plane3D object visible.

3. In the work area of the ZBrush UI, left-click and drag to create a Plane3D object into the viewport. I recommend holding down Shift to constrain the object's orientation. Figure 11.11 shows the Plane3D object in the ZBrush viewport.

Figure 11.10 *Plane3D object visible in the Tool menu.*

Figure 11.11 *Plane3D object created in the viewport using left-click along with Shift to constrain the orientation.*

4. Hit the T key on your keyboard to make the Plane3D object go into Edit mode. You can also click on the Edit button if you can't remember the hot-key (T). *Important: To work on ANY 3D model in ZBrush you need to activate Edit. If you start working on a model without activating Edit, it becomes a 2D element that cannot be moved, rotated, or worked on as a 3D object. Also, if you deactivate Edit at any time the model will become a 2D element, and you will not be able to recover the 3D information.* Figure 11.12 shows the Edit button active. The button turns orange when active.

5. Click on the Make PolyMesh3D button. This ensures that you will be able to sculpt on the model. Figure 11.13 shows the Make PolyMesh3D button in the Tool menu.

Figure 11.13 *The Make PolyMesh3D button.*

Figure 11.12 *The Edit button active. The mesh can now be manipulated as a 3D object.*

6. Hit Ctrl+D on your keyboard three times. Ctrl+D are the hot-keys used to subdivide the mesh in ZBrush. The ActivePoints value has gone from 1089 to 66,049. Basically, the mesh is subdivided to accommodate more detail when sculpting.

7. The fun begins right now! On the left side of the screen, the brush is now active. Set the stroke type to FreeHand. Figure 11.14 shows the brush set to Standard and the stroke set to FreeHand.

8. Hover the brush (shown as two circles) over the Plane3D object in the viewport. There are two red circles. The outer circle is the draw size, and the inner circle is the focal shift. These two circles affect the way the brush will influence the mesh while sculpting. I am not going to give specific numeric values for any of the tools/options I am about to cover. I encourage you to spend a little time using different combinations of values, as well as the various alpha options.

9. Use the square bracket keys ("[" and "]") to adjust the overall size of the brush (just as you would in Adobe Photoshop).

10. If you are using a mouse, left-click and drag on the surface of the mesh to create a freeform shape. If you are using a drawing tablet (highly recommended), use the pen to draw on the mesh. Experiment with different pressures to see the change in the way the brush interacts with the mesh. Figure 11.15 shows the mesh with a few strokes created with the Standard brush and various focal shift values. *Note: When using any brush, hitting the X, Y, or Z key on the keyboard will activate symmetry along the designated axis. Consult the manual for more details.*

Figure 11.14
Brush set to Standard with a FreeHand stroke.

Figure 11.15 *Various strokes created with the Standard brush. Changing the focal shift value changes the overall appearance of the strokes.*

11. With the Standard brush still active, select DragRect as the stroke type. Under Alpha, select Alpha 59. In the viewport, left-click and drag to see the result. As long as the left mouse button is pressed you can alter the direction and scale of the pattern being created on the mesh. Figure 11.16 shows a stroke I created with the options outlined in this step.

Figure 11.16 *Reptile pattern created using the Standard brush with DragRect as the stroke type and Alpha 59 as the alpha.*

Any brush can have its stroke type and alpha type changed. As I mentioned earlier, you can also produce your own alpha images and load them into the Alpha menu for later use. Using the stroke, alpha, and brush adjustments (size, focal shift), you should be well on your way to producing all sorts of effects in just a couple of hours. I suggest going through each rollout one by one, and trying out all of the options. Start with brush, and then move to stroke. After that, move to alpha, making notes of what works well for you. I am going to highlight some of the remaining brushes I use in my work flow.

12. Hit T on the keyboard to exit Edit mode, then hit Ctrl+N to clear the canvas. *Note: This is not something you want to do when working on a real project; I am simply doing this to make the lesson move along quicker.* Again, *do not* exit Edit mode when working on a real project.

13. With the viewport cleared, create a new Plane3D object, and click on T to enter Edit mode.

14. Click on the Make PolyMesh3D button. This ensures that you will be able to sculpt on the model.

15. Hit Ctrl+D on your keyboard three times (subdivide the model).

16. Click on the Brush button, and from the rollout menu select the Clay Tubes brush.

17. For the stroke type select FreeHand.

18. For the alpha select Alpha 28. Figure 11.17 shows the brush, stroke, and alpha options highlighted.

19. If you are using a mouse, right-click on the viewport to bring up a menu with all of the brush attributes: draw size, focal shift, Z intensity, etc. Adjust

Figure 11.17 *Brush, stroke, and alpha options highlighted.*

Focal Shift to 0. Pressing and holding the space bar will bring up the same menu, as will assigning right-click to the button on the stylus of a drawing tablet. Figure 11.18 shows the menu with Focal Shift set to 0.

20. Use the selected brush to draw some shapes on the Plane3D object. Figure 11.19 shows the plane with some strokes created with the Clay Tubes brush.

Figure 11.18 *Focal Shift set to 0.*

Figure 11.19 *Plane3D with strokes drawn using the Clay Tubes brush and Alpha 28.*

21. With the brush still active, press Shift to toggle the Clay Tubes brush to the Smooth brush. The two red circles turn blue to indicate that the Smooth brush is active. With Shift held down, make some strokes over the existing strokes to smooth them. By default all brushes have Smooth set to toggle when the Shift key is pressed and held. You can change the toggle to any brush you like; refer to the manual for further information. Figure 11.20 shows the mesh after smoothing. Note that the circles are blue, and the Brush icon is indicating the Smooth brush is active.

Figure 11.20 *Smooth used on the Clay Tubes strokes to soften them. Note the blue circles indicating Smooth is active.*

Using Clay Tubes and Smooth is a great way to block in the mass of a figure model in ZBrush.

Standard is a great brush for adding soft organic details, as we have seen so far. Let's give another brush called Layer a try. Clear the viewport and create a new Plane3D object using the process outlined earlier. Use Make PolyMesh3D and subdivide as before.

22. Select the Layer brush from the Brush rollout. Select FreeHand as the stroke and Alpha 06 as the alpha. Draw some strokes on the Plane3D object. Figure 11.21 shows the Plane3D object with strokes created with the Layer brush.

Figure 11.21 *Plane3D mesh with strokes created with the Layer brush and Alpha 06.*

You may notice that the Plane3D object is rotated in the viewport. I am going to cover manipulating objects in the viewport quickly.

- Holding down Alt+left mouse button while clicking in an area outside of the mesh (black/gradient viewport areas) will let you pan the mesh up and down and side to side in the viewport.
- Holding down Alt+left mouse button and then releasing the Alt button while keeping the left mouse button pressed will allow zooming in and out as you move the mouse. Again, clicking in an area that is not covered by the mesh is required.
- Clicking in a background area and dragging the mouse will rotate the model in the viewport. The direction of rotation depends on the direction in which the mouse is moved.

23. Back to the Layer brush. As mentioned earlier, holding Shift toggles the Smooth brush, so give it a try—smooth the new strokes created with the Layer brush. Figure 11.22 shows the object after using Smooth on the strokes created with the Layer brush.

Figure 11.22 *Strokes after using Smooth to soften them.*

Figure 11.23 shows samples of the Rake, Flatten, and Pinch brushes. Experiment with the different brushes, strokes, and alphas on your own. Trial and error is the best teacher for this type of application. Rake is an example of a textured brush; the stripes in the stroke are created by the alpha.

After you've completed your experiments with the basic brush, alpha, and stroke functions, you can pick up here. I am going to demonstrate how masks work in ZBrush next.

Figure 11.23 *Rake, Flatten, and Pinch brush stroke examples.*

1. Create a new ZBrush document by going to Document/New Document.
2. Select Sphere3D from the Tool menu.
3. Left-click and create a Sphere3D object in the viewport. Figure 11.24 shows Sphere3D displayed in the Tool menu as well as created in the viewport.
4. Hit the T button on your keyboard to go into Edit mode.
5. Click on the Make Poly-Mesh3D button. This ensures that you will be able to sculpt on the model.

Figure 11.24 *Sphere3D displayed in Tool menu and created in the work area.*

6. Hit Ctrl+D on your keyboard three times (subdivide the model).
7. Set the brush type to Standard, and the stroke type to FreeHand.
8. Hold down the Ctrl key on your keyboard with the brush hovering over the work area. The two red circles turn yellow, and the word "Mask" appears inside them.
9. With the Ctrl key held down, draw a stroke on the Sphere3D object. You are presented with a darker area on the mesh indicating that the area has been masked. Figure 11.25 shows the Sphere3D object with a masked area.
10. Once the mask has been created, let go of the Ctrl key. Now with the Standard brush, and FreeHand as the stroke type, paint strokes on the mesh to see the effect of the mask on the

Figure 11.25 *Sphere with a mask applied. The mask is the darker area. Note that the brush circles are yellow when creating a mask.*

sculpting process. Figure 11.26 shows the result of painting on the mesh with the area masked.

When masking you can invert a mask by holding the Ctrl key and clicking in an open area of the viewport. Figure 11.27 shows the mesh with strokes created when the mask is inverted.

I am going to conclude the overview of ZBrush basics here. There are other masking options and an abundance of other tools in ZBrush. For more information consult the manual. I will return to ZBrush a little later on in this chapter to give an overview of importing and exporting 3ds Max models as well as displacement map creation and export.

Let's take a quick look at Mudbox. I am going to cover much of the same information covered in the ZBrush section to show the similarities in the two applications. They are both very powerful, and you can't go wrong by purchasing either of these two programs.

Figure 11.26 *Mesh with strokes painted on and area masked.*

Figure 11.27 *Mesh after sculpting with the mask inverted.*

Mudbox Basics

Launch Mudbox. You will be presented with the UI seen at the beginning of this chapter. The UI is more traditional than that of ZBrush, which is a big plus when you are first learning the application.

1. Go to the Create menu, and click Create/Mesh/Sphere. A sphere is placed in the viewport. Figure 11.28 shows the menu rollouts and the sphere in the viewport.

2. On the keyboard press Shift+D three times to subdivide the mesh.
3. In the My Tools window at the bottom of the screen select the Soft brush. The brush-selection menu was seen earlier in this chapter—Figure 11.4.
4. By default Mirror is active. Click on the Mirror drop-down menu under the Properties tab on the right of the UI and turn off Mirror. Figure 11.29 shows the menu highlighted.

Figure 11.28 *Create menu rollouts, as well as the Sphere mesh in the viewport.*

Figure 11.29 *Properties tab and the Mirror drop-down menu. Select Off from the options in the drop-down.*

As with ZBrush, you can change the size of the brush with the square bracket keys ("[" and "]"), just as you can in Photoshop.

5. With your mouse or tablet and pen, draw a stroke on the sphere mesh in the viewport. Adjusting falloff is equivalent to adjusting focal shift in ZBrush. Falloff options are found at the bottom of the screen. In Mudbox, you have the ability to create custom falloff curves in the Falloff rollout found on the right side of the screen. Figure 11.30 shows the Sculpted brush stroke on the mesh as well as the Falloff menu and Falloff rollout.

6. With the Soft brush still active, hold down the Shift key on the keyboard, and use the brush to smooth the strokes created with the Soft brush. Shift toggles the Smooth brush in Mudbox. This should be easy to remember, the same functionality and key combination are used in ZBrush. Figure 11.31 shows the stroke after using Shift to toggle the Smooth brush and smoothing the strokes.

Figure 11.30 *Mesh with stroke created with the Soft brush and default falloff. Falloff menu and rollout are highlighted in orange.*

Figure 11.31 *Stroke is smoother after toggling the Smooth brush by using Shift and the Soft brush.*

I am going to cover manipulating objects in the viewport briefly.

- Holding down Alt+left mouse button while clicking in an area outside of the mesh will enable you to orbit around in the viewport.

- Holding down Alt+middle mouse button enables you to pan the mesh side to side and up and down. Again, clicking in an area that is not covered by the mesh is necessary.

- Holding down Alt+right mouse button enables you to zoom in and out.

7. Using the Stamp options will create texture when you sculpt. At the bottom of the screen, click on the Stamp tab and activate one of the Stamp images by clicking on it. Paint a stroke on the mesh to see the results. Figure 11.32 shows the result of using Stamp when sculpting.

Figure 11.32 *Mesh after applying a stroke with a Stamp image selected.*

8. On the right side of the UI is a Layers tab. Click on it to display a Layer Manager similar to those found in any imaging software package. Click on the small circular button with an arrow in it to bring up a drop-down menu. Select New Layer from the options listed.

9. In Mudbox, creating a new layer lets the user work with some powerful masking options. Click the Value Paint

Figure 11.33 *The Layers tab and the drop-down menu, as well as the Value Paint Tools menu with Mask selected.*

Tools tab. By default you are presented with Freeze, Mask, and Erase. Click on Mask to select it. Figure 11.33 shows the Layers tab and the drop-down menu as well as the Value Paint Tools menu with Mask selected.

10. Click on the new layer in the Layer Manager. With the Mask brush selected, paint a mask onto the sphere mesh. Figure 11.34 shows the mesh with a mask painted on it. The mask is shown in red by default.

11. In the My Tools menu, select the Soft brush again. Sculpt on the mesh to see the effects of using a mask. Figure 11.35 shows the resulting mesh after sculpting with the mask in place.

Figure 11.34 *Mesh with a mask painted on it.*

I am going to conclude the overview of Mudbox basics here. There are plenty of other tools to explore in Mudbox; for more information consult the manual.

Now that you have a grasp of the basic functions of both applications, let's talk about implementing them into your work flow. Before you can sculpt on any 3ds Max model using either application, there are several steps that need to be taken into account:

Figure 11.35 *Mesh with Mask active and additional sculpting.*

- Keep in mind that both ZBrush and Mudbox work best with Quad-based meshes. Meshes with Tris or *N*-gons may also work fine. I recommend reading the manuals and doing extensive experimentation before incorporating *N*-gons of any sort into the work flow of either application. Also keep in mind that depending on the final usage, the base mesh you create in 3ds Max does not need to be overly detailed or high in polygon count.

- Your base mesh created in 3ds Max needs to be completely UV Unwrapped. Eliminate overlapping faces and try to have your polygons consistently sized in the UV editor.

Unwrapping your model is essential if you plan on using the displacement maps created in either application back in 3ds Max. UV Unwrapping can be a complicated process. I am not going to cover UV Unwrapping for this exercise. Consult the 3ds Max manual and included tutorials for more information about UV Unwrapping.

Figure 11.36 OBJ export settings in 3ds Max.

- Once you have your base mesh completely modeled and unwrapped, it will have to be exported. Export the mesh as a wavefront .obj file using the settings seen in Figure 11.36. *Note: There is another Import/ Export option that works nicely with both Max and ZBrush created by Guruware called gw::ObjIO. gw::ObjIO can be found at http://www. guruware.at/main/. Follow the instructions for usage and installation.*

I am going to take you through the process of importing and sculpting your models as well as creating displacement maps for use back in 3ds Max. I will be using ZBrush in this exercise as I am more familiar with the ZBrush work flow. The support files for this and all of the exercises in this book can be downloaded at http://www.todddaniele.com/FocalPress.htm.

At this point you have modeled and UV Unwrapped your base mesh in 3ds Max and exported it with the settings seen in Figure 11.36.

Figure 11.37 shows the base mesh as well as the UV Unwrap window. When unwrapping for use in Mudbox or ZBrush, be sure all of the unwrapped elements are located within the thicker grid lines of the UV Unwrap window. The bold lines designate the boundaries of the texture map. *Note: I have gone back and edited the model to produce all Quads and a slightly lower polygon count.*

3ds Max to ZBrush

1. Launch ZBrush. From the "What would you like to do?" screen, choose Import

Figure 11.37 Our old friend the iguana, and the Edit UVWs window with the unwrapped elements.

an .OBJ and select the Quad_Iguana_Sculpt_Base-01.obj file from the accompanying Zip files you downloaded.

2. Be sure Edit is active before subdividing and sculpting.

3. Use the Ctrl+D keys on the keyboard to subdivide the model. I have a powerful workstation, so I divided the model to 2804 million active points (subdivision level 7). Depending on the configuration of your hardware you may need to use fewer subdivisions. Figure 11.38 shows the subdivided mesh in the viewport, as

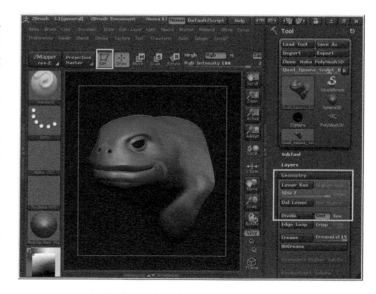

Figure 11.38 *Subdivided mesh in the viewport. Edit is active, and the subdivision level is 7.*

well as the active Edit icon and the Geometry rollout displaying the subdivision level.

4. Sculpt the mesh with various brushes, alphas, and strokes as outlined at the beginning of this chapter. I recommend using masks as well. Figure 11.39 shows the mesh after a brief sculpting session.

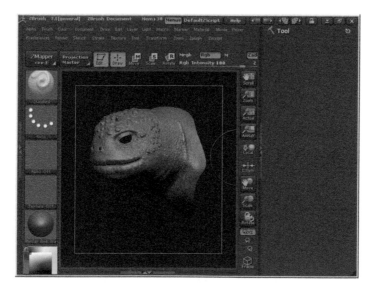

Figure 11.39 *Mesh after being sculpted. This mesh will be used to generate a displacement map.*

5. In the Geometry rollout you will see the words "SDiv 7" with an orange slider button below them. Click and drag the slider down to the lowest SDiv level (1). Your mesh will appear as it did when first imported from 3ds Max. Don't worry; all of the sculpting information is still stored at the higher subdivision levels. Dropping the SDiv level to 1 is necessary for both mesh export and displacement map creation. Figure 11.40 shows the SDiv level set back to 1 and the mesh as it appears; notice that the detail is not present.

Figure 11.40 *SDiv level set to 1, and mesh displayed at SDiv level 1. Note that the SDiv level 7 detail is not being displayed.*

6. The ZBrush mesh must be exported. It will be imported back into 3ds Max as an .obj model to ensure exact vertex count. Under the Tool rollout, click on the word "Export." You will be presented with an Export Mesh dialog box. Name the mesh something descriptive and save it as an .obj file to the desired target directory. Figure 11.41 shows the Export button and the Export Mesh dialog box.

7. With the mesh exported it is time to generate a displacement map. At the top of the ZBrush UI there are menu lists with rollouts. Click on the Zplugin menu and a rollout appears. Click on the circular icon to dock the

Figure 11.41 *Export button and dialog box.*

Zplugin rollout on the right side of the screen. Figure 11.42 shows the Zplugin menu highlighted in blue as well as the Docking icon circled in red.

8. With the Zplugin rollout docked (right) click on the words "MULTI DISPLACEMENT 3" (MD3) to expand the rollout. Figure 11.43 shows the MD3 rollout (blue) and the MD3 settings area (red).

Figure 11.42 *Zplugin rollout (blue) and Docking icon (red).*

9. Click on the GetMeshInfo button. If your UVs in Max were located within the thicker grid lines of the UV Unwrap window, the ZBrush GetMeshInfo dialog box will list one tile (Figure 11.44). This step is just a check to be sure there is only one tile.

Figure 11.43 *MD3 rollout (blue) and settings area (red).*

10. Adjust the MD3 settings as follows:

- UDim: 0
- InitialFileIndex: 1001
- MaxMapSize: 2048 (larger maps produce better results but take longer to create; input the desired resolution of the displacement map)
- MapSizeAdjust: 0
- DpSubPix: 0
- Border: 8

Figure 11.44 *Clicking GetMeshInfo brings up the tile prompt (blue).*

Figure 11.45 shows the settings described above in the MD3 rollout.

11. Click on the Export Options button to bring up the Displacement Exporter.

12. In the Displacement Exporter click on R32.

13. Set the status to On if it isn't already on.

14. In the Quick Code window type in or paste the following code: DE-LBEK-EAEAEA-R32. This is simply a code that creates an optimal map for use in 3ds Max.

15. Close the Displacement Exporter. Figure 11.46 shows the Displacement Exporter with the settings outlined in steps 12–14.

16. Click the Create All button in the MD3 rollout and the process of creating displacement maps begins. Depending on your computer hardware, and the size of the map you are creating, this may take some time. An orange status bar appears near the top of the ZBrush UI. When the bar reaches the right of the screen it will disappear, and the map creation is done. Save the ZBrush file and exit ZBrush.

Figure 11.45 *MD3 settings.*

Figure 11.46 *Displacement Exporter.*

Back in 3ds Max

1. In 3ds Max go to File/Import. *Note: For this exercise the renderer should be set to mental ray. Consult the 3ds Max Help files if you do not know how to designate mental ray as the renderer.*

2. Select the .obj file you exported from ZBrush. Figure 11.47 shows the Select File to

Figure 11.47 *Select File to Import dialog box with .obj file to import selected.*

229

Import dialog box with the file selected. *Note: In the accompanying files for this lesson there is a file named Quad_Iguana_Sculpt_Base-01zee_eXPORT-01 that you can use to complete this exercise.*

3. When the OBJ Importer window pops up be sure to select Single in the Import options box. Figure 11.48 shows the OBJ Importer with Single selected. Click OK and the ZBrush mesh appears in the 3ds Max viewport.
4. Add a TurboSmooth modifier to the model with two iterations.
5. Open the Material Editor (keyboard shortcut M).
6. Select an open material slot.
7. Click the Standard button and select Arch & Design (mi) from the list of shader types. Figure 11.49 shows the options highlighted in the Material Editor.

Figure 11.48 *OBJ Importer with Single selected (red).*

Figure 11.49 *Material Editor with options highlighted.*

8. Apply the material to the model.
9. In the Material Editor scroll down to the mental ray Connection rollout.
10. In the Extended Shaders box you should see Displacement listed. Displacement is grayed out with a small yellow Lock icon next to it. Figure 11.50 shows the Material Editor with the mental ray Connection rollout opened and the Displacement slot highlighted.
11. Click on the yellow Lock icon to unlock the Displacement slot.
12. Click on the slot next to Displacement (with the word "None" printed on it). The Material/Map Browser opens.
13. Select Height Map Displacement from the options list. Figure 11.51 shows Height Map Displacement highlighted.
14. After selecting Height Map Displacement you will be presented with a Height Map Displacement Parameters rollout. Right-click the spinners next to Minimum Height and

Figure 11.51 *Height Map Displacement highlighted.*

Figure 11.52 *Minimum Height and Maximum Height values before and after right-clicking the value spinners to set them to 0.*

Figure 11.50 *Material Editor with Displacement slot highlighted.*

Maximum Height to set the values to 0. Figure 11.52 shows the Min/Max Height with their default values (−10 and 10) as well as the Min/Max Height after the values are set to 0.

15. Click on the slot next to the words "Height Map" (with "None" printed on it). The Material/Map Browser opens.

16. Select Bitmap from the list. The Select Bitmap Image File dialog box will appear.

17. Browse to the directory with the displacement map created in ZBrush. Figure 11.53 shows the displacement map file (Quad_Iguana_Sculpt_Base-01disp1001+R32) highlighted in the Select Bitmap Image File dialog box. The image is a 32-bit TIF file.

Figure 11.53 *The Select Bitmap Image File dialog box with the ZBrush-generated displacement map selected.*

Figure 11.54 *The Coordinates and Bitmap Parameters rollouts with options highlighted.*

Figure 11.55 *Enable Color Map checkbox and the Color Map window.*

Figure 11.56 *Show End Result button before and after clicking. The result on the right (2) is what you want to see.*

18. In the Material Editor under the Coordinates rollout right-click the spinner next to Blur to set it to 0.01. Under Bitmap Parameters set the Filtering type to Summed Area. Adjusting these settings creates a cleaner end-product as the displacement map is not blurred. Figure 11.54 shows the Coordinates and Bitmap Parameters rollouts with the options highlighted.

19. In the Material Editor, go to the Output rollout and check the Enable Color Map checkbox. The Color Map window becomes active. Figure 11.55 shows the Enable Color Map checkbox and the Color Map window.

20. Go up to the Show End Result button just below the material slots in the Material Editor. It should be yellow; click on it, and it will turn gray. The material slot will change from the sphere preview to a square image to display only this level of the material definition. Figure 11.56 shows the Show End Result button and the material slot before and after clicking.

21. Double-click on the material slot to open a larger preview of the image. This image is a preview of the ZBrush displacement map from the Displacement slot.

22. Scroll back down to the Output rollout. The color map graph lets you adjust the tonal range of an image. Adjust the points to create more contrast in the displacement map (examine the preview opened in step 21 as you adjust the color map). Figure 11.57 shows the displacement map before and after adjusting the color map points.

Figure 11.57 *Displacement map before and after adjusting the color map.*

23. In the Output rollout change the RGB Offset value to −0.05. Figure 11.58 shows the Output rollout with the RGB Offset value highlighted. This value can be adjusted to control "bloating" of the mesh. Sometimes when using displacement, the modeled geometry can be overinflated by a displacement map.

Figure 11.58 *The RGB Offset value set to − 0.05.*

Figure 11.59 *Height Map Displacement Parameters rollout with the values highlighted.*

24. Click the Go to Parent button in the Material Editor to return to the Height Map Displacement Parameters rollout.
25. For the Minimum Height Value input 0.01, and for the Maximum Height Value input 1.0. Figure 11.59 shows the Height Map Displacement Parameters rollout with the values highlighted.
26. Close the Material Editor.
27. In the perspective viewport pan and zoom to an angle you would like to see rendered.
28. Hit F10 on the keyboard to bring up the Render Scene dialog.
29. Leave the settings at default and click Render. Figure 11.60 shows the resulting render created with the default settings. Figure 11.61 shows the same model with a lower edge-length value and a simple lighting setup.

There are numerous adjustments that can be made in both the Material and the Render settings. When using mental ray you can adjust the Displacement Global Settings under Shadows and Displacement in the Render Scene dialog. By default the edge length is set to 2.0; lowering

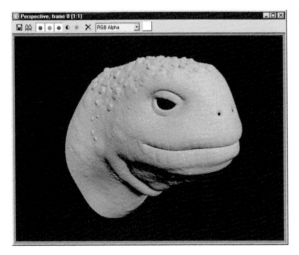

Figure 11.60 *Iguana rendered with ZBrush displacement map creating surface details.*

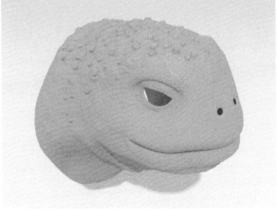

Figure 11.61 *Render with a lower edge-length value.*

this value will increase the amount of visible detail the displacement map creates, but will also increase render time. It is up to you to decide how to balance displacement quality and render time using these values.

This is meant to be a basic overview of the 3ds Max/ZBrush displacement map process. For more information on using ZBrush with 3ds Max go to www.zbrushcentral.com.

The process in Mudbox is very much the same. Under the File menu you can import the .obj base mesh created in 3ds Max. The same rules apply:

- The model should be properly UV Unwrapped.
- Subdivide and sculpt with Mudbox tools.
- Export low-level Mudbox mesh as an .obj model.
- Create a displacement map in the Utilities/Texture Baking rollout.

Consult the manual or use a search engine to find more information about the Mudbox Texture Baking settings.

Back in 3ds Max, the process is nearly identical to the one I outlined in this chapter for ZBrush.

That concludes this chapter. In the next chapter I am going to show you some powerful scripted modeling tools.

Chapter 12

Scripts, Plug-Ins, and Other Additions

In this chapter I am going to discuss and demonstrate some additional modeling tools that are available to 3ds Max users in the form of scripts. Scripts are pieces of code that are used to automate processes and add functionality to 3ds Max. For more on how to write and use scripts, refer to the user's manual (hot-key F1). The accompanying files for this chapter can be downloaded at http://www.todddaniele.com/FocalPress.htm.

There is an insane amount of free scripts available on the Internet; not all pertain to modeling functions. There are scripts for just about every aspect of 3ds Max. To find scripts use your favorite search engine and search for "3ds Max Scripts" or check out www.scriptspot .com. Before some of the polygon editing tools that are currently available in Max were implemented, there were scripts that provided some of the more advanced modeling capabilities. Scripts like Meshtools and CSPolytools were must-haves in older versions of 3ds Max. Today users are lucky enough to have a robust set of tools to work with, and 3ds Max is a formidable modeler without adding a single script. Many of the features of my old favorite scripts are now a part of the standard tools in the software. That doesn't mean independent developers have stopped pushing the limits though; there are new powerhouse scripts pushing the limits even farther. Without further delay, let's take a look at my absolute favorite, PolyBoost.

PolyBoost was developed by Carl-Mikael Lagnecrantz. A PolyBoost demo is available at www .PolyBoost.com. The demo gives you twenty sessions to evaluate the features and tools. Follow the installation process outlined in the documentation. I am going to review the tools I use most often in my own work flow. For additional information, consult the PolyBoost Help by going to the Help menu at the top of the 3ds Max UI: Help/Additional Help/PolyBoost reference.

Upon opening the PolyBoost interface you will be presented with a floating panel with quite a few icons in it. Figure 12.1 shows the PolyBoost interface. You can dock the panel to either side of the Max workspace using the small arrows near the top of the panel.

Across the top of the interface are two rows of icons. From the top left they are Selection, Modeling, PatternMaker, SelectionMixer, and Texturetools. The next row starting at the left: Tools, UVW/Skin, Transform, and Other. These are all powerful tools, but in keeping with the topic of this book, I am going to focus on the modeling tools I use most in my work flow.

1. In the top viewport, create a sphere primitive with the default values and a radius of 42.
2. Convert the primitive to an Editable Poly object. For the tools in PolyBoost to function properly, your models must be in Editable Poly mode. Clone this sphere to several new objects (10) so you can use it as a base mesh for the various tool examples I am going to outline. You can also create new sphere primitives with default settings and convert to Editable Poly if you need additional base meshes.
3. At the Edge subobject level, select the edge seen in Figure 12.2.
4. Click on the InsertLoop button under the Modeling rollout in the PolyBoost interface. As you may have expected, a new edge loop is inserted into your mesh. Figure 12.3 shows the new loop, as well as the InsertLoop button highlighted.
5. With the edge loop still selected, click on the RemLoop button to the right of the InsertLoop button. The loop will disappear; RemLoop

Figure 12.1 *PolyBoost interface.*

Figure 12.2 *Edge selection.*

removes loops with a single click. *Note: What makes InsertLoop and RemLoop so handy is the ability to select a single edge and have these tools execute the function. With traditional methods you would need to select the entire ring or loop to add or remove them.*

6. At the Edge subobject level, select the edges seen in Figure 12.4.

Figure 12.3 *A new edge loop is created.*

Figure 12.4 *Edge selection.*

7. Click on the CL button in the PolyBoost interface. This tool builds a corner loop into your mesh with a single click. What is a corner loop? With each direction change the PolyBoost CL function creates a Quad-based corner on the loop, hence the name. Figure 12.5 shows the resulting mesh after using CL on the edge selection.

8. Select the edge selection seen in Figure 12.6.

Figure 12.5 *Resulting corner loop after using CL.*

Figure 12.6 *Edge selection.*

9. Click the EL button in the PolyBoost interface. This tool builds end loops, a double loop with Quad-based ends. Figure 12.7 shows the resulting double loop with Quad ends.

10. Select the two sets of edges seen in Figure 12.8 (left) and use the standard 3ds Max Connect function on one set at a time to create the edge configuration seen in Figure 12.8 (right). The first edge selection is highlighted in red, the second in blue.

Figure 12.7 *Double edge loop with Quad ends after using EL.*

Figure 12.8 *Edge selections and resulting new edge configuration after using Connect.*

11. Select the two vertices seen in Figure 12.9 (left) and use the BCorner button to end up with the result seen in Figure 12.9 (right). BCorner creates a Quad-based corner when used on similar edge configurations.

12. Alter the basic sphere mesh to match the object seen in Figure 12.10 (left). You should have an open four-sided border created by deleting a single polygon, as well as a six-sided

Figure 12.9 *Vertex selection (left) and resulting mesh after using the BCorner function on the vertices (right).*

Figure 12.10 *Base mesh with a four-sided and a six-sided polygon deleted (left). Mesh after using the CreatePoly button to create polygons from the border selections (right).*

open border created by adding an additional edge loop and deleting one of the polygons that is split by the new edge loop. At the Border subobject level, select the two open borders, and click the CreatePoly button. This function works pretty much the same as the standard 3ds Max tool Cap, but you can use this tool at the Vertex and Edge subobject levels as well. Figure 12.10 (right) shows the resulting mesh. *Note: The six-sided border is now a six-sided polygon; additional steps are required to restore an all-Quad mesh.*

13. Alter the basic sphere mesh to match the object seen in Figure 12.11 (left). Select the two vertices seen in Figure 12.11 (left) and click the BEnd button to create an all-Quad end to the double row of edges. Figure 12.11 (right) shows the resulting mesh after using the BEnd function. BEnd is an abbreviation for Build End.

14. Select the nine polygons seen in Figure 12.12 (left) and delete them. Figure 12.12 (right) shows the end result after deleting.

15. At the Border subobject level, select the open border (Figure 12.13, left), and use Cap to create a single polygon that fills the opening (Figure 12.13, right). *Note: The new polygon is a 12-sided N-gon.*

Figure 12.11 *Base mesh with vertex selection (left) and resulting mesh after using BEnd (right).*

Figure 12.12 *Polygon selection before (left) and after deleting (right).*

Figure 12.13 *Border selection and resulting polygon after using Cap.*

Figure 12.14 *Polygon selection before and after using GeoPoly.*

16. At the Polygon subobject level, select the large polygon (Figure 12.14, left) and click on the GeoPoly button in the PolyBoost interface. You will be presented with a perfectly circular polygon (Figure 12.14, right).

17. With the large circular polygon still selected (Figure 12.15, left), use the standard 3ds Max Inset settings dialog box with an Inset Amount of 1.0 (this value is based on the original

Figure 12.15 *Polygon selection (left) and resulting mesh after insetting the selected polygon (right).*

Figure 12.16 *Polygon selection before and after using Extrude (×2).*

radius of the sphere being 42). What you are left with is a small secondary loop around the circular polygon (Figure 12.15, right).

18. With the same polygon selected (Figure 12.16, left), use the Extrude settings with an Extrude Amount of −1.0 and Local Normal checked. Before clicking the OK button, hit Apply to create a second extrusion with the same settings (Figure 12.16, right).

19. Delete the selected polygon and add a TurboSmooth modifier with two iterations to see the final result (Figure 12.17).
20. You can use the same technique to create circular indents or to branch tubular structures off of your base mesh. Figure 12.18 shows some alternative results.

Figure 12.17 *Mesh before (left) and after deleting the polygon (right). The right mesh has a TurboSmooth modifier with two iterations added to the model.*

Figure 12.18 *Alternate results created with the same technique.*

I am going to skip a few of the other tools listed to take an in-depth look at the PolyDraw set of tools. For additional information on the tools I skipped, refer to the PolyBoost manual.

When viewing the PolyBoost interface you may notice that some of the buttons have a small rectangle at the right side. Any tool button featuring this rectangle will open an additional window with a set of tools of its own. PolyDraw is the set of tools I use more than any other in PolyBoost, so I tend to dock the PolyDraw

Figure 12.19 *PolyBoost interface docked to left, and PolyDraw window docked to right.*

window to the right of the 3ds Max UI next to the modifier stack. Figure 12.19 shows the 3ds Max UI with PolyBoost docked to the left and the PolyDraw window docked to the right.

21. Open the file PolyBoost_highlights-02 (the file can be found at the download link at the beginning of this chapter). Upon opening you will be presented with a simple athletic shoe model. This model will be used to demonstrate some of my favorite PolyDraw features.

22. At the top PolyDraw window there is a Draw on section. Click the circle next to Surface to activate the option.

23. Click on the Pick button and select the Sneaker mesh. The word "Sneaker" should replace the word "Pick" on the button. Figure 12.20 shows the PolyDraw Draw

Figure 12.20 *Draw on section highlighted after selecting Surface and the Sneaker mesh with the Pick button.*

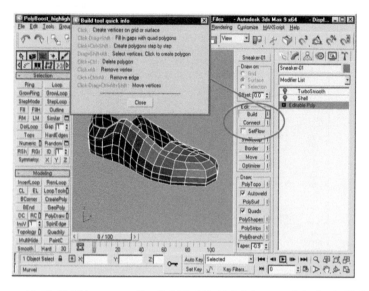

Figure 12.21 *Build button as well as Build Tool Quick Info button and display highlighted.*

on section with Surface checked and the Pick button after selecting the Sneaker mesh.

24. Click on the Build button as well as the Build Tool Quick Info button. The Quick Info button for each tool is right next to the button. It is a smaller button with a vertical line on it. The Quick Info button displays the key combination options for each tool. Different key combinations will invoke different functions of the selected tool. Figure 12.21 shows the Build button as well as the Quick Info box.

25. At the bottom of the PolyDraw window is a button with EmptyObj printed on it. Click that with the Sneaker mesh selected. The sneaker mesh will appear to deselect; this is normal, do not select it again. EmptyObj creates a new Editable Poly object with no existing geometry. When using the Build tool this step is necessary as it makes it possible to create polygons on the surface of the selected mesh. Figure 12.22 shows the full PolyDraw window with the EmptyObj button highlighted.

26. Adjust the Offset value just above the Build button to 0.05. This value will depend on the scale of the models you build. Remember, I recommend building your models to real-world scale. The sneaker mesh in this example is 12 inches long.

27. With Ctrl+Shift keys held down, click four times (at each corner of the desired new polygon shape) to create a new polygon on the surface of the sneaker mesh. Figure 12.23 shows the new polygon drawn on the surface.

Figure 12.22 *PolyDraw window with the EmptyObj button highlighted.*

28. Do not deactivate the tool. Continue to build new polygons by clicking on one of the existing verts and then creating the additional vertices needed to create each new polygon shape. Figure 12.24 shows additional polygons created with the Build tool.

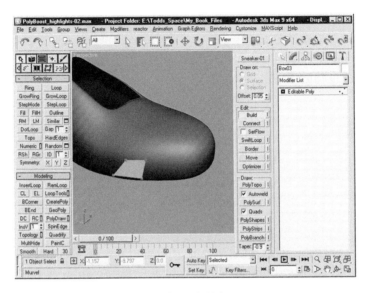

Figure 12.23 *Polygon created with Build and the Ctrl+Shift keys held down.*

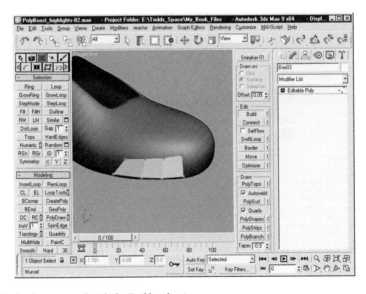

Figure 12.24 *Additional polygons created with the Build tool active.*

29. Continue building polygons around to the other side of the sneaker. Figure 12.25 shows the resulting new polygons. Some verts and edges aren't perfectly aligned. Luckily, a simple key combination activates a move function while you are still using the Build tool.

30. To move vertices around with the Build tool still active, hold down the Ctrl+Shift+Alt keys. When you move over a vertex it will turn red. Simply left-clicking and moving the mouse will move it smoothly

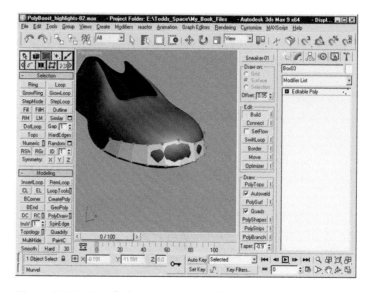

Figure 12.25 *Row of polygons drawn onto existing mesh. Some edges and verts are not perfectly aligned.*

to whatever location you wish. This is a nice feature because it enables the user to continue on with the Build tool without needing to disable it, use another tool, and then go back through the process to restart building. Figure 12.26 shows vertices after being moved with the alternate key combination and the Build tool.

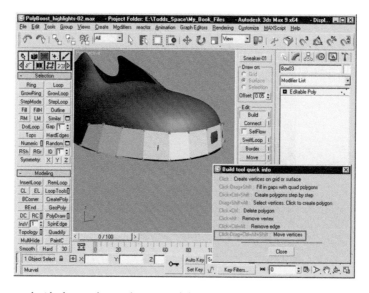

Figure 12.26 *Vertices moved with alternate key combination and the Build tool.*

Notice in Figure 12.26 that in the modifier stack the words "Editable Poly" are highlighted in yellow. When you deactivate Build, the Editable Poly will remain highlighted. To complete the Build, click on the highlighted text to deactivate it.

31. Add a Shell modifier with an Inner Amount of 0.04 and an Outer Amount of 0.03. Above the Shell modifier, add a TurboSmooth modifier with two iterations. Figure 12.27 shows the resulting mesh (left) as well as the resulting mesh with two additional chamfers to create a cleaner/crisper shape (right).

Figure 12.27 *Resulting mesh (left) and resulting mesh with additional chamfers added (right).*

With a working knowledge of the Build tool, let's move on to the Border tool.

1. Rotate the sneaker mesh so that the rear and side are visible as seen in Figure 12.28.

Figure 12.28 *Perspective viewport with shoe rotated.*

2. Select the sneaker mesh, and click on the EmptyObj button. As before, EmptyObj creates a new Editable Poly object with no existing geometry and enables us to create polygons on the existing mesh's surface. *Note: The Draw on options should be the same as in the previous exercise (set to Surface).*

3. Select the Build tool. That's right, I said the Build tool, not the Border tool.

4. As in the last exercise create the first polygon with Build. Create only a single polygon.

Figure 12.29 *Initial polygon created on the sneaker's surface using the Build tool.*

Figure 12.29 shows the mesh with the first polygon created on the sneaker mesh surface.

5. The Build button should still be highlighted in green. Click on the Border button to activate it. Also click on the Border Tool Quick Info button to bring up a list of key combinations for the tool. Figure 12.30 shows the Border button activated as well as the Quick Info for the tool displayed.

Figure 12.30 *Border button is active (green), and the Quick Info list for the Border tool is displayed.*

6. While holding down the Shift key, drag from the edge of the polygon created in the last step. Repeat the process to create another polygon. Figure 12.31 shows two additional polygons created with the Border tool.

7. With the Border tool still active, continue creating evenly spaced polygons around to the other side of the sneaker mesh. Figure 12.32 shows the resulting mesh with nine total polygons in the row.

Figure 12.31 *Additional polygons created with Border. Holding down Shift while dragging creates new polygons along the surface of the mesh.*

Figure 12.32 *New polygons created around to other side of shoe.*

8. Using the Shift key and Border drag a new polygon from every other polygon as seen in Figure 12.33. I also adjusted the vertex positions using Ctrl+Alt with the Border tool still active.

9. With Border still active, hold down the Ctrl+Shift keys to fill in the gaps between the polygons created in the last step. Work from side to side, creating Quad polygons to fill the voids. Figure 12.34 shows the resulting mesh.

Figure 12.33 *New polygons create with Border. Vertices were also moved during the process by using the Ctrl+Alt key combo.*

Figure 12.34 *New polygons created with Border and the key combination Ctrl+Shift.*

10. Add a Shell modifier with an Inner Amount of 0.04 and an Outer Amount of 0.03. Above the Shell modifier, add a TurboSmooth modifier with two iterations. Figure 12.35 shows the resulting mesh (left) as well as the resulting mesh with two additional chamfers to create a cleaner/crisper shape (right).

The results of the last two exercises are very similar. I like the ability to use the tools together, as it speeds the work flow and creates fantastic results. Some additional vertex manipulation may be required, but the new mesh conforms nicely to the sneaker and was made quickly and accurately.

With the front and back trim pieces added to the shoe, I think this is a good time to add a logo or stripe to the side. This could be easily done with the tools that were just covered, but there is one more powerful option that is well suited to this type of situation. The PolyTopo tool is another of my favorite tools in PolyBoost.

1. Select the sneaker mesh, and click on the EmptyObj button.

Figure 12.35 *Resulting mesh (left) and resulting mesh with additional chamfers added (right).*

Figure 12.36 *PolyTopo is active; line is drawn onto the sneaker surface (seen in black).*

2. Uncheck the Autoweld box just below the PolyTopo button.

3. Click on the PolyTopo button.

4. Left-click and draw a line onto the sneaker base mesh in the shape of the desired stripe or logo. Figure 12.36 shows the line drawn on the mesh.

5. Draw a second line with a similar shape, as seen in Figure 12.37.
6. Draw a series of lines that span across the two lines that were just created. Think of this process as drawing the polygons you desire in the final mesh. Figure 12.38 shows the lines as they cross the distance between the first two lines drawn. These shorter lines should overlap the first two lines created.

Figure 12.37 *Second line drawn on sneaker surface.*

Figure 12.38 *Lines crossing over the span between the first two lines drawn.*

7. Once you have finished laying out the lines, right–click to finish the operation and exit the PolyTopo tool. Figure 12.39 shows the resulting stripe on the sneaker's surface.

As with the previous examples in this chapter, adding a Shell modifier, along with TurboSmooth, will result in a new piece of trim on the shoe's surface. Chamfering edges will again result in a crisper result (Figure 12.40).

Figure 12.39 *Mesh created by drawing with the PolyTopo tool, seen in yellow.*

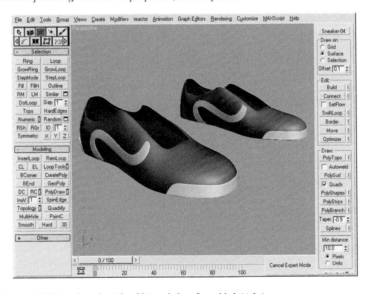

Figure 12.40 *Resulting mesh (left) and mesh with additional chamfers added (right).*

The PolyDraw tools make modeling fun. Just when you think "It can't get any better than this," it does. Let's take a look at the PolyShapes tool next. I know we skipped PolySurf; I haven't had much success with that tool so I can't comment on it.

1. As in the previous exercises, select the sneaker, and click the EmptyObj button.

2. Click on the PolyShapes button to activate it.

3. Draw a curved shape as seen in Figure 12.41. The PolyShapes tool creates a multi-sided polygon in the shape you draw. It is not Quad based; however, there is a tool to fix this.

4. Go down to the SolveSurf button and click it. A small window appears with options. Leave the settings at their defaults, and then click the SolveSurf button in this small window. This will "Create clean connections on Polygon shape," resulting in a multi-polygon mesh. You may have some *N*-gons, so be sure to inspect and correct any problems in the new mesh. Figure 12.42 shows the result of using SolveSurf.

Figure 12.41 *New shape created with the PolyShapes tool (mesh shown in orange). Note that this shape is one large multi-sided polygon.*

Figure 12.42 *Resulting new mesh created on the sneaker's surface using PolyShapes and SolveSurf.*

Additional steps outlined in the earlier examples result in a new mesh conforming to the sneaker's surface. Figure 12.43 shows the result after performing the additional steps.

Figure 12.43 *Final result after additional steps.*

Figure 12.44 *Green strip of polygons created with the PolyStrips tool.*

Let's move along to the PolyStrips tool.

1. To begin, use the same process from the previous examples; select sneaker and click EmptyObj.
2. Click on the PolyStrips button. Draw on the surface of the sneaker object, creating a strip of polygons as you go. That's all there is to this tool; it is both simple and effective in many cases. Figure 12.44 shows the strip of polygons created with the PolyStrips tool.

I am going to skip the PolyBranch tool for a moment and demonstrate the Splines tool next.

1. To begin, use the same process from the previous examples; select sneaker and click EmptyObj.
2. Click the Splines button to activate it.
3. Draw a spline that follows the shape seen in Figure 12.45.
4. Right-click to deactivate the Splines tool.
5. Select the spline that was just created.
6. In the Modify panel, under Rendering, check both the Enable in Renderer and the Enable in Viewport boxes.
7. Adjust the Thickness value to 0.06 for this example. Figure 12.46 shows the Rendering rollout with the options highlighted. Figure 12.46 also shows the resulting renderable spline in the viewport.

Let's go back to the PolyBranch tool. I don't feel it is applicable to this particular example, but I want to demonstrate it anyway, as it is a good tool to be familiar with.

Figure 12.45 *Spline drawn onto the surface of the sneaker mesh.*

Figure 12.46 *Renderable spline created with the Splines tool. Rendering options are highlighted in red.*

1. Select the yellow stripe along the side of the sneaker.
2. Turn off the TurboSmooth and Shell modifiers in the modifier stack.
3. At the top of the PolyDraw window, click on the Pick button. The Pick button should actually say "Sneaker," as that is the last object that was being drawn on. With the button

active, select the yellow stripe. Figure 12.47 shows the Pick button after selecting the yellow stripe, as well as the Shell and TurboSmooth modifiers turned off in the modifier stack.

4. Click on the PolyBranch button as well as the Quick Info button for the tool.

5. Hold down the Ctrl key and click a polygon that makes up the yellow stripe to select it (Figure 12.48, left).

Figure 12.47 *Yellow stripe picked with modifiers turned off.*

Figure 12.48 *Polygon selection (left) and resulting PolyBranch branch (right).*

6. Left-click on the polygon and drag (with the left mouse button pressed as you go) to create a "branch" as your mouse moves away from the polygon selection (Figure 12.48, right).

I strongly encourage you to explore each and every tool in PolyBoost, not just the modeling tools. This is a well-thought-out set of tools that is a welcome addition to my work flow. With a little practice I am sure it will impact the way you work as well.

For those of you who wish to experiment with other scripted modeling tools, there are products out there. A set of tools that has functionality similar to that of PolyBoost is OrionFlame. I haven't tried OrionFlame myself, but upon reading the manual, I do see alternatives to the modeling tools in PolyBoost included in OrionFlame. Both PolyBoost and OrionFlame have demo versions; try them out and decide for yourself which you prefer. OrionFlame information and demo software can be found at http://www.orionflame.com.

That concludes this chapter, as well as the practical exercise sections of this book. In the next chapter I will give a few closing thoughts.

Chapter 13

Final Word

I hope you have found this book to be a valuable learning tool. Writing it has been a great learning experience for me. 3ds Max is a powerful application; with the information provided in this book you should be well on your way to modeling impressive, detailed models with relative ease. The last piece of advice I can give you is to practice, and to never become complacent. When something doesn't make sense . . . think outside of the box!

Index

Index

Printed and bound by CPI Group (UK) Ltd, Croydon, CR0 4YY

21/10/2024

01777057-0001